I wished to stimulate the mind

and awaken large thoughts

G. F. Watts

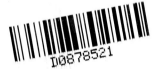

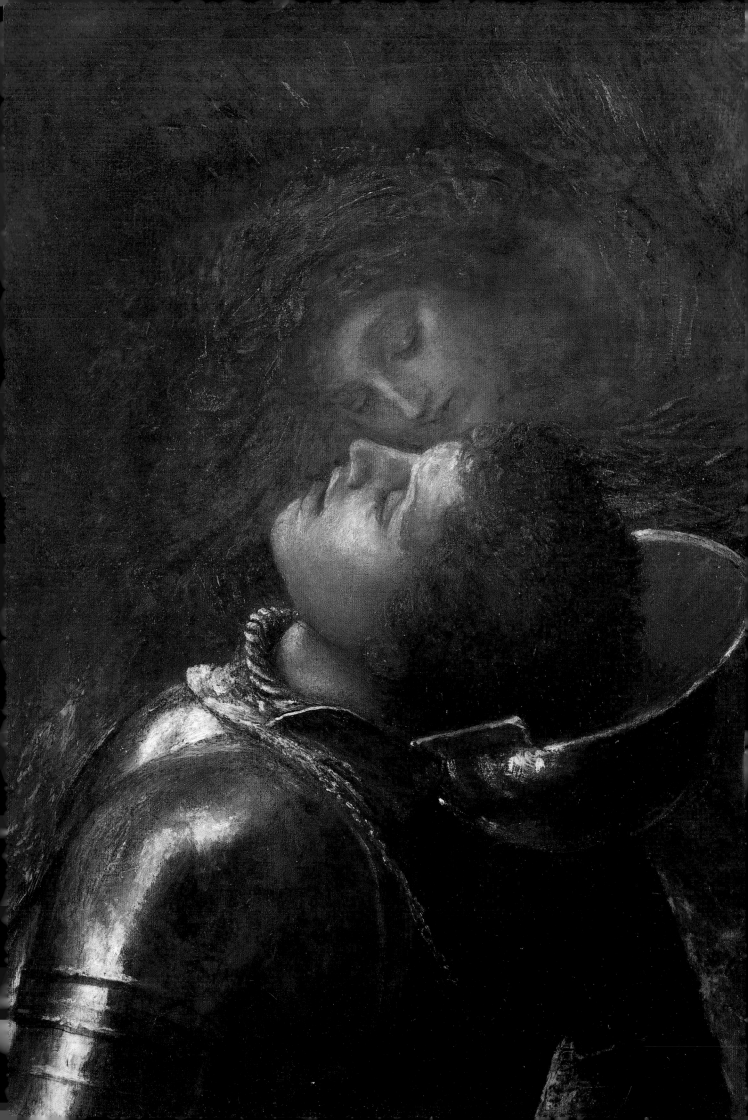

THE VISION OF G. F. WATTS
OM RA (1817-1904)

Edited by Veronica Franklin Gould

With contributions by

Richard Ormond, Richard Jefferies,

Alison Smith, David Stewart and Hilary Underwood

WATTS GALLERY

Published by Veronica Franklin Gould
For the Trustees of the Watts Gallery for the
Watts Centenary Exhibition
2 July – 31 October 2004
© 2004 Veronica Franklin Gould and contributors

Typeset in Garamond and printed by
BAS Printers Ltd., Salisbury, Wiltshire
Distributed by The Antique Collectors' Club Ltd.

ISBN 0 9515811 3 9

Illustrated on cover
Love and Life (No. 96, detail)

Illustrated on title page
The Happy Warrior (No. 78)

Illustrated on back cover
After the Deluge: The 41ª Day (No. 113)

Contents

As part of the Watts centenary celebrations, the Watts Gallery is mounting an exhibition of the artist's visionary works. This is one in a sequence of exhibitions and displays at the National Portrait Gallery, Tate Britain, the Royal Academy and Leighton House. In his own lifetime, Watts was regarded as the greatest British artist of his day. His allegories on themes of time and judgement, progress and chaos, love and death, appealed to the imagination and the spiritual values of a Victorian audience. His art, spanning the reign of Queen Victoria whom he outlived, was endlessly experimental. All his pictures were works in progress to be gone over again and again. History subjects for the Palace of Westminster were succeeded by stark scenes of social realism, by the high art works of his maturity confronting the fundamental issues of human existence, and by the mystical and symbolist works of his last years. Watts was a truly Renaissance man, draughtsman, painter, sculptor, muralist and ardent social reformer. He was at the heart of artistic and intellectual life in Britain, and his achievements, which deserve wider recognition today, were formidable.

We are grateful to our lenders and donors, to our enlightened sponsors who have supported us financially, Adam Prideaux and Blackwall Green for sponsoring the exhibition insurance and to the Esmée Fairbairn Foundation and the Manifold Trust for grants for the exhibition transport. Our thanks to Martin Beisly, Lady Angela Nevill, Simon Edsor, Grant Ford and Julian Hartnoll, to Sir Andrew Duff Gordon, Colin Ford, Timothy Seago, and to Geoffrey Beare, Colin Clark, Celia Clear, Emma Dennis, Tom Duff Gordon, Mark Eastment, Simon Edsor, Donato Esposito, Susanna Fergusson, Grant Ford, Robin Francis, Peter Funnell, Melanie Gardner, Werner Guttmann, Colin Harrison, James Hervey-Bathurst, Guy Holborn, Ingrid Huber, Robert Jefferies, Jennifer Johnson, Vivien Knight, John Schaeffer, Tim Knox, Sir John Leslie, Janet Maclean, Mary McDougall, Philippa Martin, Sue Meynell, Julian Morrison-Bell, Paul Nelson, Peter Nahum, Dottie Owens, Daniel Robbins, Richard Ryder, Alison Smith, Sheila Stoddard, David Stewart, Michael Thoms, Simon Toll, Julian Treuherz, Jane Turner, Hilary Underwood, Michael Vickers, John Waters, the Compton Village Committee and the Little Green Paint Company. We are delighted that Winsor & Newton – Watts's paint suppliers – are sponsoring a student art prize and painting workshops.

Our thanks to the scholarly contributors to the catalogue; to the Gallery team led by our new director, Perdita Hunt, and our long-serving curator, Richard Jefferies; and finally to Veronica Franklin Gould, the begetter and organizer of the exhibition, who has not only selected the works and edited the catalogue, but has worked tirelessly behind the scenes to ensure that the exhibition actually happens.

RICHARD ORMOND

From modest beginnings Watts was, at the end of his life, one of the most revered figures in the land, held in affectionate esteem, even by those who did not care for his art. It is puzzling that such a man has been largely ignored, when most of his contemporaries have enjoyed a renaissance. Watts was always the odd one out. He did not found a group, nor did he belong to one, but followed his own ideas unswervingly.

Watts enjoyed, as the Victorians put it, delicate health. He enjoyed it for nearly ninety years, his inner determination overcoming his frail constitution. As he said, Work is the life of life'.

Despite the disapproval of his closest friend Frederic Leighton, the president of the Royal Academy, he drew attention to subjects that the polite world did not discuss. Gambling, drunkenness, child prostitution, the over-tight lacing of stays, the slaughter of birds for the millinery trade were all given merciless examination by his brush or pen. All these subjects were secondary to his central aim which was to bring art to all rather than just the rich, to dignify it and to encourage people to make it part of their lives. A more daunting task than persuading the average Englishman to take art seriously can hardly be imagined. However, gradually the word spread from patrons who bought Watts's pictures, from slightly dotty parsons who preached sermons on them and upper-class spinsters of uncertain age who wrote poetry about them, that is pictures could comfort, inspire, or even provoke. He became the thinking person's painter.

Watts had immense personal charm, which captivated all who knew him. His innate simplicity and modesty provided a note of calm in a turbulent age, but was at odds with his work. As ever, there were those who mocked. His marriage at the age of 47 to the teenage Ellen Terry, although brief, yielded a remarkable legacy in paint. At 69, he married 36-year old Mary Fraser Tytler, on the face of it a triumph of hope over experience, and proved to be his most innovative period.

Watts's achievement was to traverse two centuries in one lifetime. In his youth taste in art looked backwards, and so his early work pastiched the eighteenth century. By the 1850s, he had found his own style; he moved progressively forward and the gulf between his art and that of his contemporaries widened. Watts was not content to paint pretty pictures that would find a ready sale. Such a course was not without its perils. He was prepared to risk failure in order to advance. How far he advanced is evidenced by looking at *The Wounded Heron*, to *The Sower of the Systems*. The first looks back to the eighteenth century, the second forward into the twentieth. This exhibition on the centenary of his death illustrates Watts's vision as an artist. He waits ready to astonish and inspire the twenty-first century as he did the nineteenth.

RICHARD JEFFERIES

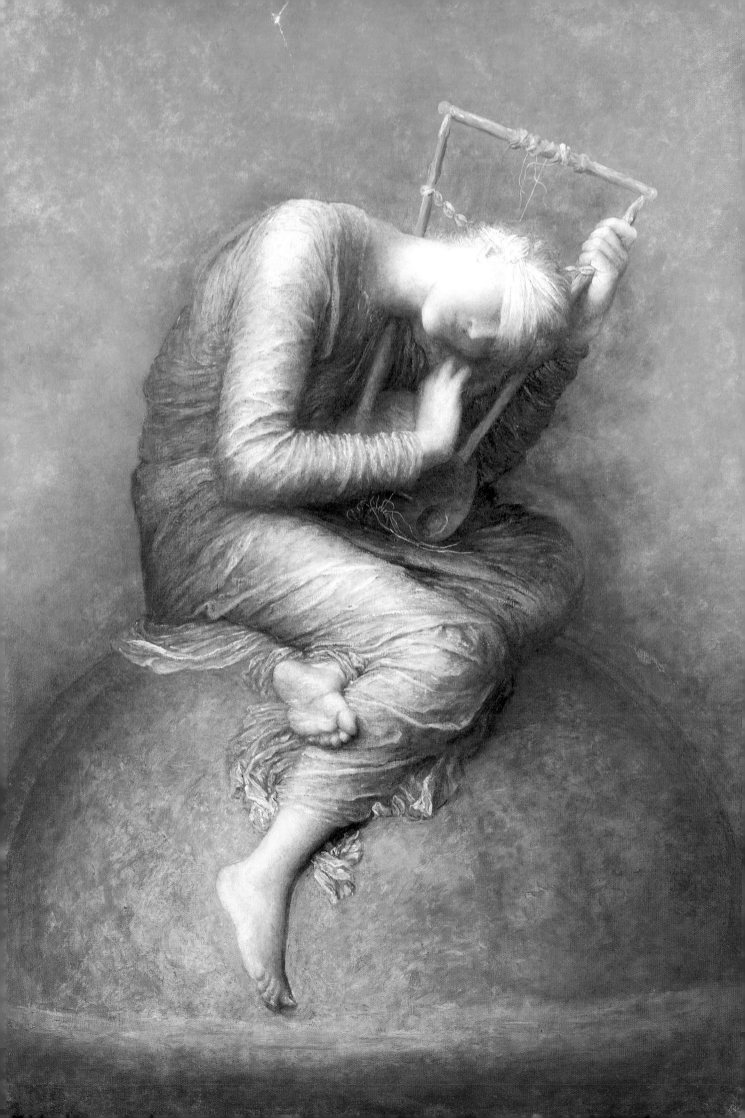

The Vision of G. F. Watts: Good and Evil Interwoven

VERONICA FRANKLIN GOULD

'I am painting a picture of *Hope* sitting on a globe with bandaged eyes playing on a lyre which has all the strings broken but one out of which poor little tinkle she is trying to get all the music possible, listening with all her might to the little sound. Do you like the idea? In this iconic image of 1885-86, as in all Watts's visionary work, the idea is paramount. Just a segment of the world is visible to stimulate the viewer's imagination. The seated figure is bent double in her effort to make beautiful music from the single string. Her luminous robe falls in multiple folds, breaking up the mass, so that attention is focussed on her hands, face and vulnerable bare feet. The pathos of her pose heightens the intensity of her expression. This confrontation of a negative state to achieve a positive goal underlies Watts's imaginative painting and sculpture. The artist, whose health was so precarious, that he felt on the brink of death one moment and on top of the world the next, explained, 'It is only when one supreme desire is left that one reaches the topmost pitch of hope'.[1]

Within months, the French poet Jean Moréas's definition of symbolic poetry's 'attempts to clothe the Idea in a perceptible form which, though not itself the poem's goal, serves to express the Idea to which it remains subordinate', established the term 'Symbolist', which French artists adopted to describe Wattsian concepts that had mystified the British public for decades.

George Frederic Watts was born above his father's piano-manufacturing workshop at 52 Queen Street, in the Marylebone district of London, on 23 February 1817. George Watts senior aspired – but failed – to invent a musical instrument that would combine wind and string. The artist inherited his father's ambitious drive and would consciously infuse his paintings with musical harmonies of line and colour. An imaginative artistic child, he was apprenticed at ten to William Behnes, the future Sculptor in Ordinary to the Queen. At the age of eighteen, he entered the Royal Academy Schools, but left to study directly from the Parthenon marbles, whose poetic sense of form and drapery folds would influence his painting.

Watts's career spanned the reign of Queen Victoria. In 1837, the year of her accession, he acquired an enduring patron Alexander Ionides, and exhibited at the Royal Academy the earliest known example of his preoccupation with themes of Life and Death, *The Wounded Heron* (No.1), painted as though still alive but dying. His *A Dedication* (No. 62), an angel weeping over iridescent birds' feathers, painted in the 1890s as a protest against killing birds for millinery, headed the Society for the Protection of Birds' appeal against the feather trade.[2]

For his patriotic life-size cartoon of *Caractacus Led in Triumph Through the Streets of Rome* (Fig. 16), Watts was awarded a top prize in the 1843 Palace of Westminster competition. His depiction of the British chieftain towering over his captors – clearly influenced by Thomas Carlyle's lectures 'On Heroes, Hero-Worship and the Heroic in History', published in 1841[3] – transformed the humiliating march into one of glory.

Watts aspired to emulate the greatness of the old masters. In September 1843, he set out to study the Grand Manner in Florence. Under the patronage of the British Minister Lord Holland, he painted distinguished portraits, Michelangelesque frescoes – *Flora* and *The Drowning of the Doctor* (1844-45, Villa Careggi, Florence) – and large imaginative easel paintings – *The Story from Boccaccio* and *Echo* (1844-47, Tate Britain) and *Fata Morgana* (1846-89, Leicester City Museums). He established the old master influences that would inform his work: the glowing colours of Titian and the Venetian school and the monumental *disegno* of Michelangelo's frescoes, as well as the restrained form of Pheidias and the Parthenon figures. And in preparation for his paintings, he adopted Michelanglo's technique of modelling figure studies in wax or clay.

Elated by the Sistine Chapel, Watts returned to London in 1847 determined to fill a hall with inspiring frescoes. He mapped out a universal epic that would embody the progress of the cosmos and civilization, cultural history and spiritual thought. This reflected Carlyle's call for a 'Poet, Painter, Man of Genius' to unravel the mystery of Time. The frescoed hall was never built, but transcendental paintings for the scheme – later referred to as *The House of Life* – would preoccupy the artist for the rest of his life.[4]

For *King Alfred Inciting the Saxons to Resist the Landing of the Danes*, Watts again won a top award in the 1847 Palace of Westminster competition. Surging with energy and luminous Venetian colour, *Alfred* combines the gestures and dramatic frozen moment of Tintoretto, sharp outlines and flat treatment of fresco studies, and the dignified form of Greek sculpture. The critic John Ruskin

[1] Where Watts painted more than one major version of a subject, locations are not named in the text.

Hope, 1885-86
(No. 80)

saw the Westminster pictures as 'the beginning of English historical art ... victorious powers of design'.⁵

Watts embarked on a solitary crusade to paint symbolic pictures for the nation, to elevate British art to the status accorded poetry and music. However, his proposals – to dignify public buildings with grand imaginative frescoes fell largely on deaf ears.

His earliest cosmic subject, *Time and Oblivion* (1848, Eastnor Castle, Ledbury), glowing sculptural figures painted on canvas, with sparse abstract detail, established his symbolic style. Watts reinvented allegory⁶ with a modern anthropomorphic vocabulary, he presented Time, not as an old man, but as a vigorous youth. He placed the figures between Night and Day, showing only part of the larger fiery sun in order to stretch the viewer's imagination. 'I wished to stimulate the mind and awaken large thoughts', he explained. 'It is solemn, sad and hard, for solemn, sad and hard are the conditions: an organ chord swelling and powerful but unmodulated.'⁷ In his first moral message *Life's Illusions* (1849, Tate Britain) was a sensual assault on the perils of power, nude figures embodying Hope and Ambition hover over a knight on horseback, who chases 'a rainbow-tinted bubble of glory'; the animal's forelegs are over a precipice. Both pictures prefigured Continental Symbolism, but mystified critics in 1849. *The Athenaeum* declared on 19 May: 'The conditions under which Mr Watts may have dreamt his dream of *Life's Illusions* it enters not into our nature to divine.'

Fig.1
Life's Illusions, 1849
Oil on canvas
Tate Britain

Watts established, as his lifelong suppliers, Winsor & Newton of Rathbone Place for materials and Joseph Green of Mortimer Street for his characteristic frames with wide oak flats and inner fillet of the English acorn.

An eight-feet-high painting of *The Good Samaritan* (1850), inspired by the prison philanthropist Thomas Wright and accepted by the Corporation of Manchester, was his first public donation and fulfilment of his ideal, to paint art to provoke imaginative thought and encourage 'all that is best and noble in humanity'.[8]

Except for the social realist pictures of 1848-50, addressing poverty – *Under a Dry Arch, Found Drowned* (No. 7), *The Song of the Shirt* and *The Irish Famine* (1848-50, all WG) – his symbolic pictures presented idealized figures to embody universal issues. Pursuing his vision, Watts stood apart from the young Pre-Raphaelite Brotherhood. He preferred shadows and mood to their illuminated detail. As Ruskin transferred allegiance from Watts's broader aspirations to the medieval art of the Pre-Raphaelites, Watts explained to the critic:

My own views are too visionary, & the qualities I aim at, too abstract to be attained. My instincts cause me to strive after things ... that are rather felt than seen. My instinct rebels against mere imitation. Like you I am most interested in the progress of Art & believe it can only be great by being true, but I am inclined to give truth a wider range'[9]

Ruskin, described Watts as the one painter capable of large-scale designs in colour, writing in *The Stones of Venice*:

He stands alone among our artists of the old school, in his perception of the value of breadth in distant masses, and in the vigour of invention by which such breadth must be sustained; and his power of expression and depth of thought are not less remarkable than his bold conception of colour effect.[10]

Watts painted symbolic frescoes at Little Holland House in Kensington, where he lived as the tenant of Thoby and Sara Prinsep. Idealized nudes in his Taylorian ceiling design upset the Oxford authorities, who rejected his planned fresco in 1852. Reintroducing the nude as the purest expression of high art, Watts informed his modern art with the Titianesque principle that a naked woman, symbolizing celestial love, is superior to her draped companion, who represents personal love. His fresco of *The Red Cross Knight Overcoming the Dragon* at the Palace of Westminster, commissioned that year, was noted for its poetic harmony with the architecture[11]

In June 1852, Lincoln's Inn accepted Watts's proposal to decorate the Great Hall. For this monumental record of civilization he offered his services free, asking only the cost of materials. He designed *Justice: A Hemicycle of Lawgivers* to pervade the building 'like a strain of Handel's music, becoming one with the architecture'. Completed in 1859, it was hailed by John Everett Millais and Dante Gabriel Rossetti as the finest modern specimen of true fresco[12]

At the same time, he was painting frescoes of *The Elements* for Earl Somers, and was deeply impressed by visits to Venice and Padua. He also witnessed Charles Newton's excavation of the Mausoleum of Halicarnassus. Memories of the blue waters and the reflected light over the Aegean Sea inspired his painting *Genius of Greek Poetry* (No. 27).[13] While the Lincoln's Inn fresco was under way,

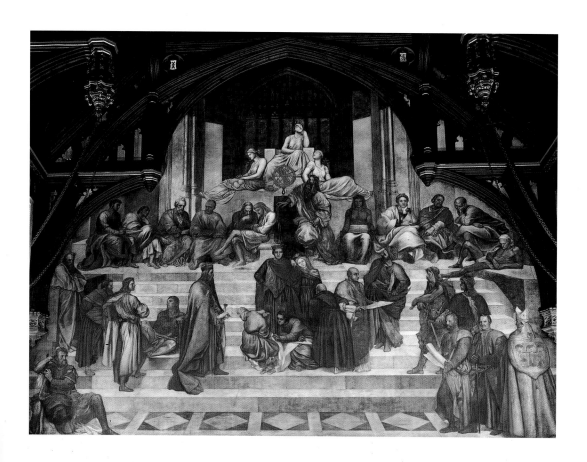

Fig.2
Justice: A Hemicycle of Lawgivers, 1852-59
Fresco
Lincoln's Inn

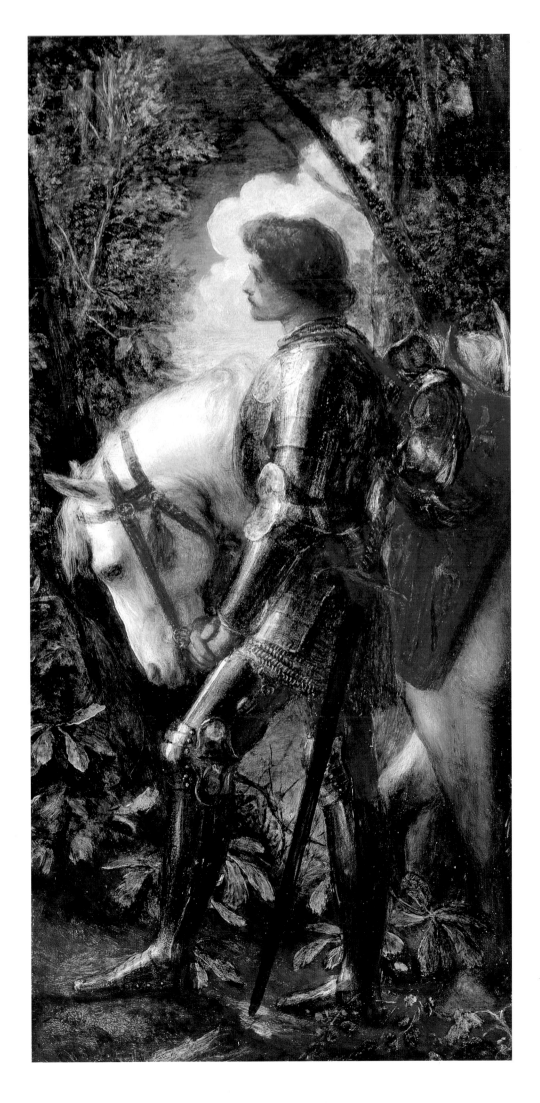

Sir Galahad, 1862
(No. 75)

the poet laureate Alfred Tennyson sat for two portraits – these are not the subject of this essay, except to point out that both artist and poet aspired to interpret the noblest Victorian mind in their work, and that the more popular part of Watts's dual crusade for the nation was his portrait series of memorable figures of the era.

The evolutionary debate arising from Charles Darwin's *The Origin of Species* (1859) would direct the public to look anew at Watts's imaginative subjects. In the meantime, he painted a monumental fresco of *Christ and the Evangelists* at St James the Less in Westminster (1861-62)[14] and designed cartoons of St Matthew and St John to be executed in mosaic for the spandrels under the dome at St Paul's Cathedral. For St John, he spent hours with a model to achieve a 'beautiful and suggestive' arrangement of drapery folds. By breaking up the mass into folds with a sense of movement that became increasingly ethereal over the years, Watts focussed attention on the figure's head.[15]

The heroic chivalrous qualities of armour fascinated him.[16] A life-size visionary picture of the contemplative Arthurian knight *Sir Galahad* standing in armour by his horse, was warmly received at the Royal Academy in 1862, for its poetic, suggestive qualities and Venetian colour handling. (In 1897 Watts would repaint the original sketch for Eton College.) By contrast, his more frenzied series of apocalyptic horsemen confronted death and the principle of good versus evil. The teenage actress Ellen Terry, brought to the studio with her sister in 1863, posed in armour, her hands pressed to her breastplate as Joan of Arc. Her illuminated face, blue eyes, and the strands of her hair suggest an inner vision. Watts's assistant Emilie Barrington observed that sensory experience informed his art, and that when he painted this picture - later retitled *Watchman, What of the Night?* (No. 41) – 'it was not Isaiah, but the dramatic genius of his sitter influencing the artist's imagination in a psychic manner, which made the work what it is, a quite inspired creation.[17]

Watts married his teenage muse on 20 February 1864. *Choosing* (1864, National Portrait Gallery), a jewel-like symbolic picture of Ellen Watts in her bridal gown, painted with almost Pre-Raphaelite intensity, shows the actress attempting to smell an exotic scentless camellia, symbol of worldly vanities – the theatre – while clutching to her heart fragrant violets that symbolize Innocence and Love. Her charisma spurred the artist to produce outstanding work. He painted her running and, prophetically, as the deranged, drowning *Ophelia*, for theirs was a marriage in paint alone and they separated within a year.[18]

Her face was the model for Watts's important visionary subject *Love and Life*, in which the winged figure of Love leads a nude maiden up Life's rocky path, (although the sketch for this first *House of Life* theme to interest critics at the Academy in 1865 showed Love with 'wings of fire' guiding a man along a thorny path).[19] In Watts's oeuvre, a naked figure represents humanity. He felt that clothes lessened the impact. For her body, he had referred to his archive of nude studies taken from a statuesque Little Holland House maid. The artist used these studies from 'Long Mary' as a writer uses a thesaurus, and never painted imaginative nudes from life. Watts explained: 'The model is but the grammar of the higher language of art'. Friends posed for limb studies for the archive, to be dipped into for future reference, 'when I want to be sure as to the play of a joint or a muscle, or the fall of light'.[20]

He painted a series of sensual half-length nude paintings that challenged the British art establishment with an erotic art form decried for decades. The first, *A Study with the Peacock's Feathers* (Fig. 3),[21] relates to two contemporary French paintings, Eugène Delacroix's *Odalisque* (1857, Private Collection) and Edouard Manet's *Olympia* (1863, Musée d'Orsay, Paris) and closer to home, Dante Gabriel Rossetti's *Venus Verticordia* (1863-68, Russell-Cotes Art Gallery, Bournemouth). Watts's first painting of *Ariadne* abandoned on the island of Naxos (1863), clothed, but in dishevelled reverie, inspired his fellow Olympian Frederic Leighton to tackle the theme, which he himself would develop over the years, with a gesturing attendant and leopards in a poetic landscape in his 'most complete' version of 1875 (Guildhall Art Gallery). His later atmospheric, painterly versions of the late 1880s and 1890s show the contemplative beauty alone, her dress broken into multiples of folds.[22]

On classical themes of unfulfilled longing, *Clytie* (c. 1865, WG) and *The Wife of Pluto* (No. 68), their faces stretched away – the latter, in impure contrast to *Choosing* ravished yet unsatisfied, with her nose thrust towards

luxuriant drapery shaped like a giant carnation – were clearly inspired by Watts's estranged wife.

Following the exhibition of Ingres's vertical nude *La Source* (1820-56, Musée d'Orsay) at the London International Exhibition of 1862, Watts painted a series of languid classical nudes in a similar format; the first, *Thetis* (Private Collection) was exhibited in 1866; and over the decades he transformed the larger version with atmospheric effects (No. 51). As Alison Smith points out, the verticality appears to ennoble and purify the figure beyond sexual desire. Inviting association with architectural form, it exemplifies the 'sensuous intellect', the Greek perception of the human figure favoured by the eighteenth-century German art historian Winckelmann.[23]

Julia Margaret Cameron looked to Watts for artistic guidance when she took up photography in 1864. He encouraged her to produce photographs that would mirror the souls of her sitters. Her diffused focus and broad modelling of form and colour through light, shadow and tone, was comparable to his controversial abstract technique and his visionary *Lamplight Study* of the Hungarian violinist Joseph Joachim (No. 43). Like Watts, the photographer felt that a greater effort heightened a picture's value. His collaboration in her quest to emulate High Art resulted in one of her best-loved images, *The Whisper of the Muse* in which the artist posed with his violin and two children (No. 39), similar to his *First Whisper of Love* (No. 38), both owing much to Rembrandt's *The Evangelist Matthew Inspired by the Angel* (1661, Louvre, Paris).[24]

By 1866, Watts had embarked on large-scale memorial sculpture and produced an oil sketch of *The Titans*, the giant recumbent figures stretched out to represent a mountain range, with female figures gliding below to suggest revolving centuries. This was the right hand section of *Chaos* (No. 13), the cosmic 'introductory chapter' to *The House of Life*, which shows the turbulent planet on the left, a small central figure emerging from the swollen tide to mark the beginning of the strides of time.[25]

He conceived his imaginative pictures as painted poems and often referred to them as sonnets, or anthems. In his series on themes from Ovid, notably *Orpheus and Eurydice* (Nos. 23 and 44), he would capture the supreme symbolic moment – whether at the point of death or metamorphosis – and re-create it as though for eternity. Each monumental character was charged with emotion, making full use of colour and drapery folds to suggest mood. Rossetti had already begun to combine ecstasy and death in *Beata Beatrix* (c1863-70, Tate Britain). The French painter Gustave Moreau exhibited an idealized vision of Orpheus's severed head in the 1866 Paris Salon. He and the European Symbolists would take up the theme again in the 1890s.[26]

Watts's *The Wife of Pygmalion* (No. 22), bringing to life the classical marble bust he had discovered in Oxford, appears more kissable against a simple virginal background of lilies, than Rossetti's luscious, almost overpowering *Venus Verticordia*. Both artists celebrated the poetry of female beauty, using mythology and symbolism to recreate images of extraordinary sexual power. Breaking new ground with an impassioned Michelangelesque bust modelled first in clay and later carved in marble, Watts's *Clytie*, exhibited with *The Wife of Pygmalion* in 1868, was seen as the forerunner of the New Sculpture movement.[27]

The Royal Academy reformed its election procedure to elect Watts, who was reluctant to be tied to an establishment. Formerly suspicious of his avant-garde symbolic work, the Academy had consulted him at their Inquiry of 1863, and, exceptionally, in 1867 elected him an associated and full member.[28] Two years later, Watts and Leighton transformed the summer exhibition, celebrating the emergence of classicism, idealism and a broader range of modern art, showing the influence of Continental styles.

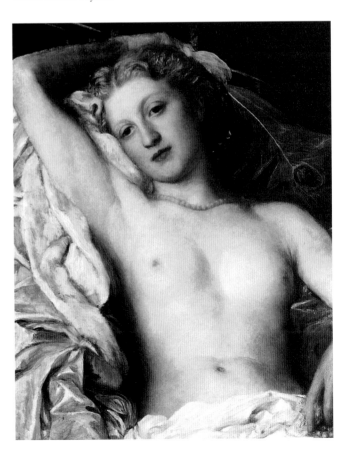

Fig. 3
A Study with the Peacock's Feathers 1863-65
Oil on panel
Private Collection

13

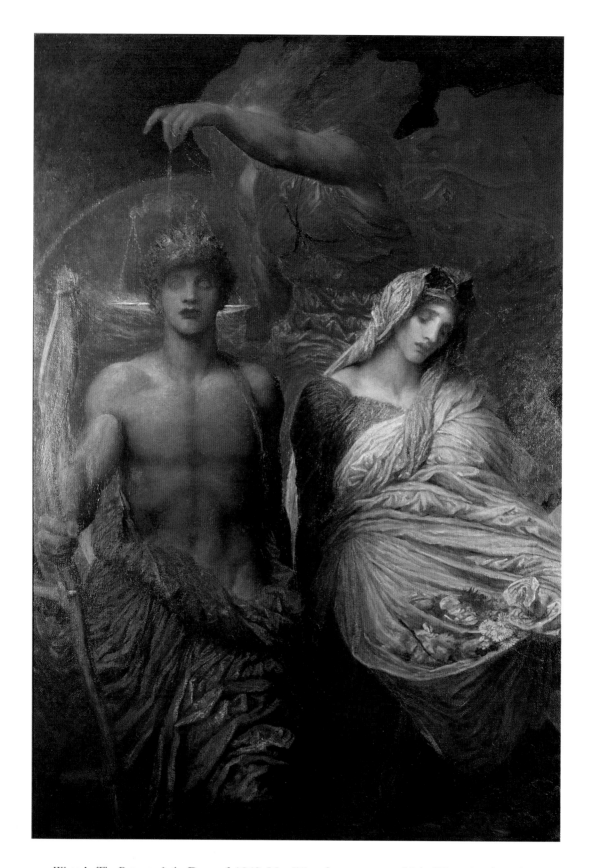

Watts's *The Return of the Dove* of 1869 (No. 71), of an exhausted bird flying across an horizontal canvas, high above the waves, would be remembered years afterwards as the sensation of the Academy. By contrast, in 1877, he would exhibit *The Dove Which Returned Not Again* exhibited in 1877 (No. 72), his vertical protest against the evils of the day, drew attention to greed, which the floods were sent to destroy, and was increasingly prevalent in Victorian society. Meanwhile, in 1869, with *The Return of the Dove*, Watts showed a poetic picture of the moon goddess Diana in phosphorescent draperies, surging over the sleeping youth *Endymion* (No. 25), which impressed Rossetti. Towards the end of his life, Watts developed a more visionary, less sculpturesque version (No. 26). But now he was recognized as a guiding power in raising the tone of modern art.[29]

Charles Rickards of Manchester was building up a collection of Watts's imaginative work. In 1868 he bought a study for a powerful metaphysical subject *Time, Death and Judgment*, in which the youthful *Time* advances hand in

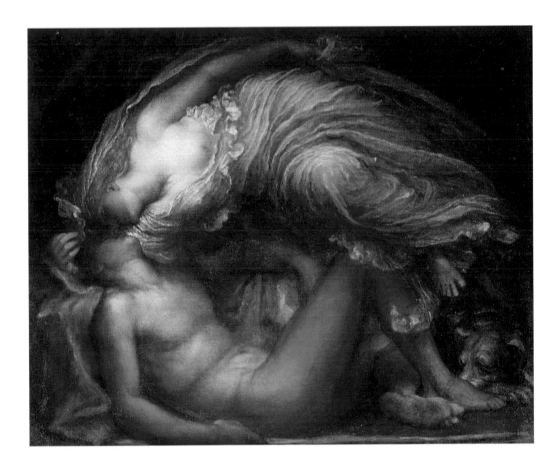

Endymion, 1869
(No. 25)

hand with Death. Time's body – brown to suggest a human form exposed to the sun – is modern and inclusive. Eternal Judgment hovers above them, red-robed and faceless. As the artist explained, 'I am a painter of ideas & not realities & do not consider myself called upon to reproduce a closer resemblance to ordinary reality than is necessary for my subject, or my object in painting for all times & for all climates'.[30] In Watts's iconography, Death is not skeletal, but a compassionate female figure – tender rather than terrible.

The first version of his compelling masterpiece *Love and Death* (No. 88) was exhibited in 1870, following the death of a friend. It embodies Watts's vision of the impotence of Love facing the inexorable approach of death.[31] The imagery relates to Moreau's *The Young Man and Death* (Fig. 11), but is unrelenting and very much Watts's own.[32]

The enthroned angel of *The Court of Death* (No. 102) receiving homage from all humanity, rich and poor was conceived in 1853 – then named *The Angel of Death* – to decorate a paupers' chapel. Showing the influence of William Blake's illustration to *The Grave* (1808, Petworth House, Sussex),[33] it was regarded in 1867 as one of the most noble conceptions of contemporary art. In 1871, Watts began the fourteen-foot canvas that would dominate his studios until he donated it to the Tate Gallery in 1902.[34] *The Court of Death* and *Time, Death and Judgment* were among his growing collection of subjects for the cosmic *House of Life* scheme reserved for the nation or for public institutions.[35]

Among these were subjects for an epic from Genesis – a trio of vertical pictures of *Eve Tempted* and *Eve Repentant* (No. 49) and Eve as the newly created woman, later known as *She Shall be Called Woman* (No. 16). One of

Watts's most visionary subjects, the central figure of the universe emitting light, she represented the mind of modern times.[36] There were also compositions of *The Creation of Eve* (No. 15), *The Denunciation of Adam and Eve* (1873-98) and the subject of his Academy diploma picture *The Denunciation of Cain* of 1872,[37] which Watts envisaged as a cantata. In 1886, he presented to the Academy a huge skeletal pendant, of the *Angel Removing the Curse of Cain* at the moment of death.[38]

Mistrustful of formalized religion, Watts was deeply spiritual. He addressed the subject from the highest plane of thought, to show the spirit of divine teaching, love and charity acceptable to all faiths. In his iconography the spirit of God is not confined by sex. The picture known variously as *Dedicated to All the Churches* or *The Spirit of Christianity*, exhibited in 1875, demanded religious tolerance. The cloaked seated figure of the Saviour dominates the upper part of the picture and beneath his or her lap, cherubs, representing multi-faith humanity, nestle in the clouds. There is no cross or detail to identify creed, because the artist aimed to embrace universal faith,[39] as he explained to the critic William Stillman:

> I see a very noble expression of Art in the visionary, very monumental & even splendid, not religion in the ordinary sense having nothing to do with any sort of dogman, but touching the highest & I think the truest religious sensibilities, suggestively touching philosophical imagination.[40]

Though unconvinced by the supernatural claims of theosophy, Watts was interested in the mystic element. 'Of course it is an illusion, but if you come to that almost everything we see is an illusion, the very colour we see is

not the same to other eyes, it is a matter to bear in mind for till we do we shall never understand a truth spiritually'. He believed that man evolved the idea of God and a moral conscience, in 'the continuous aspiration of the human heart for that which is spiritual & outside itself as it passes through the ages, results now & again in a great revelation through one mind'.[41] To Watts, conscience was the supreme spiritual force, 'the one revelation by which we should live ... quite apart from mind or reason'. This he would embody in *Dweller in the Innermost* (Tate Britain), first exhibited in 1886 as *The Soul's Prism* – a vibratory embodiment of conscience, in which refracted rays give the impression of beating wings in the mind of mankind.

Faith itself, Watts regarded as 'the elevation of the material reason into the region of the spiritual idea'. He would symbolize *Faith* (1890, Tate Britain) as a female figure loosening her sword and soaking her bloodstained feet in the stream of Truth. Startled by the dawn chorus, she looks up, turns away from violent memories and listens instead to the voice of Eternity.[42]

These poetic pictures of Watts and Burne-Jones attracted wide interest at the avant-garde inaugural exhibition of the Grosvenor Gallery in 1877. Oscar Wilde, describing Burne-Jones as 'a seer of fairy visions', recognized Watts's 'great and imaginative genius' and saw 'startling vividness' in the metaphysical *Love and Death*.[43] Watts himself admired Burne-Jones's paintings, criticizing

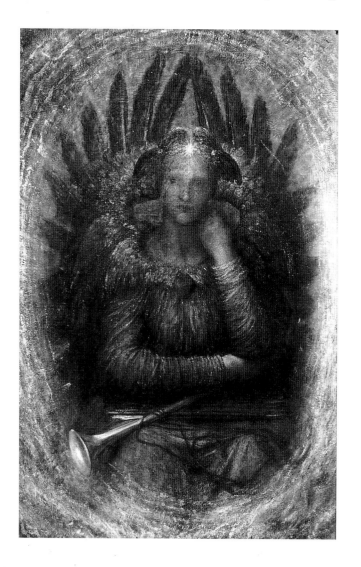

only the limited nature of his subjects. At the 1878 Paris Exposition Universelle, the two were introduced to the Continent through the periodical *L'Art*, as leading artists of supreme imaginative and poetic power, despite Watts's less appealing abstract technique.[44] Among his ten works in Paris, for which he was awarded a gold medal, was a triple nude study of the goddesses Pallas, Juno and Venus,[45] highlighted as a key example of Wattsian form, elevated sentiment and poetry. Struck by 'the calm and powerful study', the French critic Ernest Chesnau saw Watts as 'the only painter of the English school who has treated the female nude simply from the point of view of style, and with no other object than to realize its purely plastic beauty'.[46] His celestial opalescent variants on the theme, exhibited in London and Paris in the 1880s as *Olympus on Ida*, appealed to the French Symbolists.

The visionary *Paolo and Francesca* (No. 50), floating in the hurricane of the Inferno – exhibited at the Grosvenor in 1879 and in Paris in 1883 – was said to suggest 'a passion too strong for death'.[47] As long as humanity is humanity', Watts wrote in 1880, 'man will yearn to ascend the heights human footsteps may not tread, and long to lift the veil that shrouds the enigma of being, and he will most prize the echo of this longing in even the incoherent expression of literature, music, and art'.[48]

In protest against pictures of Lady Godiva as a nude sex symbol Watts painted her collapsing into the arms of the people of Coventry, after her noble naked ride through the streets, to compel the Earl of Mercia to reduce taxes (No. 69). He was determined not only to stimulate, but to provoke his apathetic contemporaries to a higher level of thought.[49]

Woven throughout his polemic 'The Present Conditions of Art' (*Nineteenth Century*, 1880) is a concern for positive steps to overcome weakness. The analytical, unsatisfied age having sapped unquestioning faith, offered no better consolation and 'material prosperity has become our real god'. Watts called for social reforms. He proposed that the leisured classes offer skills and resources in art and craft education of the working classes, that art – 'poetry manifested by science' – should address serious issues, help combat evil and provide a vital spark to stimulate progress, the spirit of the age.[50] To test his opinion on any subject – political, religious or social – he would offset it by setting the situation forward and back 500 years, to sift out 'the dross of convention'.[51]

Rickards exhibited his Watts collection – 54 paintings, predominantly imaginative subjects, with the marble head of *Medusa* and bust of *Clytie* – at the Royal Manchester Institution in April 1880,[52] and Watts sent his full-length *Orpheus* (Salar Jung Museum, Hyderabad) to the Paris Salon.[53] Despite the growing interest in his imaginative work, he suspected that the public would never care for or purchase the pictures, but as he wished them to be seen, he commissioned the architect, George Aitchison, to design him a gallery. Old Little Holland House had been pulled down to make way for the new Melbury Road, where he

Fig. 4
Dweller in the Innermost, 1885-86
Oil on canvas
Tate Britain

had built its replacement, keeping the same name,[54] and built a house in Freshwater on the Isle of Wight.[55]

The Little Holland House Gallery was hung with pictures by the end of May 1881, but within months it had been emptied, for Watts's collection of 204 pictures spanning four decades – the first major retrospective of a living artist – opened at the Grosvenor Gallery on 31 December.[56] His avant-garde paintings were becoming increasingly abstract in texture as he experimented with atmospheric effects; their sculptural line and form was paramount to Watts.

His method was to extract the oil from Winsor & Newton paint tubes, reduce the paint under water to the texture of putty, mix in benzene or turpentine, and apply the colour with a brush he had ground down into a tiny pyramid-shaped point. Ever alert to new ideas, he kept a close eye on nature, observing how various effects required different treatment. He outlined the visionary effects he sought to achieve and valued in art:[57]

> A great picture should ... respond to varying moods & especially should have the power to awaken the highest of our small mental & intellectual sensibilities. To my mind it is nearer in its operation on these sensibilities to music than to anything else, but it must not only have the power to touch & awaken. It must have also the power to sustain the awakened & elevated spirit in that pure atmosphere that we only breathe in our happiest & least earthly moments. This can never be achieved by technical merits alone, never except by the artist throwing his whole & best self into his work.[58]

Watts's mental and emotional adaptability in attuning to the wide variety of spiritual and intellectual forces of the Victorian age was seen as extraordinary. Even his land and seascapes were accorded the dignity of his figure painting. Particularly telling were areas of pure or increasingly atmospheric light colouring, as in the *Carrara Mountains from Pisa* (1881, Private Collection). There was an overall sense of mystic sorrow. Acknowledged as 'the leader of the reformation of portrait-art in England', Watts was seen as England's most imaginative – if imperfect – modern artist and the finest living painter of the idealized nude, in dignity of form and gesture, purity and, in view his large scale and subject matter, power.

His stature as a Victorian Olympus remained controversial. In his imaginative work, Watts treated the entire figure as an impression. Rather than present a typical woman, identifiable by her education or breeding, Watts expressed ideal truths through intensified emotion and the use of colour. Long Mary's idealized, almost androgynous figure was disturbing. Leighton recommended *Psyche* (1882, Tate Britain) as a Chantrey bequest purchase by the Academy,[59] but he opposed the use of art to express ideas, and pressed home the point in his December discourse to Academy students, stressing that, 'The language of Art is not the appointed vehicle of ethic truths'.[60]

While Watts professed to be a painter of ideas, pointing out that 'painting may be said to represent ideas, poetry and prose to suggest ideas, and music to create

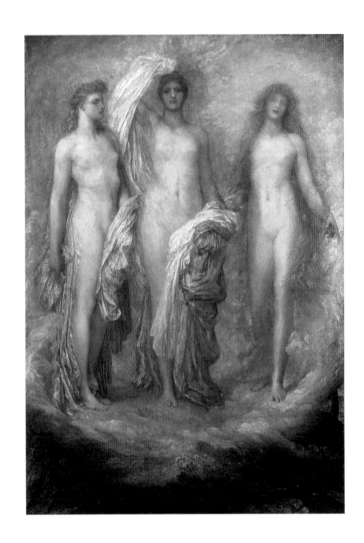

ideas',[61] he agreed with Leighton that neither painting nor poetry should be didactic. Nevertheless, he pointed out, there was a wide difference between being didactic and being suggestive. At times, he crossed that boundary. The president's paintings were too perfect for Watts. 'There is never anything unexpected in his work, consequently nothing that appeals to you'. Leighton, his closest friend, had an imaginative mind, and it maddened Watts that his art was not more suggestive.[62]

Even the equestrian statue of *Hugh Lupus* (1870-82) commissioned by the future Duke of Westminster as a historic portrait, Watts infused with a sense of 'human will bridling in brute force'.[63] When it vacated the sculpture trolley, he began the great symbolic statue that would absorb him for the rest of his life.[64]

Awarded honorary doctorates by Oxford in 1882 and by Cambridge in 1883, Watts was elected an honorary member of the Society for Psychical Research.[65] He was lined with Burne-Jones in Ruskin's Oxford lecture as leaders of mythic art.[66] Of his seven pictures at the Galerie Georges Petit in Paris in 1883,[67] all but one were visionary subjects. J.-K. Huysmans worked them into his novel *Against Nature* (1884). His vision, so different from the French Impressionists – (to Watts, Impressionism, or any dextrous quality in painting, was anathema) – inspired

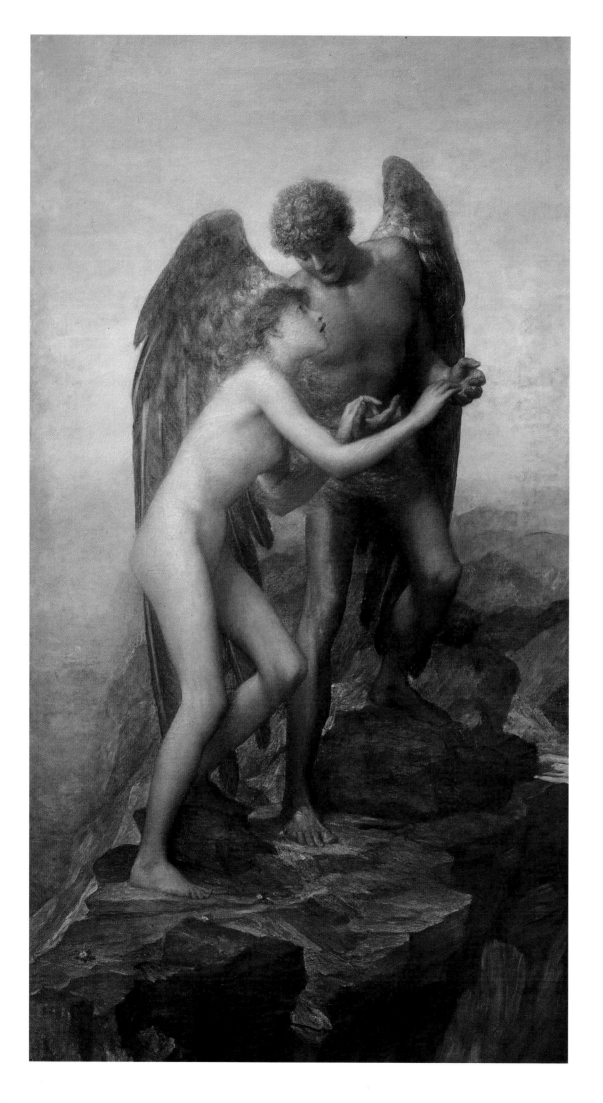

Love and Life, 1884-93
(No. 96)

a young American woman, Mary Gertrude Mead, to make his work known across the Atlantic. In 1884-85, Watts was the first Englishman, and first living artist, to be the subject of a retrospective exhibition at the Metropolitan Museum of Art in New York.

Meanwhile, he was achieving extraordinary atmospheric effects with broken prismatic colour in both painting – a mystical *Island of Cos* (No. 30) – and sculpture, in a monumental gesso model of the future *Physical Energy* (1882-1904, WG), larger than *Hugh Lupus*.[68] The opalescent rainbow spirit *Uldra* (No. 52), the cosmic full introductory *House of Life* subject, *Chaos* (c.1875-82) and the large *Love and Life* (No. 96) were included in the Metropolitan exhibition, which aroused unprecedented interest.[69] Watts presented *Love and Life*, his most significant message of the era, to the American people, to inspire them to create a national gallery of art. The White House won the battle to house it, fighting off feminists up in arms at the nudity.[70] The composition inspired the sculptors Alfred Gilbert's *Icarus* of 1884 and Harry Bates's *Mors Janua Vitae* (1899, Sudley Art Gallery, Liverpool).

Watts stepped up his attack against greed, with a grotesque personification of *Mammon, Dedicated to his Worshippers*; and W. H. Stead's exposé of child prostitution shocked him into painting *The Minotaur* crushing an innocent bird in his brutal hand (both 1885, Tate Britain). At exhibition, Watts added the explanation: 'the real mission of Art – not merely to amuse, but to illustrate and embody the mental form of the beautiful and noble, interpreting them as poetry does, and to hold up to detestation the bestial and brutal.'[71] After the sorrowing rich man *For He Had Great Possessions* of 1893-94 (No. 70a), his frenzied image of *Jonah* preaching with arms outstretched, against the evils of the day, (1894-95) appeared 'truly great', to the *Magazine of Art*, but 'hideous in his earnest gesticulation'.[73]

Categorizing his paintings for Marion Spielmann, who was cataloguing them for a special issue of the *Pall Mall Gazette* in 1886, Watts referred to these abstractions as 'symbols'; and the mythologies and literary figures as 'types', his portraits as 'reality'.[74]

He saw the press as an important vehicle for his national mission, and as the first nine pictures went on public display at South Kensington, prior to their presentation to the nation, he explained to Spielmann, 'My distinct object in painting these ... has been to oppose the principle that "Art for Art" is the only principle or even the best. I do not deny that beautiful technique is sufficient to constitute an extremely valuable achievement but it can never alone place a work of art on the level of the highest effort in poetry and by this it should stand.'[75]

Watts married Scottish artist Mary Fraser Tytler on 20 November 1886. During their honeymoon in Egypt and Greece – 'the keynote to all that is beautiful in art'[76] – Mary resolved to design symbolic decorative art. For the rest of his life, the imaginative pair would influence each other in art. Meanwhile, the Royal Jubilee Exhibition opened in Manchester with 34 paintings by Watts.[77]

Two new subjects of 1887 addressed the end of life. *Death Crowning Innocence* and *The Messenger*, a robed woman standing against the light, reaching out to lead away a soul, were designed to comfort the bereaved and show Watts's conception of Death as a friend. These appealed to Victorians who saw nobility in bereavement. Whereas *Sic Transit*, the shrouded epitaph of 1890-92 (Tate Britain), and *The Happy Warrior* (No. 78) centre on the soul and achievements of the dying or dead figure, *Love Triumphant*, conceived in 1893 – the final visionary picture featuring the moment of death, and following *Love and Life* and *Love and Death* – shows the spirit of Love above the fallen figures of Time and Death.[78]

Meanwhile, two others of 1887 explored the idea of the creator: *The All-Pervading* (Tate Britain), a mystical robed figure holding a globe of the universe in its hand and *After the Deluge: The Forty-First Day* (No. 113), the sun radiating over the waters to suggest 'the hand of the Creator moving by light and by heate to recreate'. Rather than a portrait, *After the Deluge* gave an impression of its enormous power, in keeping with Watts's notion of art as 'a representation of a sensation'.[79]

Peace and Goodwill (No. 65), conceived in May 1888, is disturbing, in its format of a Madonna and child, for the subject is ironic, suggesting the reverse. Peace, who should have been a queen, was a starving outcast from her kingdom. Her infant sits on her lap as she turns towards the light that could mean hope or conflagration.[80] More sinister, *The Slumber of the Ages* (No. 104), a variant of his 1850s fresco *Humanity in the Lap of the Earth* (Leighton House Museum) a child on the knees of a sleeping woman, would symbolize in 1898 the brevity of life and small human aims.[81] But the positive, practical ideal overrides the negative in Watts's explosive image of *Progress* (No. 108) conceived in July 1888,[82] in which the conquering apocalyptic rider leaps through a golden blaze, over apathetic countrymen, only one of whom turns to gaze at the spirit of *Progress* in the air.[83] That year, the artist chose as his motto 'The Utmost for the Highest'.[84]

Watts, like Burne-Jones, rejected an ecstatic invitation from Joséphin 'Sâr' Péladan to exhibit at the Salon of the Rose + Croix in Paris, which he saw as a dying protest against realism, with no sense of progress, but he sympathized with its idealism.[85] In March 1893 Léonce Bénédite, now acquiring foreign works of art for the Musée du Luxembourg in Paris, visited Watts's new country home, Limnerslease, near Compton in Surrey. He spoke of Watts as the head of the English school of art and picked out *Eve Repentant* (No. 49). His final choice, however, was *Love and Life*, which was not after all a purchase, but Watts's gift to France. When the Luxembourg reopened on 1 January 1894, Love and Life was seen as England's most important contribution.[86]

After 24 of his works were shown in the first international exhibition of the Munich Artists Association, Watts, unusually, agreed to part with his only version of *The Happy Warrior* (No. 78), in which the knight faces a female spirit embodying the ideals for which he had fought.[87] The Belgian Symbolist Fernand Khnopff's drawings of a narcissistic woman with her reflection '*My Heart Weeps for Days of Yore*' of 1889 is similar but more intimate.[88] Reading Samuel Laing's study of the dual spiritual forces of good and evil, *A Modern Zoroastrian*, Watts was intrigued to recognize the imagery

19

of *The Happy Warrior*. 'My work is in harmony with all that,' this effort of the human mind, always trying to raise itself to its *own* origin.'[89]

Watts was seen as a prophet and seer. 'Like St John, he stands in the wilderness of the world, and points to eternal truths'.[90] He liked to think of himself as a beacon, his duty to stir the nation. He had in mind a picture of a lifeboat to reflect Man in the midst of uncontrollable conflicting forces, with Love's guiding hand at the helm, but when the artist William Holman Hunt pointed out in August 1894 that he too planned a lifeboat with Christ as pilot, Watts dropped the subject until the outbreak of the Boer War.[91] Having forecast a dreadful war, he came to see in its horrors a redeeming patriotic grandeur, an opportunity for social reform and national service, and exhibited *Love Steering Boat of Humanity* (No. 103) in 1902.

Following the presentation of his portrait collection to the new National Portrait Gallery,[92] the New Gallery in Regent Street organized another Watts retrospective, of 155 pictures, opening on 31 December 1896. He gave his finest Symbolist paintings to the National Gallery of British Art (now Tate Britain) for its opening on 21 July 1897.[93] These 'hieroglyphs', as he called them, were infused with modern thinking and English character,[94] and Watts wondered whether they would compare with Wordsworth's *Intimations of Immortality*, which fascinated him.[95] After achieving his dual ambition, he forwarded other major works to both galleries as he finished them.

In his eighties, pessimistic about the future of the nation, he painted an ominous warning *Can these Bones Live?* (No. 106), which shows an English oak crushed by a golden pall, covering symbols of destruction, death and corruption. Even here, a whispy new shoot suggests hope.[96] Light shines on the dying trunk of a tree strangled by luxuriant ivy in *Green Summer* (No. 67), admired by the critic Roger Fry as impressionist. What Fry saw was the 'breathing quality' achieved by painting over and again, to encapsulate 'our atmosphere, for beyond it there is no such thing as living and breathing for us'. This is can be seen in *The Two Paths* (No. 54), the result of a dark dream about the downward path.[97]

On 30 July 1900, Watts achieved a long-held desire, when his memorial cloister to unsung heroes opened in the churchyard of St Botolph's, Aldersgate. In his polemic 'Our Race as Pioneers', he stressed what he believed to be England's crucial role for the progress of civilization,[98] He painted an ambiguous picture of Evolution (No. 107) of a primeval mother – her monumental figure anticipating those of Picasso and Henry Moore – seated above her troublesome children. A recent reassessment of Watts suggests that she is looking back.[99] More likely, as in *Hope*, she is desperately seeking a better future. David Stewart discusses the picture. At the end of his life, Watts confronted the mystery of Creation. *The Sower of the Systems* (1903, WG), a dynamic, almost abstract, veiled figure of no definable sex, sweeping through the stratosphere, would herald twentieth-century abstraction.

In April 1904, the Watts Picture Gallery opened in Compton. As the artist began to paint the Angel of Destiny with an open book ready for life's record, he sent five new works, notably *Prometheus* (1857-1904, WG), to the New Gallery. His bronze statue of *Physical Energy* stood in the courtyard of Burlington House, soon to front Cecil Rhodes's memorial in South Africa. The artist was making improvements to the original gesso model, when he caught a chill and died of pneumonia on 1 July 1904.[100] London's *Physical Energy* was erected in Kensington Gardens in 1907.

One of the first recipients of King Edward VII's Order of Merit in 1902, Watts had forged a controversial new path throughout the Victorian era, to elevate his countrymen through painting and sculpture. Described as 'the greatest of England's modern poet-painters … in aspiration, if not in achievement',[101] he had challenged constraint and his transcendental vision opened the eyes of his nation. His pictures were not as finely finished as those of Leighton and Burne-Jones, and are therefore less valued today, his imaginative scope was greater. In 1903, Picasso reflected the imagery of *Hope* in his Blue Period paintings of *Life* (Cleveland Museum of Art) and *The Old Guitarist* (Art Institute of Chicago).[102]

Notes

[1] Letter to Mrs Percy Wyndham, 8 December 1885 (Fiche 27, G1); Robert Burton's *Anatomy of Melancholy* of 1621 interested Watts at this time.

[2] *Society for the Protection of Birds*, 1897, pp. 8-9.

[3] MSW, 1912, I, pp. 43-44; Carlyle, 1907, pp. 6-7.

[4] Carlyle, 1907, pp. 7-14; MSW, 1912, I, pp. 101-3. Chambers, 1844, presumably influenced the cosmic focus of the scheme.

[5] Cook and Wedderburn, 1903-12, XXX, p. 303.

[6] Watts referred to his metaphysical pictures as 'imaginative' or 'allegorical' in the 1860s, but when 'allegory' suggested to other artists a mixture of the real and unreal, which did not apply to his art, he preferred to describe them as 'symbolical'.

[7] MSW Cats.S.145a and b, 131b; Barrington, 1905, pp. 24 and 47.

[8] RA 1850; Cartwright, 1891, p. 13.

[9] Letter to John Ruskin from Watts, (draft, WG).

[10] Ruskin, 1853, III, p. 26fn.

[11] From Spenser's allegorical poem *The Faerie Queen.*; Janet Maclean in Trodd and Brown, 2004, p. 117.

[12] D G Rossetti to Lord Aberdare (WG); Millais, 1899, I, p. 357.

[13] MSW Cats.S.63a and b.

[14] The decayed fresco of Christ and the Evangelists was replaced in the 1880s by a mosaic reproduction.

[15] *Proposal for Completing and Adorning St Paul's Cathedral*, May 1863; 'Mosaic Work in St Paul's Cathedral', *The Builder*, 30 July 1864, p. 567. Watts was commissioned to design all four Evangelists. His *St Matthew* was executed in mosaic by Salviati's glass house in 1865, and *St John* was adapted by W. E. F. Britten in 1889; MSW diary extracts, 25 August 1889.

[16] Watts painted two self-portraits in armour, in (Cat.P.167a, 1844-45 and *Eve of Peace*, Cat.S.51a, 1868-76).

[17] Barrington, 1905, pp. 35-36.

[18] Following legal separation on 26 January 1865, the Wattses divorced on 6 November 1877.

[19] Exhibited at the Royal Academy in 1865, cat. 300, as *Design for a Larger Picture. The Athenaeum*, 6 May 1865.

[20] MSW diary, 30 June 1896; Cat.S.53a; Long Mary studies c. 1863-70; Spielmann, 1886, p. 18.

[21] Exhibited at the French Gallery, 1865, cat 108; MSW Cat.S.115b (*The Peacock Fan*, also known as *The Amber Necklace*).

[22] MSW Cat.S.6a; Royal Academy of Arts 1996, p. 30; New York 2003, p. 437.

[23] MSW Cat.S.144b; *Thetis* was followed by *Daphne* and *Psyche*, Tate 2001, p. 93, cat.29.

[24] Arnold Bocklin developed the theme in *Self-Portrait with Death playing the Violin* (1872).

[25] Sketchbook (WG 15/5); MSW Cat.S.25c, listed in Watts's will, dated 19 Jul 1866, New York, 1884-85, pp. 38-41, cat.108.

[26] Paris 1998, cat. 32.

[27] Beattie, 1983, p. 147.

[28] MSW, 1912, I, pp. 231-32 and III, 9pp. 9-146. Watts urged the Academy to allow all students to study from live models, and to train them to paint large-scale murals on public buildings.

[29] Atkinson, 1871, p. 30.

[30] Letter to C. H. Rickards from Watts, 7 December 1878 (NPG, III, ff. 214-17).

[31] Exhibited at the Dudley Gallery, 1870, cat. 108.

[32] Paris 1998, cat. 88.

[33] MSW Cat.S.29c; *A Vision of the Last Judgment*, 1808, Tate, 2000, cat.59.

[34] MSW Cat.S.30b; diary extracts, 19 March 1902.

[35] Letter to Rickards, 27 December 1874 (NPG II, ff. 363-66).

[36] MSW, 1912, II, pp. 138-39. First exhibited at the Dudley Gallery, 1873, cat 75.

[37] Then exhibited as 'My punishment is greater than I can bear,' (Genesis 4: 11-13.)

[38] In the 1870s Watts believed *Love and Death* more suited to a gallery.

[39] MSW Cats.S.135-36.

[40] Letter to W. J. Stillman, 14 January 1885 (Schaffer Library, Union College: WJS 584).

[41] MSW diary extracts 25 January and 19 November 1892. Theosophical Society, founded in 1875.

[42] MSW diary extracts, 21 December 1890; Cats.S.53b and 54a.

[43] Wilde, 1877, p. 119.

[44] Carr, 'La Grosvenor Gallery' *L'Art: Révue hebdomadaire illustrée*, 1877, III, pp. 2-4, reprinted in Carr, 1878, pp. 14-15.

[45] First exhibited at the Deschamps Gallery in 1876, cat 55.

[46] Chesnau, 1885, pp. 267-68.

[47] Cat.S.117a; untitled newscutting, 4 May 1879 (WG).

[48] G. F. Watts 1880, 255, reprinted in MSW, 1912, III, p. 190.

[49] MSW Cat.S.64b.

[50] G. F. Watts 1880, pp. 235-55.

[51] MSW diary extracts, 14 May 1889.

[52] Letter to Rickards, 12 April 1880 (NPG III, pp. 264-66); MSW, 1912, II, p. 3; *The Athenaeum*, 17 April 1880, p.512.

[53] Paris 1880. 68, cat. 3888.

[54] Number six Melbury Road, designed by Frederick Pepeys Cockerell, 1874-75

[55] The Briary, designed by Philip Webb, 1872-74.

[56] Grosvenor Gallery, 1881-82.

[57] MSW diary extracts, 26 April 1891; Barrington, 1905, pp. 65-67. He mixed in a little linseed oil to prevent deterioration

[58] Letter to Dorothy Tennant, 1880 (NPG XV, 146. Fiche 43, D10).

[59] Barrington, 1905, p. 110.

[60] Leighton, 1896, 10 December 1881, pp. 54-55.

[61] MSW, 1912, III pp. 42-43.

[62] MSW, diary, 3 May 1893.

[63] Commissioned in June 1870. Barrington, 1905, pp. 11-12.

[64] The equestrian group, known variously as *Active Force, Vital Energy* and ultimately as *Physical Energy*.

[65] *Cambridge University Reporter*, 19 June 1883, pp. 943 and 947; *Journal for the Society for Psychical Research*, 1884, pp. 33-34.

[66] Ruskin 'Mythic Schools of Painting', *The Art of England*, reprinted in Cook and Wedderburn, 1903, vol 30, pp. 302-5.

[67] Paris 1883: Cats.1-7: *Ida, Paolo et Francesca de Rimini, La Denonciation de Cain* (a reduction from the Academy diploma picture), *Eve (La Création, or She Shall be Called Woman), Eve (Le Repentir), Portrait de Algernon Swinburne* and *La Création d'Eve*.

[68] *The Athenaeum*, 29 December 1883, p. 874. 'George Frederick Watts, RA' *The Art Journal* 1884, pp. 1-4.

[69] New York 1884-85. The exhibition opened on 1 November 1884 and transferred with additions, to Birmingham 1885-86, Nottingham 1886 and Yorkshire 1887.

[70] Other large versions were presented to France and Britain. See No. 96

[71] Liverpool 1885, cat.175; Barrington, 1905, 38.

[72] RA, 1894, cats. 259.

[73] *Magazine of Art*, 1895, p. 283.

[74] Letter to Marion Spielmann from Watts, 21 November 1885 (John Rylands Library, University of Manchester).

[75] *Ibid*, 5 , 8 and 12 November 1886; Science and Art Department Gen Stores report 5 November 1886, (V&A/MA). *Love and Death, Love and Life, Time Death and Judgment, Mammon, Dedicated to all Churches, The Minotaur, Hope* and portraits of *Cardinal Manning* and *Lord Tennyson*, later joined by *The Midday Rest* and *The Court of Death* (formerly the *Angel of Death*).

[76] MSW, 1912, II pp. 63 and 71.

[77] Phillips, 1888, p. 44.

[78] MSW diary, 29 November 1893.

[79] – 1912, III 40.

[80] – diary extracts, 16-18 May 1888; Cat.S.118a; 1912, II, pp. 124-25.

[81] – diary, 22 October 1898; Cat.S.133c.

[82] – diary extracts, 22 July 1888; Cat.S.121a.

[83] – 1912, II pp. 137-38.

[84] – diary, 3 and 9 September 1891; Letter from EBJ to Watts, 1891 (Fiche 17, D3-10).

[85] MSW, diary, 2 March 1893.;Bénédite, 1894-95, p. 92; *The Art Journal*, 1893, 62, 1894, p. 60.

[86] MSW Cat. S.69b; Munich, 1893, cats 1635-54c and 2253b; *Clytie*, bronze. Watts first refused payment, but was persuaded by the German artist Max Nonnenbruck to sell the picture. *The Magazine of Art*, November 1893, viii.

[87] *Fernand Khnopff: 1858-1921*, Ministère de la Communauté française de Belgique, cats.155-59.

[88] MSW diary extracts, 2 January 1894; 1912, II, pp. 243-44; Mills, 1894, pp. 44-57.

[89] Meade, January 1894, p. 16.

[90] MSW Cat.S.95a; Letters from W. H. Hunt, 13 and 20 August 1894 (Bodeleian Library: Mss Eng lett.e118, ff. 3-5, 39-40and e116, ff.92-93); to Hunt. 18 August (Huntington: HM 588).

[91] MSW, diary extracts, 18 June 1896; NPG, 1896.

[92] New Gallery, 1896-97.

[93] MSW, diary extracts, 13 July 1897; *Report of the Director of National Gallery 1897*, p. 5. The first 18 pictures given in 1897 were: *Love and Life, Love and Death, Death Crowning Innocence, Hope, Dweller in the Innermost, Faith, The Messenger, Sic Transit, She shall be called Woman, Eve Tempted, Eve Repentant, Chaos, The Minotaur, Mammon, Jonah, For He had Great Possessions, The Spirit of Christianity, The Dray Horses.* In 1900 the Watts Collection transferred to room 7, known as the Watts gallery.

[94] Letter to Spielmann, 8 December 1896

[95] MSW, diary extracts, 29 August 1897.

[96] *Ibid*, 9 November 1897; Cat.S.22c.

[97] MSW, 1912, II, p. 313; Cats.S.66c and 148c; *The Athenaeum*, 2 May 1903, 569 and 16 May, 632.

[98] G. F. Watts, 1901, pp. 849-57; MSW, 1912, II, p. 299.

[99] Trodd and Brown, 2004, p. 44.

[100] MSW, 1912, II, p. 322.

[101] Tate, 1997, p. 33.

[102] *The Daily Telegraph*, 2 July 1904.

The Symbolic Language of G.F. Watts

ALISON SMITH

When G. F. Watts died in July 1904 he was hailed as much as a prophet as a painter on the basis of works that were seen to communicate a consolatory message of transcendental hope while condemning in powerful visual terms pervasive social ills and vices. A hundred years on Watts's reputation as a seer has been somewhat tarnished, with the moralising purport of his art appearing tendentious to modern sensibilities; and despite being recognised as a major Victorian artist, his works do not share the popular appeal of those of his contemporaries Millais, Rossetti and Burne-Jones.

The decline in Watts's reputation can partly be ascribed to the indeterminate nature of the visual language he evolved to express his ideas. Whereas the Pre-Raphaelites painted recognisable figures in a solid world, Watts, in Ruskin's opinion, gave 'personifications in a vaporescent one'.[1] While the abstract nature of Watts's compositions should not be particularly problematic for a twenty-first-century audience, the didactic content of his work has proved to be more of a stumbling block, with the consequence that when it comes to the modern appraisal of Watts, issues of style tend to be prised apart from those of content to the detriment of both. Early in the last century the writer George Moore described the surfaces of the artist's paintings to be like the crumbling rind of a stilton cheese, a comment that effectively deflates the grandiloquent sentiments the artist intended to convey.[2]

In light of such derision it is difficult for audiences to recover today the synthesis Watts aimed for between the spiritual content of his work and the formal means he employed to communicate it. This is not to suggest that there was a widespread perception of an integrated vision in Watts's time. Several commentators found his works to be obscure in meaning and his method dry and even repellent to the eye. Others, however, were more attuned to the paradoxical nature of his aesthetic, particularly Watts's concern to turn what was essentially an esoteric private language into a public form of address. This paradox lies at the heart of the artist's symbolic enterprise as his more astute critics were all too aware. For G. K. Chesterton, writing in 1904, Watts's art was a symptom of the doubtful faith and faithful doubt of the nineteenth century, being the articulation of a personal response to key ethical and spiritual uncertainties, and governed by a conviction that art should serve the public good 'linked to life, and to the strength and honour of nations'. Similarly, P. T. Forsyth thought Watts's 'sacred hermeneutics' commensurate with the national purpose the artist envisaged for art, offering through non-doctrinal means the re-unification of art and national aspiration in face of sectarian and individualistic interests.[3]

Watts's symbolic language evolved over an extensive period of time and can be seen as a quest to harmonise the public and private strands of expression he had developed during the early part of his career. His first allegorical statements were conceived along the lines of the grand decorative schemes he had studied in Italian churches following his success in 1843 with the first competition to design murals for the new Palace of Westminster, which itself had contributed to his quest to develop an allegorical form of painting. In accordance with the principles set down by Joshua Reynolds in his *Discourses*, Watts aimed at the expression of elevated concepts through grand hierarchically organised compositions based on history, myth and the bible in which the idealised human figure acts as the main carrier of meaning. Thus in *Time and Oblivion*, his first design for a scheme of visionary metaphysical frescoes, two Michelangelesque sculptural figures are portrayed in general rather than particular terms, with Time cast as a bronzed youth encompassing all creeds and races. An emphatic flat curve, symbolic of the divide between day and night, was further intended to stretch the viewer's imagination. The monumental character of Watts's paintings around this time partly relates to his aim of developing the fresco technique in England, an ambition governed by his conviction that this hard dry medium allowed for a more intellectual and didactic treatment than the sensuous properties of oil. However, the fact that none of his public mural schemes was realised – a fresco titled *Justice: A Hemicycle of Lawgivers* for the new hall at Lincoln's Inn began to deteriorate shortly after its completion in 1859 – would indicate that Watts lacked both backers willing to underwrite such ventures and a public ready to engage with them.[4]

During the 1860s Watts's close association with classicists such as Leighton and a second generation of Pre-Raphaelites encouraged the development of a more material and sensuous strain in his art as can be seen in nude studies such as *A Study with the Peacock's Feathers* of c.1863-65 (private collection) and *The Wife of Pluto*, started in 1865 (No. 68), with their glowing evocation of flesh. However, rather than seeking to disturb the moral sensibilities of his time in soliciting feelings of carnal desire, as Rossetti did, Watts aimed at creating a transhistoric aesthetic by fusing Venetian colouristic sensuousness with the abstract compactness of form he admired in ancient Greek Pheidian sculpture. The pursuit of a language that transcended specifics of time and place allowed for the development of a figure style that played down sexual characteristics in favour of an idealised treatment of form and which in the artist's words did not cling to the taint of the individual.[5] Central

Fig. 6. *Time and Oblivion*, 1848
Oil on canvas
Eastnor Castle

to Watts's thinking during this period was the idea that music should function as a metaphor for painting, not just because of the way it impacted on the senses, but for the very integration it proposed between the content of a work and the form in which it was presented.

Watts's concern to convey a universal human symbolism emerged as he found conventional history painting too restricting for what he wanted to express, and as he aimed at embracing a broader public than the essentially elitist Aesthetic style permitted. This said, he had in fact earlier in his career adumbrated the use of suggestive symbolism in an abortive project now known as *The House of Life*, which he envisaged as a series of cosmic murals in a large hall arranged to elucidate the origins of mankind and its spiritual development. Watts had been compelled to abandon this scheme for practical reasons, but continued to develop the ideas associated with it in the form of discrete easel paintings which seen together would have comprised one vast symphonic statement. What is distinct about the *House of Life* paintings is the emphasis Watts placed on the dematerialisation of the figure in order to release its inner spiritual charge. Although denaturalisation would appear to be a gesture towards abstraction, these compositions were emblematic enough to be comprehended on elemental emotional terms. This is important because by the 1880s Watts had theologically declared himself to be a Deist, one who felt the immanence of a higher presence in existence, without subscribing to any particular doctrine. He was often quoted as saying: 'I teach great truths but I do not dogmatise … On the contrary, I purposely avoid all reference to creeds and appeal to men of all ages and every faith. I lead them to the church door and then they can go in and see God in their own way'.[6]

The arcane nature of Watts's symbolism thus developed in tandem with the democratic humanism he espoused, and was very much encouraged by his second wife, Mary Fraser Tytler, whom he married in 1886, a craftswoman and philanthropist who believed in the amelioration of the working classes through the teaching and appreciation of art. Greater exposure of Watts's pictures in the public domain also owes a lot to the impact of a succession of retrospective exhibitions that took place in the 1880s (outlined in chapter one), which encouraged the artist to expand his vision. In 1881 he took the initial step of opening his own gallery at Little Holland House in Kensington, and became reluctant to sell important works because of his desire to bequeath them to the nation. Watts first expressed his intention in January 1886, to gift them during his lifetime, and in 1897 eighteen of the artist's imaginative compositions were placed in the two small octagonal galleries that flanked the east and west wings of the new National Gallery of British Art on Millbank.

The retrospective exhibitions and the Watts bequest were further significant in allowing audiences to see Watts's paintings flow as a sequence of ideas relating to great evolutionary myths and the unfathomable themes of Love and Death. There is, however, little evidence that Watts intended that his works be hung in a particular order: rather he allowed for the possibility of multiple cross-readings by the interweaving of pictures belonging to various categories. The *Daily News*, for example, thought the artist's paintings had suffered in the past from being shown in isolation instead of being allowed to illustrate one another by close juxtaposition and comparison, while P. T. Forsyth argued it was impossible to ascertain Watts's philosophy from a single image, and that understanding could only come through studying a whole series.[7] Influenced by the Wagnerian concept of synaesthesia, it was Watts's ambition that his paintings communicate in symphonic terms, with different

Fig. 7
Jonah, 1894
Oil on canvas
Tate Britain

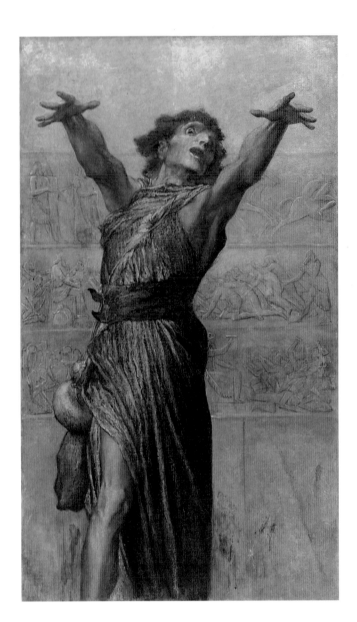

components sustaining each other in totalling one grand statement. Nevertheless some critics felt the need to decode each constituent part. R. E. D. Sketchley thus divided her analysis of Watts's vision into the main strands of didactic symbolism, pictures of ideas and mythic pictures, while Hugh Macmillan classified the works under the neat headings of Greek myths, scenes from Hebrew history, interpretations of Italian and Greek poets, allegory, realism and the cycle of death.[8]

For most commentators three themes dominated: those of Love, Death and moral judgement or Conscience. The latter relates to mystical paintings such as *The Dweller in the Innermost* (c. 1885-86, Tate Britain), in which a female winged figure gazes intently at the viewer though an atmospheric halo of radiating beams. The didactic, or what Chesterton termed Watts's 'Puritan' pictures, comprise works such as *Mammon* (1884-85), the *Minotaur* (1885) and *Jonah* (1894) – all Tate Britain – which combine monumental with grotesque form in condemning social iniquities such as materialism, sexual exploitation, gambling and intemperance, which the artist believed eroded the moral substance of the nation. These compositions were deliberately kept simple and centralised in order to drive the central message into the inner conscience of the spectator. The *Minotaur*, for instance, originated as a defence of the journalist W. T. Stead's diatribe against the traffic in child prostitution 'The Maiden Tribute of Modern Babylon', published in the *Pall Mall Gazette* in 1885, which caused such a furore that it forced the government to raise the age of consent for girls to sixteen.[9] In order to universalise what he judged to be the essential viciousness of the crime, Watts chose to personify the spirit of male rapaciousness as the Minotaur from Ovid's *Metamorphoses* grasping a pathetic bird as it leers into the distance eager for its next prey.

Watts's paintings of Love, on the other hand, are less dependent on biblical and Classical sources and more on the artist's own personal mythology. *Love Triumphant* (No. 98) shows an ethereal youth (the incarnation of the spirit of Love) rising to the heavens above the sleeping figure of Death who has just claimed Time (shown powerlessly clutching a scythe); while in *Love and Life* (No. 96), Life is represented as a fragile young woman limping up the path of existence, her nudity expressive of the vulnerable essence of the human condition. Significantly Watts's presentations of Love are inseparable from his conceptions of Death, and in connecting the two themes he aspired to rid the latter of its fearful associations, re-casting it as a kind nurse who says 'Now then, children, you must go to bed and wake up in the morning.'[10] Indeed so central to Watts's mission was his concern to project Death in a more affirmative light that he dedicated over twenty years to completing an enormous canvas entitled *The Court of Death*, which he originally intended for the chapel of a paupers' cemetery, but eventually gave to the Tate in 1902. Here Watts dispenses with traditional *memento-mori* imagery and presents Death as a solemn female, cradling a new born infant just taken from its mother, presiding over an assembly gathered from all ranks of humanity who are shown paying their allegiance to this ultimate of judges. Similarly in *Love and Death* (No. 88), he confronts the inevitable in powerful uncompromising terms by showing a nude youth helplessly struggling to guard the citadel of life from the steady advance of death.

Contemporary descriptions of Watts's symbolic paintings tend to be straightforward in exegesis, positing a one-to-one correspondence between motif and idea. Although the main intention of such interpreters was to assist in a widened understanding of the thinking behind each painting, such reductive readings also resulted in Watts's works being seen as overtly didactic or even crude and mawkish. However, the very transparency in symbolism often assumed contradicted accusations of obscurity and of impenetrable meanings. *Hope* (No. 81), for example, is probably the most iconic of all Watts's images, but not the most easily comprehended, as for many it conjured up thoughts of despair. One possible reason for such a dichotomy in interpretation would be that while Watts on one level utilised traditional iconography (the Greek myths, for example), his use of symbolism and allegory was far from conventional. For

Chesterton the problems audiences encountered with Watts's art arose from a misunderstanding of the artist's use of allegory. According to Chesterton, Watts's allegories were 'not mere pictorial form, combined as a kind of cryptogram to express theoretical views or relations'; rather the meaning of a work was carried through a purely visual language of shape, line and colour.[11] Indeed, in one of the artist's final works, *The Sower of the Systems* (No.115), he abandons the idea of God as an old man, instead envisaging genesis as a centrifugal force propelled by a faceless draped figure.

In attending to the optical means Watts used to impress his ideas into the mind of the viewer, several critics recognised that the creation of formal beauty was not a prime objective in the later paintings as the artist did not set out to seduce the eye but to suggest thoughts. Sketchley thus noted that the facture of these works was more akin to pastel than oil and suggested that Watts's 'heavily-forged corrugated surfaces' should be seen as a visual correlative of the numinous meanings he wished to convey.[12] The evaporation of the figure projected in a work such as *She Shall Be Called Woman* (the first part of the *Eve* trilogy, c.1867-92, Tate. Fig. 8) can thus be seen as an optical equivalent to the idea of embodiment, the dissolving paintwork expressing the spiritual significance of the theme of Eve's ascension to life. As Watts himself stated around the time he submitted the work to the Royal Academy in 1892: 'I stray away from the ordinary conception & make the figure rather the design of the type of humanity than the consummation, eliminating all the accidents of reality…all this must be more fully carried out before I shall consider the picture finished. Perhaps it won't be hung! I have desired it to be judged severely both on my own account & on the account of

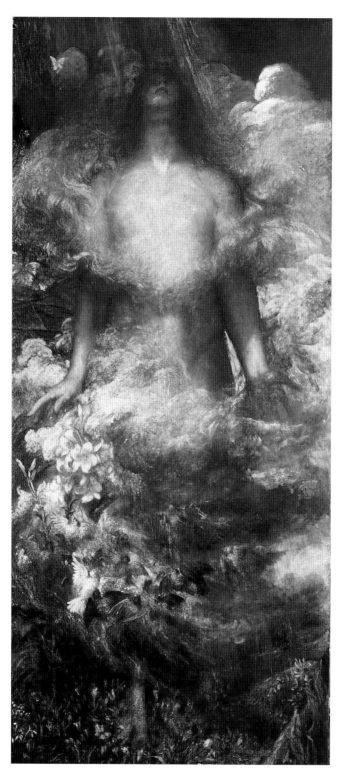

Fig. 8. *She Shall Be Called Woman*, c.1888-97
Oil on canvas
Tate Britain

the Academy.'[13] Indeed, the impression the painting gave of unfinish caused several officials of the institution to question whether it should be 'hung on the line' and accordingly it was displayed at a higher level. Watts's experimentation over the matter of finish further relates to his belief that a work should communicate on an elemental basis, touching the spectator on a primal level of consciousness that made redundant any need for verbal explanation. Chesterton's perception of 'a primal vagueness' and 'archaism' in Watts's symbolic paintings lifted them in his opinion beyond the realm of traditional allegory. Taking *Hope* as a case in point he contended that it was not exhausted by the reference to the word 'Hope' in the title; confronting the image the viewer would detect something 'for which there is neither speech nor language, which has been too vast for any eye to see and too secret for any religion to utter, even as esoteric doctrine'.[14] Accounts of conversions and revelations experienced by humble individuals after studying Watts's images would seem to testify to the artist's success in reaching both a mass and cultivated audience.

A parallel function can be seen in Watts's portraits which also aimed at the expression of a transcendental physicality or spiritual essence beyond the representation of visual likeness or social status. The importance Watts attached to the underlying concept of his works also explains why he was not averse to photographic reproductions of his pictures and how he was prepared to undertake other painted versions or copies of a particular subject. Repetition of the motif not only helped imprint the underlying message in the conscience of the viewer but also lifted it out of the hallowed space of the art gallery into the real temporal world where individuals might accidentally

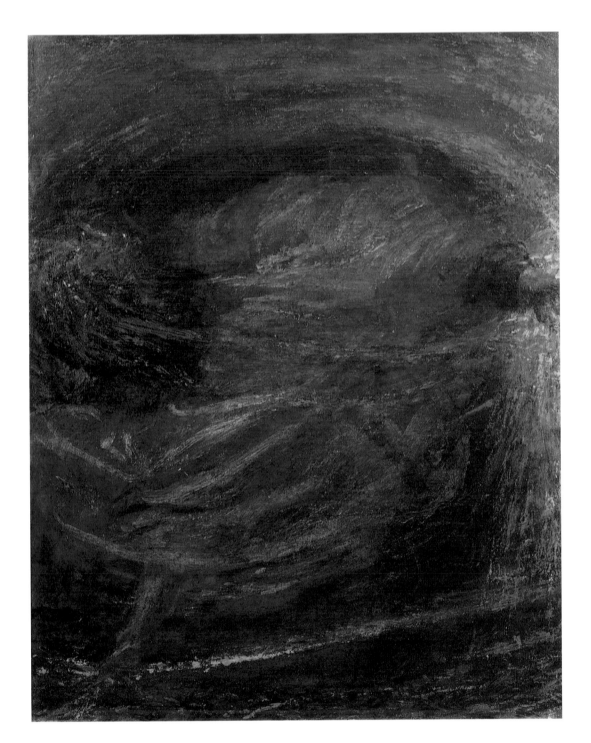

The Sower of the Systems,
1898-1903
(No. 115)

encounter it. Watts should thus be seen as an artist who looked backwards into the past, utilising traditional sources, media and influences, but who also. looked forward in embracing the latest reproductive technology

and exhibition strategies to allow his thoughts to infiltrate new audiences. In this sense he deserves to be recognised as a pioneer in forging a new kind of conceptual art.

Notes

[1] Quoted in Cook, 1898, 239-40.
[2] Moore, 1893, 113.
[3] Chesterton, 1904, 11, 21. Forsyth, 1889, 120.
[4] Before this, in 1852, Watts executed a fresco for the new Palace of Westminster – *The Red Cross Knight Overcoming the Dragon.*
[5] MSW, 1912, III, p. 11.
[6] Bateman, 1901, p. 30.
[7] *Daily News*, 19 November 1898; Forsyth, 1889, p. 139.

[8] Sketchley, 1904; Macmillan, 1903.
[9] Stead, 1902, p. 573.
[10] Quoted, for example, in Bateman, 1901, p. 23.
[11] Chesterton, 1904, pp. 87 and 92.
[12] Sketchley, 1904, p. 107.
[13] Letter to Marion Spielmann from G. F. Watts, 5 April 1892 (John Rylands Library, University of Manchester).
[14] Chesterton, 1904, pp. 59 and 98.

Watts and Symbolist Art in the Nineteenth Century

HILARY UNDERWOOD

Watts, despite his early nineteenth-century birth date, inspired or paralleled the work of many of the Symbolist artists of the 1890s. His contribution to the movement is increasingly widely recognized, not least in *The Age of Rossetti, Burne-Jones & Watts*, the Tate Gallery's major Symbolist exhibition in 1997.[1] It is possible to divide Watts's career into three phases, and this essay explores how distinctive characteristics he developed in each phase contributed to the 'Symbolist' character of his art.

The Symbolist movement was an international movement in art and literature, which began in the 1880s, with precursors among artists of earlier generations such as Puvis de Chavannes, Moreau, Rossetti, Burne-Jones and Watts. The movement was named by the French writer Jean Moréas on 18 September 1886 in an article in the Paris paper *Le Figaro*. He focussed on contemporary French poets such as Stéphane Mallarmé and Paul Verlaine but the term was soon given a wider meaning. Symbolism is now seen as a broad-based cultural tendency encompassing a range of artists from stylistic revivalists such as Burne-Jones and Evelyn de Morgan to early modernists such as Paul Gauguin and blue period Pablo Picasso. In style it is a reaction against the artistic realism, which had dominated since the mid-nineteenth century. The symbolists rejected the recreation of modern life or the reconstruction of the past. They called for an art which engaged with deeper meanings. As Gustave Kahn wrote, in one of the key definitions of the movement, the symbolists were:

> Tired of the quotidien, the near-at-hand, the contemporaneous; we want to set the development of the symbol in any period, and even in outright dreams (dreams being indistinguishable from life) … the essential aim of our art is to objectify the subjective (the exteriorisation of the Idea) in place of subjectifying the objective (nature seen through a temperament).[2]

In cultural terms, the movement is perhaps a response to the ending of mid nineteenth century expansion and optimism. Agricultural and economic depression in the 1880s resulted in manifest poverty and widespread social unrest, labour disputes, anarchist outrages in France and a greater difficulty in upholding belief in social progress. Symbolist art is as much part of a quest for meaning and certainty in an increasingly uncertain world as the many religious revivals of the later nineteenth century.

Watts's vision appealed to the Symbolist *fin-de-siècle* and his later art was partly shaped by its concerns. He dealt with the grand themes of human existence such as love, death and hope; with the shaping forces of history such as time, evolution and progress and with cosmic mystery, as in his painting the *The Sower of the Systems* (No. 115). This essay aims to link Watts to his symbolist contemporaries but also to highlight what is distinctive about his art by comparison and contrast.

The first phase of Watts's career lasted until the late 1840s when he was around thirty. It is dominated by his interest in High Art and History Painting. To call his art Symbolist in this period would be anachronistic, but it laid the foundation for much that was distinctive in his later achievement. History painting in the grand manner was an unusual preference for an artist of Watts's generation. It was prestigious but lacked patronage. Only the decoration of the new Houses of Parliament in the 1840s gave this anachronistic form a temporary vitality. Watts took three key interests from the history painting into his mature vision: a rejection of realism, a concern for deep level meanings and an acceptance of allegory and personification.

Grand manner history painting is a non-realistic art form. As Sir Joshua Reynolds declared in his Royal Academy *Discourses*, 'it is not the eye, but the mind that the painter of genius desires to address.'[3] In Watts's *Alfred inciting the Saxons to Resist the Invasion of the Danes by encountering them at Sea* (c.1846-47, Palace of Westminster) the figures are generalized types, and although representing Anglo-Saxons they are dressed in equally generalized High Renaissance draperies, with displays of the heroic nudity associated with history painting. Alfred is clearly the hero, shown by his physical type, his pose and his isolation in the composition, indeed throughout Watts's career, the gestural language of the human body would be central to his vision. Little archaeological detail distracts from the emotion of the moment, even though historical accuracy was increasingly important in history painting – contrast Frederic Leighton's *Cimabue's Madonna* (1855, The Royal Collection). Watts's painting, designed as a wall decoration for a public building, is not merely a historical illustration. It uses history to draw a lesson for the present about the social and moral responsibilities of those in power and about patriotism. Alfred, born in 849 and approaching his millennium when Watts created the work was regarded as the founder of the British navy. The picture was designed to remind of national traditions of naval greatness and to provide a model of patriotic response to national threat. In other works of this period Watts continues the emblematic tradition of the Renaissance and the Baroque, with allegories such as *Life's Illusions* (1849, Tate Britain). The work's hostile reception indicates the growing unfashionability of personification in

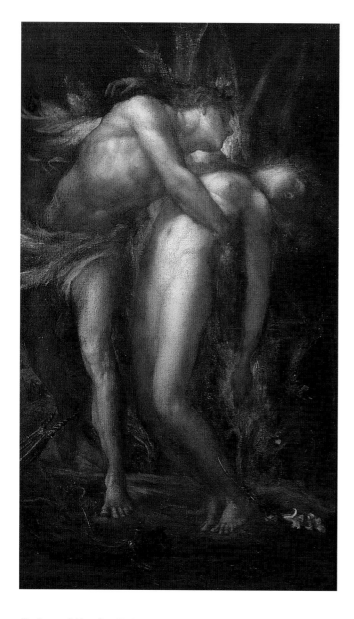

Orpheus and Eurydice, 1872-77
(No. 44)

prepared to distort form for expressive and communicative effect. Through his exposure to aestheticism, Watts was freed from dependence on literary or historical subject matter, narrative, facial expression and realism, although he still retained a history painter's concern to communicate matters of profound importance. It is this combination of profundity and indeterminacy that made him so attractive to artists of the symbolist generation.

A key work which Watts developed in this period was *Orpheus and Eurydice* a subject which he treated around nine times in different dates and formats. The Greek mythic hero Orpheus almost redeems his wife Eurydice from death by the power of his music, but loses her at the last minute because he looks back at her while still in the underworld. The version discussed is a small full-length showing Eurydice nude (No. 44). Much of the mood of yearning and loss in this image is created by formal means: the subdued colours, the spiralling lines of the composition. Bodies rather than faces convey emotion: Orpheus' face is twisted away from us, and Eurydice's is in shadow. The bodies are distorted, Orpheus' extreme, twisting pose creating a visual equivalent to his sudden emotional anguish.

Orpheus was important to the Symbolists and their precursors. Among artists who treated the theme are Rossetti, Burne-Jones, Moreau, Waterhouse, Delville and Redon. Orpheus was a musician. To aesthetic and symbolist painters, music was the supreme art: non paraphrasable, non realistic, it conveyed profound emotion through its form. Also Orpheus almost defeated death twice by his music – at the end of his story his severed head, floating on the river, continued to sing. Orpheus therefore becomes a metaphor for the power of art and the immortality of artistic creation. Many of the proto-symbolists including Watts and Burne-Jones suffered a loss of their Christian faith. British aestheticism was a post-Darwinian movement. Artists in this circle often elevate art to the status of religion to negotiate their fear of death in a newly materialistic world. In a review of William Morris's *Earthly Paradise*, of 1868, which he later developed into the famous 'Conclusion' to his book *The Renaissance*, Walter Pater wrote of the balance between the 'desire of beauty and the fear of death.'[4] In the mid 1860s, Watts first developed his composition *Time, Death and Judgment* as the more materialistic and unsettling *Time and Death*. Through the creation of an art of uncertainty Watts moved from a History Painter's to a Symbolist's vision.

Watts's contemporaries who also made a transition to a symbolist approach in this period, became, like him, admired figures to the *fin-de-siècle*. They share many of his thematic interests and like him engage creatively with history painting traditions. Comparison of his art with theirs demonstrates the similarities but also highlights what is distinctive about Watts's vision.

Rossetti was probably closest to Watts in the late 1850s and early 1860s as they developed shared interests in the decorative, sensuous qualities of Venetian Renaissance art. This can be seen in such paintings as Rossetti's *Bocca Baciata* (1859, Boston Museum of Fine Art) and in Watts's *Choosing* (Fig. 10). Rossetti's oils began

painting, which was increasingly dominated by realism. Watts withdrew from public exhibition for almost ten years.

The second phase in Watts's art is that of innovation and the formation of his individual vision. As with many artists, group activity played a crucial part in this phase. The group provides support for innovation. Additionally it is from the group's combination of shared interests and clashing individualities that innovation springs. Watts's second phase lasts from the late 1850s until the early 1870s when he was in his 40s and early 50s – unusually late in an artist's career. It is marked by links to the circle of artists and writers emerging round Rossetti and Whistler, a loose and fluid grouping which had no label at the time and is now termed 'Post-Pre-Raphaelitism', aestheticism or the Art for Art's Sake movement.

This association freed Watts from the narrow didacticism and tendency to intellectualism of the traditional history painting. It also emphasized that visual art communicates most deeply by visual means: through line, form and colour. In this pre-abstract era, representation was a given, so Watts still based his art on the human figure. However he became increasingly

to address a more profound range of subjects in the mid 1860s, as did Watts's. But Rossetti preferred to evoke images of Love, Death and Destiny through historical and mythological figures. He rarely represented abstract personifications. Also the Romantic origins of his artistic sensibility are revealed in the personal content of his art. Watts emerges from more impersonal traditions of public art. Thus, in Rossetti's *Beata Beatrix* (Fig. 9), the painting suggests a mystic meditation on love and death, but the figure is the artist's dead wife, Elizabeth Siddal, Beatrice to his Dante. And *Proserpine* (1873, Tate Britain) creates an image of brooding sorrow but also draws on Rossetti's love for the sitter, Jane Morris. He sees her trapped in her marriage to William Morris, as Proserpine was trapped in hers to the underworld god, Pluto. If Watts's *Orpheus and Eurydice* paintings contain any references to his failed marriage to Ellen Terry, they remain latent.

Burne-Jones enjoyed a forty-year friendship with Watts which began in 1858 and ended only with Burne-Jones's death in 1898. The friendship strengthened in the later 1860s when Burne-Jones moved from central London to live near Watts, first in Kensington, then in Fulham. It could be argued that Watts played a decisive role in shaping Burne-Jones's artistic maturity, encouraging him to shed the last relics of early Rossettian medievalism in favour of an elaborated renaissance style. As Burne-Jones said, probably of the 1860s, 'It was Watts, much later, who compelled me to draw better.'[5]

Burne-Jones is the Victorian painter who is closest to Watts in subjects and sensibility, although this is masked by an obvious difference in style. Burne-Jones draws on the early Italian Renaissance: Ghirlandaio, Botticelli and Mantegna and prefers a flattened, decorative art. Watts draws on the High Renaissance: Michelangelo and Titian, and prefers an increasingly painterly, spatial and dynamic treatment. Both prefer to create a large-scale art that draws on myth and personification to evoke deeper levels of meaning. But there are significant differences of approach. Burne-Jones, like Rossetti, sometimes injects personal content into his work and his world view (for all Watts's emphasis on death) is more melancholy, more pessimistic, less able to admit the possibility of human agency. Watts painted several versions of *Time, Death and Judgment*, but the inscription on the frame of one of the largest (No. 85) suggested that he intended it as an exhortation to action in the face of death rather than despair. *Love Triumphant* over Time and Death also exists in multiple versions (1893-99) and implies an ultimate

Above: Fig. 9
Dante Gabriel Rossetti
Beata Beatrix, c.1863-70
Oil on canvas
Tate Britain

Right: Fig. 10
Choosing, 1864
Oil on panel
National Portrait Gallery

optimism. Indeed Rowland Alston in this 1929 catalogue of the gallery described it as 'one of the artist's most popular compositions'.[6] Burne-Jones painted the triumphs of *Fortune, Fame, Oblivion and Love* (1871, WG). Although he reversed and Victorianized his original Medieval source, placing Love at the culmination of his series, he did not repeat the figure of Love, but instead made multiple versions of the pessimistic *Wheel of Fortune*. Watts was the owner of a study (No. 83) and Burne-Jones regarded the largest (1883, Musée d'Orsay, Paris) as his favourite painting. In the *Wheel of Fortune* the giant female figure of Fortune, who is shown as blind or blindfolded, turns her wheel on which are bound small naked figures representing Slave, King and Poet. These have conspicuously Michelangelesque torsos and probably show the overt influence of Watts. The Poet is at the bottom of the wheel about to go under, but despite his powerlessness is the only figure who sees and understands the processes of change. As with Watts in *Orpheus*, Burne-Jones seems to be embodying his view of the role of the artist in modern society. Compared with Watts, his approach is more intellectual (perhaps inevitably in view of his Oxford education) but is more pessimistic.

The dominance of Burne-Jones's female Fortune over her male victims evokes the *femme fatale*. This archetype is also found extensively in the work of Gustave Moreau, particularly in his multiple treatments of the dance of Salomé. Although Watts painted one Salomé (*The Daughter of Herodias,* private collection) and although he personified death as a Woman, his art eschews the undertones of sexual entrapment, misogyny and androgyny which pervade much symbolist art. In Watts's *Love and Death* (No. 88) for instance, the heavily draped figure of Death is masculinized and enters the House of Life almost regardless of the struggling figure of Love who is a muscular and energetic adolescent. This painting was a response to the long drawn out death of the 8th Marquess of Lothian, whom Watts had painted in 1862 and who died in 1870. Moreau's *Young Man and Death* (1865, Fogg Art Museum) was also a response to a specific death, that of the artist Chasserieau in 1856. In this painting the young man stands holding spring flowers and crowning himself with laurels, the low draped loin cloth exposing an adolescent torso inviting sensuous contemplation. Behind him hovers the female figure of death or his fate, carrying an hour glass and sword. She is young, attractive and semi-naked suggesting a sexual dimension and a fascination with death, which is absent from Watts. Moreau's art is also distinct from that of Watts in its exoticism. He draws on quattrocento and oriental sources, often superimposing patterns of linear detail upon painterly substructures stemming from Delacroix, and often including strange monsters and odd juxtapositions of scale. In *Galatea* (1880, Collection Robert Lebel, Paris), for instance, the giant figure of the triple eyed Cyclops, brooding over the nymph, could not have been conceived by Watts, whose art is more bound by the normal dimensions of the human form.

Puvis de Chavannes shared Watts's interest in public art, but in the different environment of France became a prolific and successful muralist. He developed a distinctive, static, simplified style, using muted, chalky

Fig. 11
Gustave Moreau (1826-98)
The Young Man and Death, 1856-65
Oil on canvas
Fogg Art Museum, Cambridge, Massachusetts

colours, which perhaps derive from surviving Classical wall paintings. Because of its stylisation, his art had a unique influence on the Post Impressionists and early modernists in the years round 1900. Like Watts, he painted a *Hope* (1872, Musée d'Orsay, Paris), but his was a specific response to the events of the Franco-Prussian war. Like Watts he created a new iconography for the personification, and one which is characteristically open to complex multiple readings. But his deliberate primitivism is shown in the flattened, open forms of the adolescent nude figure, in contrast to Watts's almost Baroque interlocking foreshortenings.

In Watts's third phase from the mid 1870s to his death he worked independently, his vision largely formed. His significant new relationships with fellow artists are not those of follower or equal, but that of hero. In this phase he often reworked earlier concepts. Key versions of both *Orpheus* and *Time, Death and Judgment* date from his

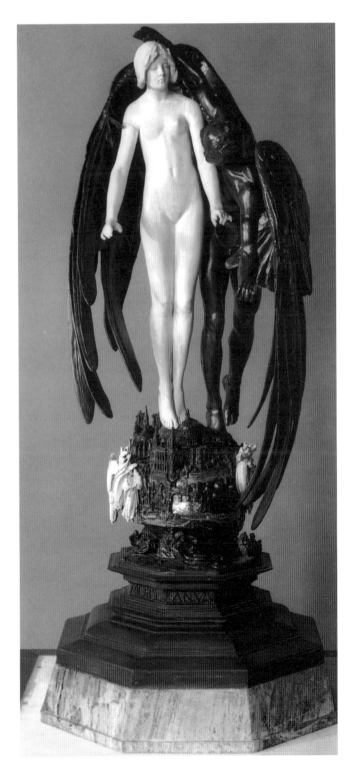

later years. There are innovations, notably the increasing numbers of meaningful landscapes among his exhibited works, a more overt concern for spiritual qualities and an interest in exploring the artistic possibilities and power of symmetry. Such concerns can be seen in the Eve trilogy, particularly *She Shall Be Called Woman* and paintings such as *The Court of Death*. These images seem to present a more consoling image than his earlier paintings. However, they can be compared with more overtly spiritualist works which may be partly inspired by Watts's interest in such

subjects, notably, Evelyn De Morgan's *Life and Thought have Gone Away* (National Museums Liverpool: The Walker l) or Harry Bates's *Mors Janua Vitae* (RA 1899. National Museums Liverpool: Sudley Art Gallery) Watts's greater indeterminacy is clear. One of the most resonant of Watts's late paintings, which combines landscape, spirituality and symmetry is *After the Deluge: The 41st Day* (No. 113). This is an exploration of the power of the sun as divinity. Watts had first explored this as a history painting in the illustration and design *The Sacrifice of Noah* in the 1860s (monochrome design, WG.) Here Noah sacrifices towards the sun: his companions look behind him, awe-struck at the rainbow. In *After the Deluge* the sun itself takes centre stage. There are artistic reminiscences of Claude and Turner, but without the narrative references of conventional historical landscape. The most direct parallel is with Edvard Munch's *The Sun*, a mural in the Aula in the University of Oslo (1909-11)

Watts was widely admired by the younger artists of the symbolist movement, but had few direct followers. Only relatively minor painters, such as Henry John Stock (1853-1930) show a direct influence of his style. The Watts influence is usually more generic, expressed in a concern for cosmic and indefinable subjects. It seems to have been strong among the British 'New Sculptors', perhaps because of Watts's role as a forerunner of that movement and his reputation as a painter-sculptor, 'England's Michelangelo'. In Bates's *Mors Janua Vitae*, the main subject of a winged Death or guardian angel leading a naked soul may echo Watts's *Love Triumphant* or *Love and Life*. The frieze on the base includes reclining figures and mountains which directly recall Watts's *Prometheus, Chaos* or *The Titans* (Nos. 61, 13 and 11). The most important of these sculptors was Alfred Gilbert, who modelled Watts's bust, and used his features for the figure of *Edward King and Martyr* on the Clarence tomb (1892-99, Albert Memorial Chapel, Windsor). Gilbert had a long-standing admiration for Watts. Mary Watts recalled him in the painter's studio on 1888, shaking his fist at the paintings, declaring, 'He steals all the best subjects away from the sculptors.'[7] And in his lectures on sculpture at the Royal Academy in 1903 he paid tribute to Watts, especially his *Love and Death*, even though it was contrary to etiquette to mention living artists.[8] According to Richard Dorment[9] the direct influence of Watts grew in Gilbert's work after 1900, as he eschewed written sources, became technically freer and engaged with the broadest symbolic subjects; Birth, Death, Love and Sorrow. Even the earlier work, such as *Icarus* (No. 97), has a certain symbolic dimension. Icarus, on man-made wings, will fly too near the sun and fall to his death. Now, winged for flight he meditatively watches a snake devour a bird. Although the adolescent figure at this stage in Gilbert's career looks stylistically towards Renaissance sculpture and to Burne-Jones rather than to Watts, it carries implicit metaphors for human and artistic ambition: perhaps this sculpture is also a reflection on what it may mean to be an artist in the modern world.

The Belgian symbolist artist Fernand Khnopff also had a long standing admiration for Watts, writing in praise of his *Paolo and Francesca* (No. 50) in one of his last articles and declaring, 'in Watts's work the sentiments dominate of eternal memory and of infinite desire.'[10] But here too there is little evidence of any direct impact of Watts's art on Khnopff's, apart from shared interests in expressing the indefinable. Khnopff's refined art of memories, dreams and reflections tends to draw from his own life and a personal iconography rather than a shared vocabulary of myth and personification. *Le Secret* (1902, Groeningen Museum, Bruges) combines an image of a mysteriously draped woman touching the lips of a classical mask on a column and a medieval building lapped by water. Significantly the images derive directly from photographs of the Hospital of St. John in Bruges and those Khnopff took of his own sister Marguerite. They are rendered delicately and deftly in pastel with none of the exploratory qualities of Watts's technique.

Watts was admired internationally in late nineteenth century because his art harmonized with its changed artistic and cultural mood. The growth of his European reputation is surveyed by Barbara Bryant in *The Age of Rossetti, Burne-Jones & Watts*.[11] This is apparent in extensive coverage in the many monographs and general histories of art which appeared around the turn of the century. Richard Muther gives a high place to Watts in his influential *History of Modern Painting*, first published in German in 1893 and translated in 1896. According to Muther, Watts rejected realism in favour of the idea: his works are characterized by 'an element of brooding thought … a meditative absorption in ideas which provoke the intellect to further activity by their mysterious allegorical suggestions'.[12] The echoes of Kahn's formulation are clear. Despite the traditional roots of Watts's art Muther does not see him as a copyist of the past, but as an artist who has retained a nineteenth-century individualism and who expresses values which are both distinctively modern and pessimistic: 'he neither makes use of Christian nor or ancient ideas but embodies his own thoughts,'[13] expressing 'a profoundly sad way of thought in which one sees the signature of the nineteenth century.'[14]

Notes

[1] Tate Gallery 1997.
[2] Gustave Kahn, 'Réponse des Symbolistes' *L'Evénement* 28 September 1886. [Author's translation].
[3] Wark, 1997, Discourse III, p. xxx.
[4] Aldington, 1948, pp. 84-86.
[5] Carr, 1908, p. 72.
[6] Alston, 1929, [unpaginated], caption to pl. VIII.
[7] MSW, 1912, II, p. 134.
[8] Richard Dorment, 'The Loved One: Alfred Gilbert's *Mors Janua Vitae*', in Minneapolis 1978, p. 47, quoting *Magazine of Art* ns 1, 1903, p. 544.
[9] Dorment, *ibid*, p. 51.
[10] Fernand Khnopff 'Les oeuvres d'art inspirées par Dante' *Le Flambeau*, Bruxelles-Paris, 31 juillet 1921 no. 7, quoted in Paris, 1979, p. 229. [Author's translation].
[11] Barbara Bryant, 'G. F. Watts and the Symbolist Vision' in Tate Gallery, 1997.
[12] Richard Muther, *The History of Modern Painting*, 1896, pp. 637-38.
[13] *Ibid*. p. 641.
[14] *Ibid*, p. 638.

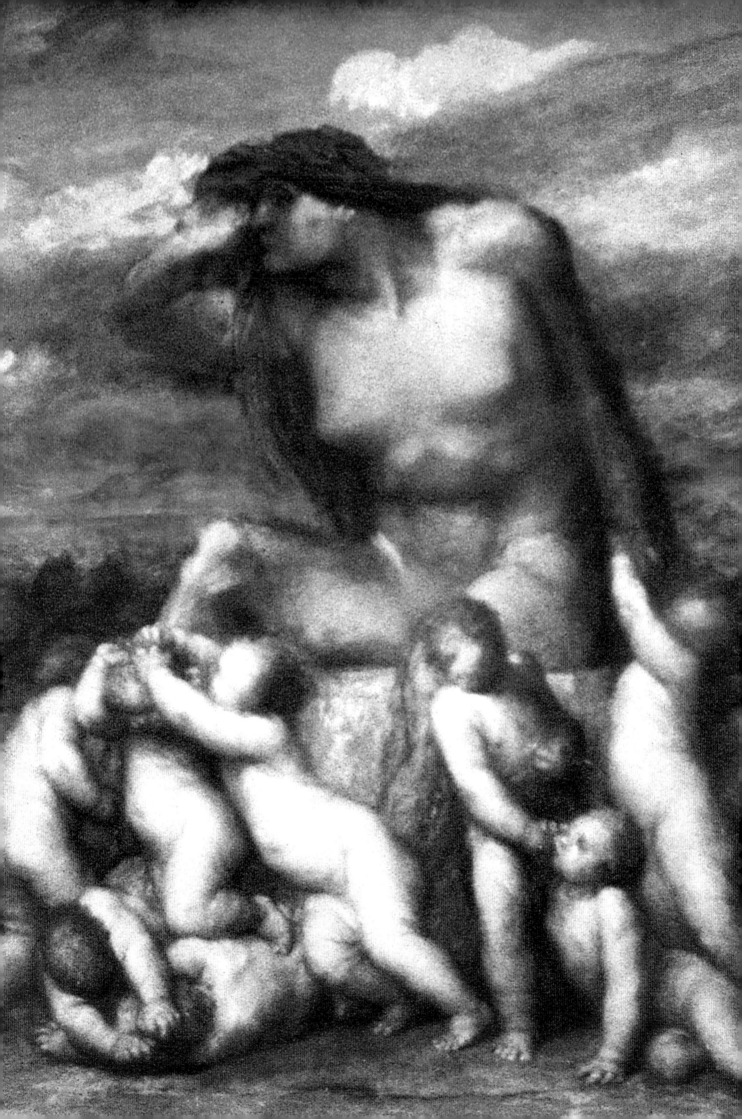

Watts, the Royal Academy and Leighton in Conflict

DAVID STEWART

Contrasting G. F. Watts and Frederic Leighton in the 1860's and early 1870's is a challenge. Both painted the classical nude, both promoted the importance of murals, and both lauded the importance of beauty in public art. Those with a keen eye will see in Leighton a finer polish perhaps, slightly greater interest in rhyming compositional elements, and frequently a cooler, more dead-pan approach to his subjects. Even such distinctions do not work perfectly well, for Leighton could be emotionally intense as in his *Helios and Rhodus* (c.1869, Tate Britain), or heavily invested in subject matter as in the cloying misogyny in his *Orpheus and Eurydice* (c.1864, Leighton House Museum).[1] Though the subtle viewer can find distinctions, Watts and Leighton in those years were more alike than different. Together they helped to change the Royal Academy and make the monumental nude a norm.[2] On the surface, it makes perfect sense to see them as a Royal Academy pair. As true as this model might be in some of its general outlines, it does not begin to define the vision of G. F. Watts.[3]

From his earliest years Watts held great disdain for the Royal Academy and let his outspoken views be widely circulated.[4] He spent thirty years of his exhibition career outside of the Royal Academy only to be bullied in by Leighton in 1867. Once on the inside his disdain grew stronger, and not just for the Academy itself, Watts became more and more vexed with Leighton's pronouncements and his art. His academic perfection disgusted Watts, Leighton's superficial interest in style repelled him, and Leighton's contempt for women's rights disappointed him deeply.[5] As President of the Royal Academy, Leighton stood for the very ideals that Watts attempted to overthrow. When we consider Watts's *Evolution* (No. 107) we see that his mature art shared almost nothing with Leighton. Here Watts lets fly all his objections with Leighton and all his criticisms of the Royal Academy on principles of style, content, and vision. This painting stands in starkest contrast to the cool aesthetic perfection of Leighton's paintings and presents instead a startling essay in imperfection as the foundation for all progression, revolution, and evolution.[6] Royal Academy displays of competence and 'perfection' never satisfied Watts.[7] For Watts, Leighton's cult of artistic perfection was anathema, and though Leighton was a dear friend, Watts's contempt for Leighton's art inspired his greatest

Overleaf:
Evolution, c.1900-03
(No. 107)

achievements. It took Watts many years to grow beyond the classical ideals that he and Leighton once appeared to champion in unison, but then Watts painted for many, many years.

Watts's art was a socially engaged art and Leighton's art was an art of withdrawal into the narcotic power of beauty. The difference was very much one of vision. Leighton pretended that achieving formal perfection could substitute for a deceased social rôle for art. Watts saw through Leighton's argument though. He saw it as painting for the status quo, as giving into entropy, and putting art and politics to bed at a time when the Victorian world needed to be shaken into growth and life. Watts's art consistently urges political and moral growth, while Leighton's art attempts to find satisfaction in beauty.

For Watts, politics and art went absolutely hand in hand, and he was appalled that the Royal Academy had done so much to sever the two. It should come as no surprise to learn that Watts painted his *The Return of Godiva* (No. 69) as a protest against the titillating, sexist paintings of his brother artists,[8] or that Watts painted the women's suffrage leader, *Josephine Butler* (1895, National Portrait Gallery), for the National Portrait Gallery, or that he painted *She Shall Be Called Woman* (1892, Tate Britain) as an embodiment of the newly awakened women's rights movement.[9] Leighton, who pretended to paint sleeping women as art for art's sake, also made it his business to take an anti-women's suffrage petition to Mrs. Watts.[10] He should have known better, but a difference of opinion never kept Leighton away from Watts's door.

Differences of opinion between Watts and Leighton ran deep, and understanding those differences helps us to understand why their mature art is so dramatically different. Standing before the students of the Royal Academy Leighton proclaimed that escapism should be the mission of art 'Art which has borne up, and daily bears up, in oblivious ecstasy so many weary souls, which has lulled and cheated if only for a moment so many aching hearts.'[11] For Leighton, escapism through beauty was a noble ideal, but he went much further in defining the proper role of art: 'What ethical proposition can it [art] convey? What teaching or exhortation is in its voice? None, absolutely none . . . Now the language of Art is not the appointed vehicle of ethic truths..[12] When Leighton said these words he damned the vision of Watts and dismissed Watts's social and political art as amounting to absolutely nothing.

The Return of Godiva, 1879-90
(No. 69)

For Leighton, art should say nothing and reform nothing. The fact that Leighton could never quite meet his lofty ideal should not surprise us, but neither should we be surprised that Watts responded. He rebutted these attacks in print within months. Watts complained that 'An Academy Exhibition room is no place for a grave deliberate work of art ...We are elated by champagne and light buzz of talk ... We must have something light, epigrammatic, not too long, or we shall be bored to death ... Modern public exhibitions are most unfavorable, it may be said disastrous, to the best interests of art – good perhaps for industry, but injurious to art as art.'[13] Watts was not vague in his definition of 'art as art', and how far Leighton missed the mark. For Watts art as art 'rests on much wider and more solid foundations than mere amusement for moments of leisure'.[14] Watts charged that the Royal Academy exhibition produced art 'treated as a

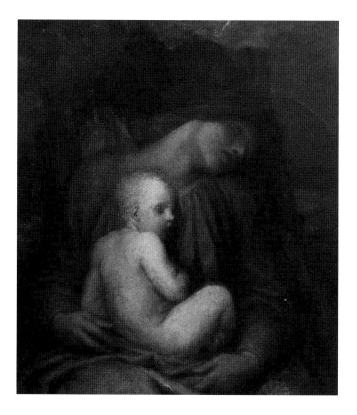

plaything, nothing more. While this is the case, artists will employ themselves in making toys, and the annual exhibition will be cared for by the nation pretty much as a Christmas tree is, and not so important an institution by half as the Maypole formerly was.'[15] To think that Watts deferred to Leighton's notion that artists could paint beauty is to miss Watts's vision entirely. He wrote; 'Beauty and Truth I do not forget, but they in their perfection, are too distant and too much obscured to be profanely thought of even.'[16] For Watts, pretending that an artist can achieve beauty was absurd. It was as absurd as equating great social art with toys and Christmas tree ornaments. To pretend to paint beauty is to paper over human failures, but not simply aesthetic failures. For Watts, to claim to paint 'beauty' is to lull the 'weary soul' and cheat reform. Watts put his social convictions into paint through works such as *The Irish Famine* (1849-50, WG), *Under a Dry Arch* (1849-50, WG), *Mammon* (1884-85, Tate Britain), *Industry and Greed* (1892-1901, WG), and through scores of other works that were designed to shake England out of its capitalist and materialist complacency. For Watts, Leighton's 'beautiful' paintings were the problem, not the solution. Watts did what he

could within the Royal Academy but exhibited far more heavily at the Grosvenor Gallery, at the New Gallery, and in countless regional exhibitions where he could exhibit his art in thought provoking clusters.

To Watts's dismay, Leighton's art of social withdrawal was winning the day, both inside and outside of the academy. Beauty in dreamland consumed the field of art from Leighton, to Albert Moore, to Edward Burne-Jones, to a slew of minor artists who used sleep as the perfect metaphor for their retreat into the numbing power of beauty.[17] In word and in paint Leighton cast aside Watts's art of direct social engagement. For Leighton the narcotic power of beauty was his greatest moral gift to a world in need of aesthetic comfort, for Watts that gift was a poisonous drug that epitomized the capitalist disease of his age. In his *Wife of Pluto* (No. 68) Watts takes Leighton and his

brother artists to task. He refuses to veil the sexual content of this female nude, as Leighton so frequently had. But this is no charming dreamland. Instead he depicts the wife of Pluto as ill. Her erotic appeal vanishes into nausea as Watts uses luxurious, sensuous and sensual imagery to create an image of despair. This is a pointed attack on Leighton's ideal land of beautiful dreams. Watts explained the meaning of the painting in a letter to the painting's buyer, 'in the Wife of Pluto I wish to suggest the disease of wealth'.[18] Watts was deeply opposed to the dreamland ideal as his wife, Mary Seton Watts, records; 'Life he [Watts] said has something more than a dream for its object. There is work wh. is what we have to live for – not sitting amongst flowers by a stream.'[19] For Watts, Leighton's escape into beauty was sickening.

Just as postmodernism dismisses Clement Greenberg for leading so many people to believe that art can exist free of social conscience, Watts attacks Leighton's supposedly amoral, beautiful images of slumbering women and lolling men. If Leighton wants England to fall asleep, Watts is ready to point out just how unsatisfying and cruel that sleep is. *Mammon* (No. 69) is Watts's most direct attack on capitalist greed, and it undermines Leighton's cult of beauty and leisure. Below Mammon are his victims, lying unconscious at his feet. These crumpled and twisted figures echo Leighton's sleeping figures in *Cymon and Iphigenia* (No. 105) and *Summer Moon* (1872, private collection, India), but Watts treats them as victims of luxury, certainly not as lofty ideals. He emphasizes their imperfection and achieves a stylistic effect that is unsettling. While Leighton would lull us into complacency, Watts attempts to jar us into motion.

For those who still believed that Leighton's ideal was indeed an ideal, Watts painted his troubling *Peace and Goodwill* (No. 65). Speaking of this painting he noted: 'the fact that the spirit of work was vanishing from among us' and that 'Man is not a nocturnal animal.'[20] In word and in paint Watts attacked the sleeping beauties that lined the walls of the Royal Academy. Leighton's *Flaming June* (c.1895, Museo de Arte de Ponce) is a sumptuous and flawless expression of his dream ideal and *The Slumber of the Ages* (No. 104) is a pointed perversion of that ideal. Here sleep becomes insomnia; sensuousness collapses into decay, flowing lines break, and precision dissolves into mystery. On the lap of Watts's sleeping mother is an alert child looking out on a strange landscape. Watts achieves this reversal not only by challenging the ideal of inaction, but by attacking Leighton's conventions for the perfected use of line, colour and brushstroke; he condemns Leighton's expressions of beauty.

Watts devoted his last two decades to expressing the absurdity of objectifying perfection. For Watts, Leighton's obsession with perfection was denial of life itself, with its inherent moral and political tensions. For Watts, revealing those tensions was part of his desperate hope for meaningful political change. When Watts saw 'perfection' in Leighton, he saw an artist who had forgotten to struggle and who had sold England out. M. H. Spielmann, in an unpublished and undated note, quotes Watts as saying that 'Leighton's perfection was too great – like himself. His successful search for beauty produced results that were necessarily apart from humanity.'[21] Mary Watts writes on 2 February 1897 that Watts believed that Leighton's 'very accomplishments, the power of dexterous mastery was a limitation to him he ceased to seek & strive & there were no birth pangs before the picture sprang full grown & *ready dressed* into the world'.[22]

It is true that Watts's amorphous style is partially a consequence of his symbolist tendencies, and it is true his interest in the cultural or spiritual nature of existence shaped his style; but we miss a fundamental grounding for Watts's style if we fail to notice the profound importance that Watts placed on imperfection itself. Mary Watts writes the following entry on 3 May 1893; in which Watts rails against Leighton's low ideals: 'He [Leighton] takes me [Watts]

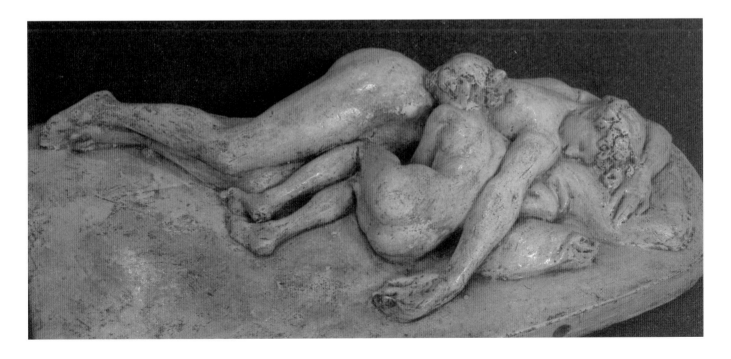

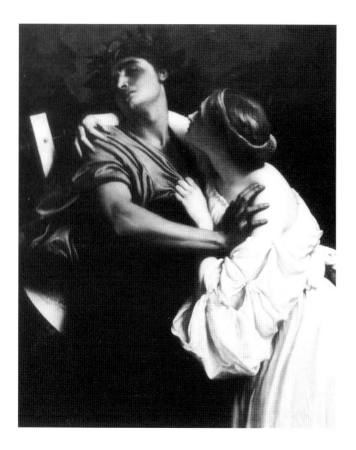

Fig. 14.
Lord Leighton (1830-96)
Orpheus and Eurydice, c.1864
Oil on canvas
Leighton House Museum

Notes

[1] Smith notes the 'rapturous embrace of the lovers,' in *Helios and Rhodus;* Alison Smith, 'Nature Transformed: Leighton, the Nude and the Model' in Barringer and Prettejohn 1999, p. 27. For *Orpheus and Eurydice* see Ormond and Ormond, 'Leighton sees the story as the destruction of an artist through the power of a woman,' Minneapolis, 1979, p. 40.
[2] See Tate, 2001, pp. 88, 93, and 94. Smith, 1996, p. 111.
[3] See Stewart, 1994, pp. 33-53.
[4] Watts hammered the Royal Academy in print in 1853 and again in Taylor, 1853, and in 1863 in statements before the Royal Academy itself. See MSW, 1912, III, pp. 80-146 for excerpts of Watts's extensive criticisms.
[5] MSW, 1912, II, pp. 145-46. Watts supported women's suffrage 'and believes that a feminine influence might have a very good effect on politics Lord Shaftesbury measures would have been carried far sooner had women had the votes.' MSW, diary extracts, 24 May 1889.
[6] See Stewart, 1991, pp. 65-78.
[7] Fry, 1905, p. 621, 'it was certainly not incompetence that led Watts to finally adopt that rocky, dry, and crumbled quality which had given rise to the curious legend of his incompetence. Even in those later works, unsympathetic though their surface may be, he shows incomparable skill in using these dry rubbings and scumblings of pigment so as to produce colour which has mystery and infinity.'
[8] MSW Cat.S.64b, 'painted as a protest against the many studies of the merely nude model exhibited under this title.'
[9] The feminist writer Oliver Schreiner saw this as the first successful painting of the 'great new ideal' of woman, MSW diary, 30 September 1893. See also Stewart, 1998, pp. 314-15, and forthcoming book.
[10] Watts Gallery, 1998, pp. 33-34.
[11] Leighton, 1896, p. 54.
[12] *Ibid.,* p. 54-55.
[13] MSW, 1912, III pp. 180-81.
[14] *Ibid.,* p. 156.
[15] *Ibid.,* pp. 165-66.
[16] Letter to Charles Newton from Watts, 1852 (WG).
[17] See Bendiner, 1985, ', (WG).
[21] Unpublished manuscript in M. H. Spielmann Papers (WG).
[22] MSW, diary extracts (WG).
[23] Moore, 1893, p. 113.
[24] 'Mr. Watts has set himself the task of conveying to the spectator an impression of the cost to the woman herself which such an action as this must have been performed,' 'Notes and News.' Anon. [probably Emilia Strong, the future Mrs Pattison] *The Academy* October 31, 1874, p. 493.
[25] Still, Watts condemned John Callcott Horsley's 'excessive tenderness' against the study of the nude. 'My aim is now, and will be to the end, not so much to paint pictures which are delightful to the eye, but pictures which will go to the intelligence … And in doing this I am forced to paint the nude. See this picture of "Mammon". The creature crushes under one foot the undraped figure of the boy, and his heavy hand he lays coarsely and brutally upon the girl's head.' Spielmann, 1886, p. 15.
[26] Mary Watts sums up her husband's frustrations, 'More & more one regrets that Signor should even nominally be connected with such a dull stupid institution,' MSW, diary, 22 January 1891 (WG).

round the Academy – "There look at that, they say the Academy does not teach- is not that good work" as far as it goes it is good –I only regret it is so, for it bringing sumptuous and flawless expression of his dream ideal so many young people up to paint, & it can never make artists of them - [sic] I feel so angry with dear Leighton for not giving himself a chance.' Watts could not reach Leighton, nor could he reach the disciples of aesthetic perfection like George Moore who castigated Watts's female nudes, saying, 'why should so beautiful a material as oil paint be transformed into a crumbly substance like – I can think of nothing else but the rind of Stilton cheese'.[23] When Watts painted Lady Godiva with breasts so broken and coarse, he was certainly not presenting the female nude as an aesthetic ideal.[24] Through Millicent Fawcett, Jane Nassau Senior, Josephine Butler, and many others, Watts came to understand the consequences of painting objectified female nudes and he refused to participate.[25] Watts was condemning Royal Academy artists for living in the past. For Watts, Leighton's art had a didactic message: it stood for the status quo, and against Watts's push for social change. What makes Watts remarkable is that he refused to conform within 'such a dull and stupid institution' as the Royal Academy.[26] Leighton stood for stylistic stasis, while Watts made evolution his creed and his practice.

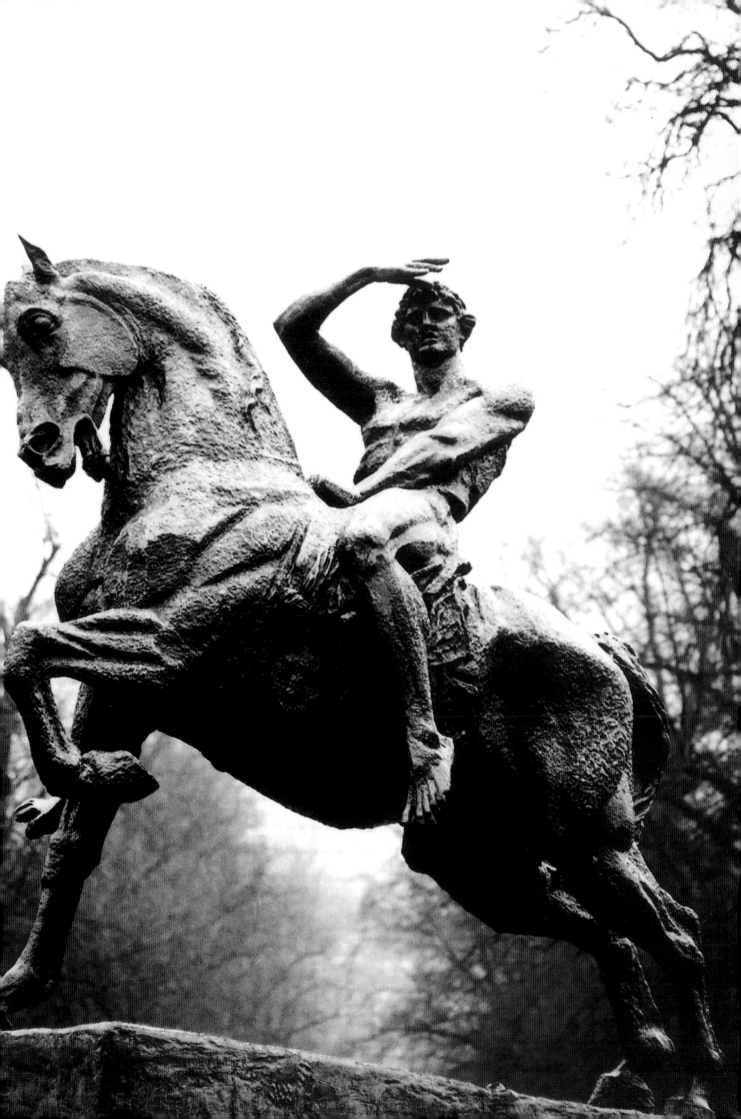

Watts, Pioneer Sculptor

VERONICA FRANKLIN GOULD

'In the best sculpture you feel the palpitations of colour, the elements of a picture; you unconsciously see it painted!' Watts wrote in 1902.[1] He believed that through its association with the culture of ancient Greece, sculpture was the medium best suited to elevate British art and express national character. Watts modelled and carved just a handful of major pieces, breaking new ground in a wide range of materials. He relished the colour and texture of each.

After his childhood training in William Behnes's sculpture studio, and with constant reference to the Parthenon marbles and ancient Greek sculpture of the age of Pheidias, Watts infused his visionary paintings with a sculptor's sense of form. He admired the sculpturesque qualities in the paintings of the Italian artists Giotto, Giorgione, Titian and Michelangelo, though not his sculpture, except for the marble *tondo* at the Royal Academy,[2] and small wax studies. Watts emulated the technique, modelling nude maquettes in wax – which he could melt and reuse – and in clay, which he could preserve, as aids to the composition of his pictures, notably the contorted figures for his cosmic painting *Chaos* (No. 13).[3] He modelled the larger composition of *Love and Life* (No. 96), and a life-size standing nude (c.1870s, WG) and head of a boy for *Love and Death* (No. 89). *Genius of Greek Poetry*, inspired by the Parthenon figure then believed to be *Theseus* was cast in bronze (No. 28).[4] These modelled figures are informed by knowledge of anatomy – in the paintings, they were idealized. Like Leighton, Watts draped the figure in damp muslin, or a handkerchief. He preferred Leighton's sketches to his paintings and treasured a plaster model for the nude sleeping group from *Cymon and Iphigenia* of 1884 (No. 105).[5]

Watts's first known sculpture was a life-size severed head of *Medusa*, modelled in clay at the Medicean Villa Careggi on the outskirts of Florence, and cast in plaster in September 1846 (WG). Although Hellenistic in style, Watts had looked at Leonardo da Vinci's head of Medusa at the Uffizi Gallery. He returned to the subject in the 1871, when Charles Rickards of Manchester commissioned a marble head of the serpent-haired Gorgon.[6]

In August 1849, invited by the British Museum archaeologist Charles Newton to examine the Arundel Marbles in the Oxford University Galleries, Watts discovered a classical idealized head of a woman, and most of her remaining fragments, her bust and shoulders dressed in a *chiton* which exposed her right breast (No. 22). He pieced her together in his studio and Newton had casts made from her, which were publicized in 1867 to encourage the revival of the classical sculpture and elevate modern art, at which time Watts painted her coming to life as *The Wife of Pygmalion* (No. 22).[7]

By now Watts had completed the first of four life-size memorial statues: *Sir Thomas Cholmondeley Owen*, an upright kneeling figure in red-veined marble (1866-67, the church of St Andrew and St Mary, Condover, Shropshire); the seated bronze figure of the Whig statesman Henry Fox, the third Lord Holland, with assistance from the sculptor Joseph Edgar Boehm (1869-70, Holland Park); a recumbent alabaster effigy of *Dr John Lonsdale, Bishop of Lichfield*, (1869-71, Lichfield Cathedral), his robes arranged in multiple folds to attract light effects;[8] and the memorial to the Marquess of Lothian lying between two life-size guardian angels (1870-78, Blickling Church). The marquess's drapery even more *mouvementé* heightens the sense of peace, giving the impression of a friend asleep. His deep-cut Italianate hair is similar in treatment to the marble head of *Medusa*, and the red and white alabaster so appealed to Watts that he stained the marble to simulate the effect, and carved another *Medusa* in alabaster (No. 46).[9]

He fought for decades to arouse public support for a monument to unsung heroes[10] – notably, around the time of Queen Victoria's jubilees – and had in mind to carry out a statue of *Britannia* (No. 19). Instead, on 30 July 1900 a simple cloister was erected in the churchyard of St Botolph's, Aldersgate, known as the Postman's Park., with plaques, chosen by Watts and painted by William de Morgan, commemorating acts of heroic self-sacrifice.[11]

Turning his back on the cold neoclassical style of contemporary sculpture, Watts, a renowned colourist on canvas, was keen to achieve a sense of colour in sculpture. He explained to the statesman William Gladstone, when he exhibited – unfinished – his innovative marble bust of Clytie (No. 34) at the Academy in 1868:

> my aim in this my first essay has been to get flexibility, impression of colour, & largeness of character, rather than purity – gravity qualities I own to be essentially necessary to sculpture but which being made as it seems to me exclusively the objects of the modern sculptor have deadened his senses & some others making part often of the glories of ancient Art, & resulted in bare & cold work.[12]

With a dramatic turn of her head, the impassioned wood nymph twists back to face the sun god and starts to metamorphose into 'a flower like a violet'. Her thrusting breasts, muscles and nerves appear to be writhing in

Fig. 14
Physical Energy, 1870-1904
Bronze
Kensington Gardens, London

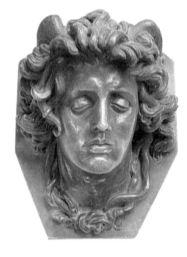

Fig.15.
Memorial to the Marquess of Lothian c.1870-78
Marble, Blickling Church.

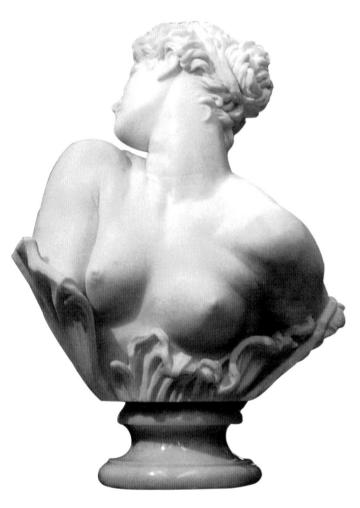

massive Michelangelesque *contrapposto. Clytie* has none of the repose, even, of Greek sculpture. An impressionist in sculpture, if not in paint, Watts broke up the surface into facets to produce atmospheric effect and a more palpitating quality than was possible from chiselling with direct touches'. Watts's *Clytie* – 'that swallow of 1868' – was seen by Edmund Gosse in his seminal reassessment in *The Art Journal* as 'the true forerunner of the New Sculpture movement'.[13] A companion, though contrasting marble bust of *Daphne* (1872-78, Tate Britain), in which her head droops affectionately over the laurel, that begins to envelop her, was not completed.[14]

Lord Westminster commissioned an equestrian statue of his Norman ancestor, Hugh of Avrances, Earl of Chester, the first *Gros Veneur*, nicknamed *Hugh Lupus* for

his lupine ferocity in the Welsh wars.[15] Asked for a strictly historical portrait, Watts himself conceived *Hugh Lupus* (1870-84, Eaton Hall) as symbolic, to embody the idea of 'human will bridling in brute force'.[16] Modelling for the first time in gesso – a mixture of tow and plaster – guided by the Italian sculptor Aristide Fabrucci,[17] Watts varied the surface texture, not only in the superficial coverings of armour and saddlery, but in the musculature and flesh of the horse and the expression of the warrior; his rolls of fat are suggested by a rippling tunic, as he stretches back in a high medieval saddle from which hangs a huge sword; his legs are heavily armed, his left hand holds the reigns and his right hand – boldly ungloved – reaches up to cast off the falcon, while the horse, its body twisting with energy, strains to gallop up and over the rocky terrain.

Once the statue left to be cast in bronze,[18] in the autumn of 1882, Watts began the symbolic equestrian group that would absorb him for the rest of his life.[19] While preparing the small sketch model for *Hugh Lupus*, he conceived a broader vision of a horse and rider, unconstrained by costume or period, which Watts regarded as his greatest work for the nation. The earliest sketch model for *Physical Energy* dates from soon after 1870.[20] His first thought had been to model the rider in

the form of the *Theseus*, but the ancient Greek form was more suited to contemplation than activity. *The Athenaeum* noted that a dynamic full-size model, known at the time as *Active Force*, stood on the modelling trolley at Little Holland House, Watts's London studio, in December 1883. He had nailed sheets of brown paper on to a wooden framework, cut them to the shape of the horse and drew in charcoal the action he wished to express. In the process, he discovered the principle that a good line in a work of art is composed by a series of flattened curves, suggesting a sense of spring and monumentality, whereas a tightly curved, small, contained circle was limited and therefore bad. As his assistant Emilie Barrington observed: 'Whatever suggested growth in the imagination was to Watts the key-note.'[21]

Physical Energy (No. 110) was his most visionary sculpture, symbolizing the physical impulse to achieve more in the material world. Both horse and rider are idealized. Characteristic of the painting *Chaos*, the rider, represents the creation and the cosmos: 'his great limbs like rocks & roots, head like sun'.[22] On an inclined plinth suggesting a rising wave, he holds the horse's reins in one hand – like a helmsman guiding a tiller – and with the other hand shades his eyes, scanning distant lands to conquer. A sense of restlessness is heightened by the horse's impatient trample, Wattsian distortion and broken surface, impressionistic light effects and shadows, and strengthened by a massive sense of power.[23] *Physical Energy* was destined for the nation when the imperialist Cecil Rhodes sat for a portrait in May 1898. He saw the statue as symbolic of his aspiration to complete the Cape-to-Cairo railway,[24] and after his death in 1902, Watts agreed to have it cast for his memorial, provided that he could improve the gesso model for Britain.[25]

Watts's eleven-foot statue of Tennyson (Lincoln, 1898-1903), gazing down at 'the flower in the crannied wall', reflected their mutual love of poetry and nature. Both men addressed the mind of the Victorian age in their art.[26] Compared to Rodin's statue of Balzac (1891-95, Musée Rodin), swathed in a cloak, his huge face framed by flowing hair and looks upward with a commanding expression of pride and drama, Watts's *Tennyson*, his cloak blowing in the wind, is contemplative.[27] The French sculptor visited Watts, whose private denigrated *The Thinker* for lack of bone structure.[28] In June 1904, as he was making final changes to *Physical Energy* – pushing back the rider's head and raising his outlook towards a higher viewpoint – he was taken ill and died on 1 July 1904.[29]

Watts used to describe the original clay or gesso model as 'life', the bronze cast as its resurrection, and a plaster cast as 'death'. He saw the resurrection of the Rhodes version, as the first proof of *Physical Energy*, and the life model (1883-1904, WG) he perfected for the British nation.[30] The sculptor Alexander Fisher referred to his last wax model to supervise the repositioning of the head and arms of *Physical Energy*,[31] which was cast in bronze at Thames Ditton. Arousing controversy even after his death, this supreme example of the Wattsian ideal was erected in Kensington Gardens in September 1907.[32]

Notes

[1] MSW, 1912, I, p. 141.
[2] *Ibid*, I, pp. 72-73, 147-49.
[3] Tate Gallery 1997, pp. 165-66.
[4] Watts owned casts of a horse's head, *Ilissus* and *Theseus*, now believed to be Dionysos.
[5] Barrington, 1905, p. 198; MSW, 1912, II, pp. 124-25; Royal Academy of Arts, 1996, pp. 199-201.
[6] Diary of Caroline, Lady Duff Gordon, 2-3, 9 and 17 September 1846 (Harpton Court Court Papers, National Library of Wales: 15591); letter to C. H. Rickards, 2 July 1871 (NPG II, pp. 151-53).
[7] Cat.S.160c; letter from Charles Newton to Samuel Birch, 26 August 1849 (British Museum, letter 3854); to Dr H. W. Acland, 29 January 1851 (Bodleian Library, Mss Acland d.64. ff.96-99); MSW, 1912, I, pp. 237-38; *The Athenaeum*, 20 July 1867, pp. 91-92.
[8] Commissioned by Gilbert Scott. MSW, 1912, I, pp. 243-44. *The Athenaeum*, 8 October 1870.
[9] A sandstone replica of the Lothian memorial was made for Jedburgh Abbey. National Trust, 1987, 47; Barrington, 1905, pp. 54-55. Watts also supplied designs for memorials to Henry Philips (1869), The Hon. William Owen Stanley (1884, Holyhead, carried out by Hamo Thornycroft), the Marchionness of Waterford (1891, Ford, with MSW), to Armstead (1871, Manchester).
[10] Letters to C. H. Rickards, 17 August 1866 (NPG aII, 25-28); to *The Times* on 5 September 1887.
[11] MSW, diary extracts 30 July 1900; MSW, 1912, II, pp. 103-4; *The Times*, 31 July 1900, p. 2; *The Art Journal*, 1900, 288; Ward-Jackson, 2003, 297.
[12] Letter to W. E. Gladstone, 3 May 1868 (British Library: Add 44415, f.7).
[13] Barrington, 1905, p. 41n; *The Art Journal* 1894, pp. 60 and 158; Edmund Gosse, 1894, pp. 138-42.
[14] Letter to Mary Chesworth, 1 November 1878 (NPG III, ff. 212-13).
[15] Letters from Lord Westminster, 14 and 21 June 1870 (NPG aIV, 102-4, 111-13); MSW 1912, I, pp. 251 and 254-55; to Rickards, 22 November 1870 (NPG); MSW, 1912, II, pp. 137-39). Watts planned to begin the full-size group in spring 1871.
[16] Barrington, 1905, pp. 11-12.
[17] *Ibid*, p. 51.
[18] Hugh Lupus was sent to the Thames Ditton foundry for casting. The gesso model presented by the duke to the cast collection at Crystal Palace was destroyed in the palace fire of 1936. MSW, diary extracts 12 August 1903; 1912, I, p. 256; *Chester Chronicle*, 18 October 1884; *The Art Journal* 1884, pp. 192-93.
[19] Barrington, 1905, pp. 51-52; MSW, diary extracts 12 August 1903. The duke's drafts for £1,300 and £200 were received on 5 and 13 October 1882. The equestrian group, known variously as *Active Force, Vital Energy* and ultimately as *Physical Energy*.
[20] Barrington, 1905, p. 12; MSW, 1912, I, p. 256.
[21] *Ibid*, 49-50; *The Athenaeum*, 29 December 1883, p. 874.
[22] MSW diary, 18 September 1893.
[23] MSW diary extracts 12 and 18 June, 2 and 31 July 1892; MSW, 1912, II, p. 265 and III, p. 270a.
[24] MSW, 1912, II, pp. 270-71.
[25] MSW diary, 15 April 1902, reports that the previous day the statue left to be cast at Parlanti's foundry.
[26] MSW, 1912, II, p. 283.
[27] *Ibid*, 306; diary extracts 6 and 11-12 August 1903: the gesso model of *Tennyson* was cast at Singer's foundry in Frome, and the bronze statue was erected outside Lincoln Cathedral in July 1905.
[28] MSW diary, 11 February 1904.
[29] *Ibid*, 25 May 1904; MSW, 1912, II, p. 322.
[30] Letters to the editor of *The Daily Telegraph*, 6 March 1907; to James Smith, 14 June 1907; MSW, 1912, II, p. 306.
[31] MSW diary, 25, 27 July 1904.
[32] MSW diary extracts, 11 June, 6 and 12 August 1903. London's *Physical Energy* was cast at Burton's foundry in Thames Ditton. A third cast was later made for Rhodes's memorial in Harare.

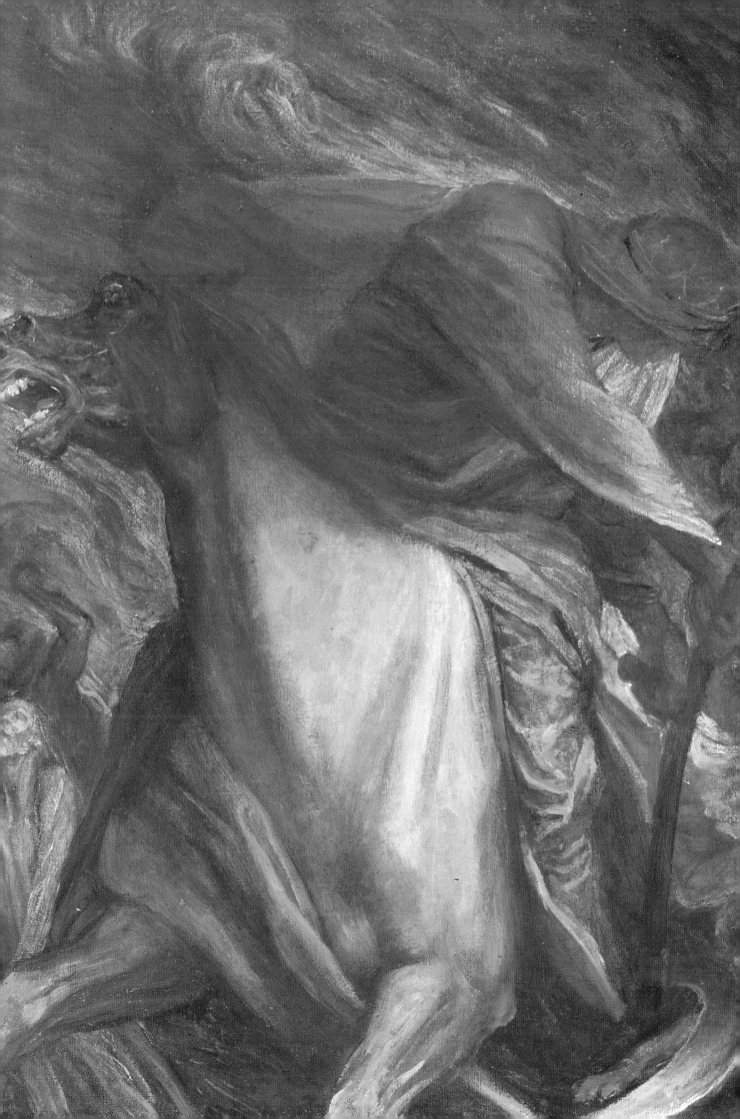

VERONICA FRANKLIN GOULD, with HILARY UNDERWOOD and RICHARD JEFFERIES

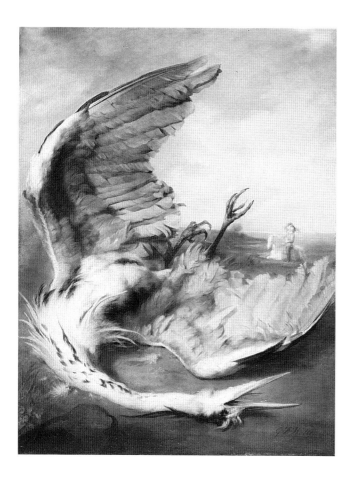

Fig. 16. *Study for the cartoon of Caractacus Led in Triumph Through the Streets of Rome*, 1842-43
Graphite
17.8 x 25.2 cm (7 x 9⁴/₅ in)
The British Museum [not exhibited]

1. *The Wounded Heron*, 1837
Oil on canvas
91.5 x 71.1 cm (36 x 28 in)
Watts Gallery

Watts's first contribution to the Royal Academy *The Wounded Heron* is the earliest recorded example of his preoccupation with themes of Life and Death and of cruelty to birds. Struck by the plumage of a dead heron hanging at a poulterer's, the artist took the bird back to his studio at 33 Upper Norton Street, Fitzroy Square. He painted it as though still alive but dying. Overhead in an English blue sky hovers a falcon, itself pursued by a huntsman on horseback below, showing the vulnerability of life in the face of violence and cruelty – as G. K. Chesterton put it, 'the pathos of dying and the greater pathos of living'. *The Wounded Heron,* painted in the manner of Landseer, reflects the artist's interest in the sport of falconry, the subject of two of his recent pictures, and in Watts's equestrian statue *Hugh Lupus* where the Norman rider is seen casting off a falcon.

 The Wounded Heron was purchased at the Academy for ten pounds in 1837, and Watts bought the picture back from a Newcastle dealer in 1888 for just five pounds.

The Royal Fine Arts Commission instituted a series of competitions to stimulate a higher standard of British art and offered artists the opportunity to decorate the new Palace of Westminster. The first competition of 1843 called for literary or historic cartoons celebrating British history.

 Caractacus, the British chieftain, who headed resistance to the Romans in south-east England in AD 43-51, was defeated on the Welsh border, but released in tribute to his courage. Watts's design shows the influence of the Italian masters – Raphael in the woman and child on the right, and Mantegna, and Anibile Carraci's *Triumph of Bacchus* for the trumpeter on the left. He may have looked to Sir Joshua Reynolds for Caractacus, but the chieftain's head was taken from the defensive reaction of a lion Watts happened to be sketching in the zoological gardens. By presenting Caractacus towering over the Romans, he transformed the humiliating march into one of glory, earning warm affection from the Welsh. Watts was awarded one of the top three prizes of £300, which funded his travel via Paris to Florence, where he studied fresco painting and the Grand Manner from 1843 to 1847.

2. *Judas Returning the Thirty Pieces of Silver to the High Priest*, 1843-47
Oil on canvas
142.3 x 132 cm (56 x 52 in)
Private Collection

In Florence, Watts established the influences that would inform his art: the monumentality and *contrapposto* of Michelangelo's figure painting and, notably here, the colour of Titian and the Venetian school, and the grandeur of both. These influences combined with his established commitment to the restrained form of Greek sculpture of the age of Pheidias. In *Judas Returning the Thirty Pieces of Silver to the High Priest*, Caiaphas – the High Priest to whom the apostle returns the money he received for betraying Christ – resembles Titian himself.

3. *Study for the fresco of The Drowning of the Doctor*, 1845
Graphite
14 x 18 cm (5 ½ x 7 in)
Watts Gallery

Living at the Medicean Villa Careggi on the outskirts of Florence, as the protégé of the British Minister Lord Holland, Watts painted a fresco of *The Drowning of the Doctor* for failing to cure Lorenzo de Medici. The Florentine ruler died at the Villa Careggi. At the time, Medici attendants were believed to have drowned the doctor in a well – he is now thought to have thrown himself in. Michelangelesque *contrapposto* in *The Drowning of the Doctor* emphasizes the attendants' violence and disdain.

Watts wrote: 'Constituted by nature to live in the most elevated atmosphere of thought, and ever dealing with the mightiest subjects, Michael Angelo passionately strove to impress on his designs the character of gigantic nobility'.

4. *Medusa*, 1846
Plaster
29 x 38 x 32 cm (11 ½ x 15 x 12 ½ in)
Watts Gallery

Modelled at the Villa Careggi in September 1846, this severed head of the serpent-haired Gorgon was Hellenistic in style. Watts looked to the head of Medusa at the Uffizi – then believed to be by Leonardo da Vinci, and now attributed to the Flemish School (c.1620-30) – and a live serpent was brought to Careggi. The *Medusa* was cast in plaster in Florence on 17 September.

5. *Medusa*, 1846
Painted plaster
14 cm high (5 ½ in)
Private Collection

This small head of *Medusa*, modelled in clay, provided the model for Alfred in *King Alfred Inciting the Saxons to Resist the Landing of the Danes* (Fig. 15) and for heads of *Medusa* of the 1870s. Georgy Duff Gordon, staying with her mother at the Villa Careggi in 1846, was taught to model in clay by Watts, and the head was given to her. The Duff Gordon family became close friends of the artist and commissioned many portraits.

6. *Study for King Alfred Inciting the Saxons to Resist the Landing of the Danes*, 1846
Graphite
21.5 x 35.5 cm (8 ½ x 14 in)
Watts Gallery

On his return from Italy, Watts won the 1847 Westminster competition, with *King Alfred Inciting the Saxons to Resist the Landing of the Danes*. The founder of the first English navy, Alfred is depicted in the heroic form of Greek sculpture. Standing on the gangplank, he indicates the arrival of the Danes. A greater sense of energy surges across in the twenty-feet picture painted at the Villa Careggi.

Watts employed the luminous colours and composition of the Venetians, with Tintoretto's Mannerist device of capturing sudden movement. Sharp outlines and broad application of colour suggest that he planned the subject as a fresco. He imbued the picture with patriotic and religious fervour. In the lower left group, which particularly interested him, the youth buckling on armour while his mother hangs a cross around his neck, reacts to his father, who is handing over his sword and urges his son not to disgrace the family. The youth with the axe threatens to exterminate the Danes. Watts explained the figure of Alfred, (seen with billowing cloak and sword in the painting):

'I have endeavoured to give him as much dignity, energy and expression as possible without exaggeration. Long-limbed and springy, he is about the size of the Apollo … cast … in the most heroic mould, simple, grand and elegant'.

Fig. 17 *King Alfred leading the Saxons to Resist the Landing of the Danes*, 1846-47, Palace of Westminster.

7. *Found Drowned*, 1848-50
Oil on canvas
220.98 x 120.65 cm (47 ½ x 84 in)
Watts Gallery

Painted in London, when Watts was depressed by the poverty in England and Ireland, *Found Drowned* is one of four realist pictures, which reflect the European preoccupation with social realism at this time, and remained relevant late into the nineteenth century. Unlike his idealized subjects, these recognizably modern nineteenth-century people are quite different from the symbolic pictures upon which he had now embarked. Watts focused on the wider sufferings of humanity.

Found Drowned, a legal term indicating suicide, shows the body of a woman on the shore beneath Waterloo Bridge, her legs immersed in the polluted river Thames. In the catalogue of her husband's works, Mary Watts pointed out that this picture relates to Thomas Hood's poem *The Bridge of Sighs*. By incorporating the Shot Tower and Brunel's new suspension footbridge loom in the background, Watts suggests that their technological progress was overshadowed by social failure.

By contrast, in Dante Gabriel Rossetti's *Found* (1854-55, Delaware Art Museum, U.S.A.), a 'fallen woman' collapsed by a wall is offered salvation by a former suitor. Rossetti's single attempt at a modern moral subject relates to Watts's shivering woman huddled *Under a Dry Arch*, her face an expression of abject misery. St Paul's Cathedral, barely visible in the background, represents formal religion, which, in the artist's view, turned the other cheek.

I see the past in the present and the present in the future

8. *Outline for a scheme of cosmic frescoes, The House of Life* 1848, with later additions.
National Portrait Gallery

Impressed by frescoes in Italy, notably in the Sistine Chapel which he visited in August 1844, Watts outlined a cosmic fresco scheme, with which he planned to fill a British hall, and thereby inspire the British nation, raising the status of art to the level accorded poetry and music.

In *On Heroes, Hero-Worship and the Heroic in History* (1840) Thomas Carlyle had called for a 'Poet, Painter, Man of Genius' to unravel the mystery of Time; and since 1844, the nation had been gripped by evolutionary debate stirred by Robert Chambers's anonymous *Vestiges of the Natural History of Creation*.

Watts's universal epic, later known as *The House of Life*, embodied the progress of the cosmos and civilization, cultural history and spiritual thought, wide-ranging issues of human existence. His plan begins:

> The ceiling to [be] covered with the uniform blue of space, upon which should be painted the Sun the Earth, & the Moon, as it is by their several revolutions in connection with & depending upon each other that we have a distinct notion of & are able to measure (& estimate the magnitude of) Time. The progress of Time & its destroying (consequent) effects I would here illustrate for the purpose of conveying the lesson, the present moment is all that can be called our own &c. I would represent this globe with symbolical figures of the antagonistic forces Attraction & repulsion & half shadowed by progressing Time.

To Watts's eternal regret, the hall lacked support and was never built, but subjects for the visionary scheme would preoccupy the artist for the rest of his life. He presented the finest examples to the opening of the National Gallery of British Art (Tate Gallery) in 1897.

9. *Sketch for Time and Oblivion*, 1848
Oil on board
31.75 x 20.32cm (12 ½ x 8 in)
Eastnor Castle
(See Fig. 6)

The first completed *House of Life* picture subject, *Time and Oblivion* established the style of the symbolic works Watts resolved to paint for the nation. Idealized sculptural figures representing humanity, rather than recognizable individuals, were painted in broad flat colour with a view to fresco, and with little detail, in order to focus on the underlying idea. 'If symbols are to be impressive the artist must to a certain extent sink the pictorial effect', the artist explained. 'The symbolic requires reticence and therefore some sacrifice.'

Reinventing allegory with a modern anthropomorphic vocabulary, Watts presented Time, not as an old man, but as a vigorous youth. He placed the figures between Night and Day, showing only part of the larger fiery sun in order to stretch the viewer's imagination. 'I wished to stimulate the mind and awaken large thoughts. It is solemn, sad and hard, for solemn, sad and hard are the conditions: an organ chord swelling and powerful but unmodulated.'

Even in this small sketch, which Ruskin hung in his studio for a while, there is a sense of expansion. 'The impression of vast size is most acutely experienced when only portions of a form are visible, perhaps because the imagination is at liberty to indulge in unrestricted flight', Watts wrote. 'For this reason fragments appear to be grander in character than complete statues, partly because imagination … supplies what is wanting.'

In the finished picture, over ten feet wide, he showed a larger segment of the earth. Watts spoke of the sphere as 'the one perfect form … the most immense that can be conceived.'

To Earl Somers, who bought the large version in 1863 and supported Watts's visionary work at a time when the authorities derided it, the artist wrote: 'I look upon it as the only picture I have painted which represents what I might do or would have done had there been any sympathy with effort in that direction.' Reviewers were still mystified when Watts exhibited *Time and Oblivion* – presumably, the present sketch – at the Academy in 1864, as a design for sculpture. He himself always regarded *Time and Oblivion* as one of his finest works. Of all the pictures in his retrospective exhibition at the New Gallery in 1897 Watts felt that only two were up to his mark, *Time and Oblivion* and *Life's Illusions*, (Fig. 1) Of *Time and Oblivion* 'I think Pheidias would have said "Go on, you *may* do something".'

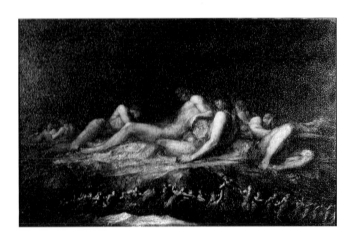

Known variously as *The Giants, The Everlasting Hills, Chaos* and *The Titans*, of which there are several versions, this is the right-hand section of *Chaos* (No. 13), the first theme of *The House of Life*, which this picture predates. In No. 7, Watts proposed.

> I would then give a nearer view of the Earth; & by a number of gigantic figures stretched out at length, represent a range of mountains, & typify the bony structure of skeleton; this I would make very grand & impressive in order to imply the comparative insignificance of man.
>
> The to us most important of the constellations should shine out of the deep ultramarine firmament, Silence & Mighty Repose should be stamped upon the character & disposition of my giants; & revolving centuries & cycles should glide in the form of female figures of great beauty beneath the crags upon which the mighty forms should be; to indicate the non effect as compared with man & his works upon them.

Cracks and stains on a dirty wall inspired the composition, which he kept in his mind and carried out years afterwards. The giant figures representing a mountain range – in contrast with small, luminescent female figures gliding beneath to represent Time – suggest man's comparative insignificance and foreshadow the reclining figures of the twentieth-century sculptor Henry Moore.

Watts invested considerable time in the picture, which he named as *The Giants* in his will in 1866. He did not wish to part with it. However, pressed by a new patron, he sold it in 1873 to Richard Johnson of Manchester, for one thousand guineas, reserving the copyright, and on condition that he could make replicas. The picture was exhibited as *Titans* at the Royal Manchester Institution in 1875.

10. *Ilissus*, 1851, reduced cast from the Elgin marbles (c.438-432 BC)
Plaster
28 x 65 cm (11 x 25 ½ in)
Watts Galley

The year of Watts's birth, 1817, the Elgin marbles went on display at the British Museum to stimulate the progress of the fine arts in Britain. Created for the Parthenon in Athens under the guidance of the Greek sculptor Pheidias, they were brought to England by Thomas Bruce, the seventh Earl of Elgin. To Watts, their restrained form was supreme. Finding negligible teaching at the Royal Academy Schools, he preferred to study directly from the Elgin marbles. In 1851, Watts was appointed to the council of the Arundel Society, whose pioneering reduced casts from the marbles won a medal in the Great Exhibition that year. He acquired casts of *Ilissus, Dionysos* (then believed to be *Theseus*) and a group of riders and kept them in his studios, constantly referring to them for the sculptural form and drapery folds in his painting.

11. *Titans*, c.1848-73
Oil on panel
103 x 44 cm (40 ½ x 17 ⅓ in)
Watts Gallery

12. *Study for Chaos*, c.1855-60
Fresco
137.5 x 54 cm (43 x 36 ½ in)
Leighton House Museum

Painted on to the walls of Little Holland House in Kensington, where Watts lived as a tenant of Thoby and Sara Prinsep, this is a study in true fresco for a primeval figure for *Chaos*, the 'introductory chapter' to Watts's intended *The House of Life* hall of frescoes. Combining the form of the *Ilissus* (No. 10) and of Michelangelo's figure of Adam on the ceiling of the Sistine Chapel, Watts has twisted the figure to heighten the effect of turbulence. In September 1875 the fresco was one of twenty removed and preserved by his assistant Mrs Charlotte Wylie, in preparation for his move to the new Little Holland House. Watts gave the frescoes to Mrs Emilie Barrington.

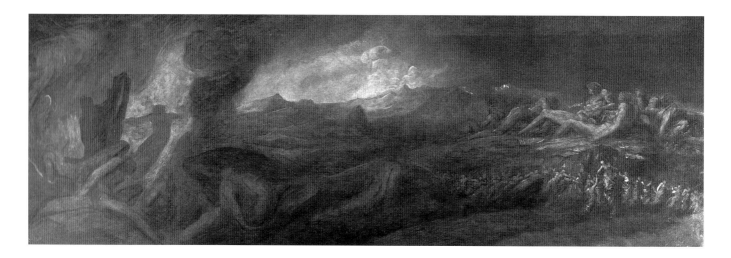

13. *Chaos*, or *Chaos Passing to Cosmos*, c.1873-75
Oil on canvas
317.5 x 104.14 (125 x 41 in)
Watts Gallery

On the advice of Leighton and Burne-Jones, Watts left
unfinished this original first sketch for *Chaos*, the introductory
chapter to *The House of Life*, painted much as he planned in
1848. Departing from literal historic record, he presented a
modern interpretation of evolution, 'the passing of our planet
from chaos to order'. Watts was interested in Turner's late
works at this time.

 From the early violent upheaval seen on the left, a single
figure emerges in the swollen tides in the middle section,
marking the start of the strides of time. Here, in the vaporous
atmosphere of unborn creations, light is still veiled by mists,
and air and water mingle. On the right, beneath the
contemplative giants, the current of time is suggested by the
continuous stream of figures.

14. *Studies for Chaos*, late 1850s-1870s
Plaster, casts from clay or wax
10-15 cm high (4-5⅞ in)
Watts Gallery (illus. p. 43)

Apprenticed at the age of ten to the sculptor William Behnes,
Watts imbued his imaginative paintings with a sense of
sculptural form. Having established a mental image of his
composition, he modelled nude figures in wax or clay to finalize
the arrangement. These figures are informed by knowledge of
anatomy, but lose this definition when painted as idealized
symbolic figures on canvas.

15. *The Creation of Eve*, 1865-99
Oil on canvas
130 x 55 cm (46 x 17 in)
Watts Gallery

The psychological truths underlying the early chapters of
Genesis fascinated Watts. *The Creation of Eve* was one of the
series – with three vertical figures of Eve (see No. 13), *After the
Transgression* and *The Denunciation* – he earmarked as an epic for
The House of Life in 1873. Figures ascending from the still
unconscious Adam heighten the creative idea, very different
from William Blake's treatment (c. 1803-5, Metropolitan
Museum of Art, New York) which includes the central all-
powerful figure of God and combines the subject with No. 16.

In Watts's picture, the down-stretched arm pointing to Adam
recalls Michelangelo's figures on the Sistine ceiling; and the
crisp brushstrokes reflect a quality Watts admired in landscape.
White scumbling, work in progress over the clouds and
draperies, was applied when Watts thought a picture too tight
or defined. He would then add colour to create atmosphere.

 Exhibited at the Galerie Georges Petit in Paris in 1883, the
picture remains a sketch, valued as such by the artist. A larger
finished version is in the Fogg Art Museum.

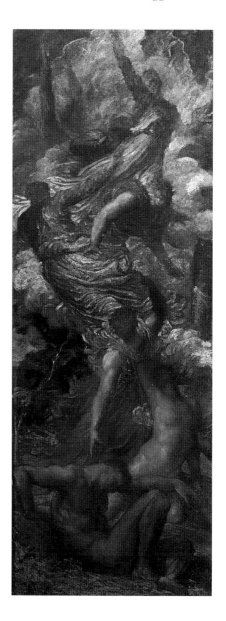

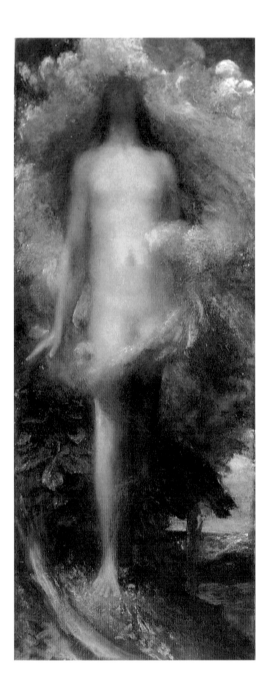

only brighter and purer'. In contrast, her upturned face is dark, to suggest areas of the human mind, quoting Milton's *Paradise Lost*, 'dark with excessive bright'.

In the final large version, Watts concentrated light over the heart and breast, the seat of love and tenderness, wreathed the lower limbs with cloud and fluttering bird life, as *She shall be called Woman* – not an apotheosis of womanhood but of feminine qualities. Ideally he would have liked the picture to be criticized beside the Elgin marbles, during a reading of the first two books of *Paradise Lost*, to the accompaniment of Beethoven's *Moonlight Sonata*. Eve was to be seen as the essence of life, strong, vital, electric, 'an incarnation of the spirit of our own time, and a hope for the future'.

17. *Education and the Muses*, 1849-52
Sanguine
16.5 cm diam (6 ½ in)
Watts Gallery

On his return from Italy, Watts embarked on a crusade to dignify public buildings with huge inspirational frescoes. Officials were sceptical. In autumn 1849, the archaeologist Charles Newton, urged by Charles Cockerell, the architect of the Taylor Library at Oxford, spearheaded a campaign for a Watts fresco on the library ceiling. His designs were exhibited in Oxford in 1850. To Watts, the nude was the purest expression of high art – (in Titian's *Sacred and Profane Love*, the naked woman symbolizing celestial love is superior to her draped companion, representing human love) – and his designs for the outer lunettes, coupling clothed educators with idealised nudes, aroused vitriolic opposition in 1852, and the ceiling remains bare. That year, Watts's proposal to carry out a fresco at Lincoln's Inn was accepted, and he was commissioned to paint a fresco of *The Red Cross Knight Overcoming the Dragon* at the Palace of Westminster.

16. *She Shall Be Called Woman*, 1867
Oil on canvas
78.3 x 31 cm (30 ½ x 12 ½ in)
National Museums Liverpool
Lady Lever Art Gallery

Originally named *Eve in the Glory of her Innocence* and first noted by *The Athenaeum* on 30 March 1867, this picture was catalogued by Mary Watts as 'The first and most beautifully complete version' of what her husband would develop into one of his most visionary Symbolist subjects. As the newly awakened woman, Watts's Eve represented the mind of modern times.

His three vertical figures of the mother of mankind, designed to hang together, represent stages of human life: here, just after the moment of creation, 'more conscious to heaven than of earth'; next, *Eve Tempted* by the senses (No. 46); and finally, 'restored to beauty and nobility by remorse as *Eve Repentant*'.

As the central figure of the universe, the newly created Eve is seen emitting light. She represents the Greek vision of 'A line of light, straight, as a column extending through the whole heaven and through the earth in colour resembling the rainbow,

18 *Justice: A Hemicycle of Lawgivers*, c. 1853
Watercolour on paper
41 x 43 cm (16 x 17 in)
Watts Gallery

Covering the forty by forty-five-feet north wall of Lincoln's
Inn's new hall designed by Philip Hardwick, *Justice: A Hemicycle
of Lawgivers* (1852-59) was the largest, most ambitious fresco
hitherto attempted in England. Designed with the grandeur and
format of Raphael's *School of Athens*, Watts's thirty lawgivers,
assembled beneath anthropomorphic figures of Truth, Mercy
and Justice, represented the evolution of civilization. He
wanted to create 'a grand monumental effect and pervade, so to
speak, the building like a strain of Handel's music, becoming
one with the architecture.' Hearing choristers in the nearby
chapel, Watts imagined them to be a choir of angels inspiring
his creation. Among the many friends who modelled as
lawgivers were the poet laureate Alfred Tennyson, Newton and
the artists William Holman Hunt and Edward Burne-Jones
Justice: A Hemicycle of Lawgivers.

19. *Britannia*, 1868
Pen and brown ink on paper
9 x 11.4 cm (3 ½ x 4 ½ in)
Ashmolean Museum, Oxford.

Writing to his Manchester patron in August 1866, Watts
revealed that he had long wished to carry out a colossal bronze
statue to unsung heroes, and was now working on a life-size
memorial sculpture. By 1868 he resolved that the subject for his
heroic monument was to be *Britannia*. 'Every poor faithful
worker should feel inspired & encouraged at the sight of it',
wrote Lady Adelaide Talbot. There was no support for the
scheme. Watts again raised the subject to coincide with Queen
Victoria's golden jubilee in 1887. He had in mind a *camp santo* –
along the lines of the *Monument des Martyrs* in Brussels – with a
central statue symbolizing Heroism, not necessarily to be
carried out by himself. Eventually, a modest cloister he had
designed by Ernest George in the churchyard of St Botolph's,
Aldersgate, was opened on 30 July 1900. Watts had selected
thirteen brave men and women, whose heroic deeds were
recorded on plaques painted by William de Morgan.

*No one understood how to give a kind of
tremendous palpitating beauty in every line of
drapery as the Greeks at this best period. It is
the music of form light & colour!*

To Watts, Greece was the natural home of the arts.
Gripped by tales of the Greek gods and goddesses
as a child, he emulated the drapery folds of ancient
Greek sculpture, enlivening these folds in his
paintings and sculpture to creating a sense of
atmosphere. In 1856-57, Watts joined the expedition
to excavate the Mausoleum of Halicarnassus. Sailing
through the Aegean Sea, he was moved by the
atmospheric light, the serenity and harmonious
layout of the islands, the palpitating depths of blue
and the reflected lights over the waters. On his
return, Watts began to paint poetic pictures of the
Greek myths. He revisited Greece in 1887.

20. *Ariadne in Naxos*, 1869
Oil on canvas
30.5 x 53.34 cm (12 x 21 in)
Private collection

The first Greek myth Watts painted on his return from the
Aegean Sea was that of Ariadne abandoned on the island of
Naxos. He would develop the theme over almost four decades.
Each new picture presented an earlier moment. Ariadne, having
helped Theseus to escape the Minotaur by marking the route
out of the labyrinth with red thread, had been left alone on
Naxos by Theseus, and Bacchus came to her aid.

Watts's earliest versions show Ariadne after a night of
revelry with Bacchus. In the first, exhibited at the Academy in
1863, she appears clothed and sorrowful, still holding the red
ball of thread and apparently longing for Theseus. (A leopard
playing with the other end of the string was removed from the
canvas when Watts reworked the canvas again in 1888-90, and
introduced atmospheric effects, transforming the princess's
expression from one of sorrow to contemplation.) It is an
image of idealized beauty, taken from Ovid's *Metamorphoses*, and
inspired in form, by the Fates from the Parthenon pediment,
Ariadne gazes languidly out to sea, searching for her lover,
Watts softened her Pheidian form with drapery folds, Venetian
colour and tonal gradations

For imaginative subjects, Watts never painted directly from
the model. In the 1860s a statuesque maid known as 'Long
Mary' modelled to him for nude studies, and he would use
these studies as a writer uses a thesaurus. Long Mary's face
appears in his sketch for the 1869 version of *Ariadne in Naxos*,
which he idealized for this finished painting, exhibited at the
Dudley Gallery in 1869. Here the now nude Ariadne, still
unconscious after Bacchus's attentions, does not hold the
thread, but Theseus's boat can be seen sailing away. Following
Watts's lead, Frederic Leighton painted the same scene, but
released Ariadne from her suffering by death.

Watts's 'most complete' version of 1875 – too fragile now
to be moved from the Guildhall – shows Ariadne seated in a
poetic landscape, watching for Theseus's return; her attendant
points and leopards prance to indicate the arrival of Bacchus.
According to Barbara Bryant (New York 2003, 437), Watts had
executed a copy of Titian's *Bacchus and Ariadne* (National
Gallery, 1522-23), to which he clearly looked for the landscape
setting and diagonal composition in the 1875 version.

It is interesting to compare Watts's pictures of Ariadne to
Manet's *Olympia* (1863, Musée d'Orsay, Paris). Both artists'
pictures present a woman whose lover is absent. Dramatic
angles and abrupt tonal contrasts in Manet's picture highlight
the cool, white body of the prostitute on her bed, and, like
Ariadne's attendant and leopards, Olympia's maid bringing in a
bouquet suggests the arrival of a man.

Fig. 18 *Ariadne in Naxos*, 1875, oil on canvas, Guildhall Art Gallery

21. *The Oxford Bust*, Roman and seventeenth century
Marble
83 x 57 x 33 cm (32 2/3 x 22 ½ x 13 in)
Ashmolean Museum, Oxford

In August 1849, Watts was invited to Oxford by the
archaeologist Charles Newton and the architect Charles
Cockerell to examine the Arundel Marbles, Britain's earliest
major collection of classical antiquities, presented to the
University of Oxford in 1755. Sifting through the fragments
Watts discovered the head of a woman. The men located most
of her remaining parts, her bust and shoulders dressed in a
chiton, exposing a single breast. Her eyes were more prominent
than characteristic idealized Greek heads. So fine was she, even
in her severed state – with corroded lips and missing parts of
her nose and forehead – that Watts believed her to be a portrait
from the age of Pheidias. The archaeologist, too, thought her
'the finest bit of sculpture I know out of the Elgin Room'. In
Newton, Watts found a kindred spirit and crusader for the
revival of that great Hellenic school of sculpture – judged
perfect in its day – to elevate modern art.

In 1867, when Oxford University Galleries were planning
their new displays, Watts and Newton revealed the bust to the
press as 'a discovery of considerable importance'. As her
expressive features, abundant hair and slightly tilted head
precluded the hand of Pheidias himself, they proposed to name
her 'Aspasia', after the celebrated mistress of Pericles. Watts
pieced the Oxford Bust together in his studio, adjusted her
head, modelled a new nose and advised the British Museum
cast-manufacturer, Domenico Brucciani, who had made a
mould from the Oxford bust by 1867, for that year a cast of
the bust was recorded in France. Watts and his neighbour, the
sculptor Hamo Thornycroft, kept a cast in their studios.

As Professor Michael Vickers points out, the bust is not
Greek after all. The head is a Roman copy of Pheidias's gold
and ivory statue of Aphrodite Ourania at Elis, and the torso is
believed to have been added in the seventeenth century, when
the bust was recorded in an etching by Wenceslaus Hollar
(1865), and identified as 'the Empress Faustina, wife of Marcus
Aurelius' on a garden ornament on the *Tomb of Germanicus* at
Easton Neston in Northamptonshire.

However, because of the – albeit, qualified – Pheidian
resemblance, Watts painted a picture of the bust coming to life as
The Wife of Pygmalion, A Translation from the Greek (No. 21).

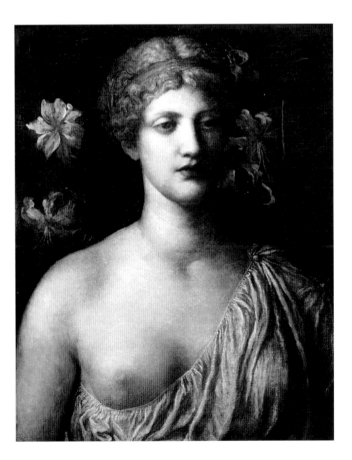

22. *The Wife of Pygmalion, A Translation from the Greek*,
c. 1865-68
Oil on canvas
67.3 x 53.3 cm (26 ½ x 21 in)
The Faringdon Collection Trust, Buscot Park,
Oxfordshire

From 1865, after separating from his teenage bride, Ellen Terry, Watts painted a series of half-length sculpturesque nude pictures, mostly on themes from Ovid's *Metamorphoses*, and referring to nude studies taken from the Little Holland House maid Long Mary. He captured the supreme symbolic moment, and re-created it as though for eternity.

Pygmalion fell in love with an ivory statue of a beautiful woman he had carved, and imagined that when he embraced her, she returned his kiss. As discussed in No. 19, Watts painted *The Wife of Pygmalion* from the classical bust he had found in the Arundel Marbles collection at the Oxford in 1849, and drew it to the attention of the press in 1867. The academic view then – now disproved – was that the bust was Greek.

Watts's painting of *The Wife of Pygmalion* embodies the influences that moved him as a modern day Olympian, for at the same time he had embarked on large-scale sculpture. Fascinated by the interrelation between sculpture and painting, he employed glowing Venetian colour and clearly bore in mind the composition of Titian's *Flora* (1515-20, Galleria degli Uffizi, Florence) in this aesthetic 'translation' of the half-draped sculpture into a Grecian beauty whose flesh softened at the sculptor's touch. As blood reaches her ripening lips and exposed nipple, her *chiton*, arranged in irregular folds, especially large over her left breast, appear to be palpitating to her heartbeat. Watts's golden-haired Galatea seems more kissable against a virginal background of lilies, than Rossetti's luscious, almost overpowering *Venus Verticordia* (1864-68, Russell-Cotes Art Gallery and Museum, Bournemouth) in a profuse floral setting, with butterflies, the souls of her lovers, fluttering over the arrow pointed at her breast. Both artists celebrated the poetry of female beauty, using mythology and symbolism to recreate images of extraordinary sexual power. Burne-Jones first drew in 1867, then painted a sequence of pictures 'Pygmalion and the Image'. Unlike Burne-Jones's subsequent sequence of paintings (1868-79, Birmingham Museums and Art Gallery), Watts simply presented the ideal beauty of a woman, unencumbered by symbols, the metamorphosis from statue to human suggested by flesh tones and the blossoms at her head.

At the Academy in 1868, *The Wife of Pygmalion* was seen as 'an exquisite modern painting ... on which the reputation of Mr Watts will always rest unshaken.' The poet Algernon Swinburne wrote in *Notes of the Royal Academy Exhibition 1868*:

> The soft severity of perfect beauty might serve alike for woman or statue, flesh or marble; but the eyes have opened already upon love, with a tender and grave wonder; her curving ripples of hair seem just warm from the touch and the breath of the goddess, moulded and quickened by lips and heads diviner than her sculptor's. So it seems a Greek painter must have painted women, when Greece had mortal pictures fit to match her imperishable statues. Her shapeliness and state, her sweet majesty and amorous chastity recall the supreme Venus of Melos ... we see how in the hands of a great artist painting and sculpture may become sister arts indeed, yet without invasion or confusion, how, without any forced alliance of form and colour, a picture may share the gracious grandeur of a statue.

Among several offers Watts received for *The Wife of Pygmalion* at the private view was an impassioned request from William Gladstone, but the picture was promised to the collector Eustace Smith. 'I will cure you of your love & console you for your disappointment ... by showing you the fragment from which it was painted, wherein you will see all that you admire in the picture with infinite beauties altogether missed.'

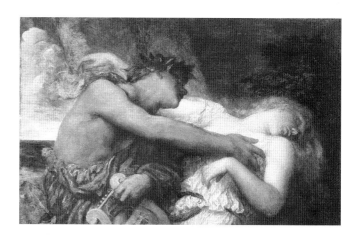

23. *Orpheus and Eurydice*, 1867-68
Oil on canvas
33.2 x 53.3 cm (13 ½ x 21 in)
Private Collection, Courtesy of Christie's

The myth of *Orpheus and Eurydice*, with reference to both music and poetry, held particular interest to Watts, who created nine pictures on the theme from 1867. Madeline Wyndham, who in May that year sat, or rather stood, for an aesthetic portrait that made an impact at the opening of the avant-garde Grosvenor Gallery in 1877, was the model for this first half-length painting of *Orpheus and Eurydice*. The Thracian poet mourning the death of his bride Eurydice, ventured down to the underworld and sang to the music of his lyre, which moved Pluto and Persephone to let his wife return to him, but if he saw her, she would be taken from him. Just as they reached the surface of the earth, Orpheus eagerly looked towards Eurydice and she slipped back into Oblivion.

This is the instant Watts represents. Whereas Leighton painted Eurydice alive and clinging to the Thracian poet, who pushes her away in order to avert his gaze, Watts chose a later moment, full of hope, but fatal. His impassioned image, echoing perhaps the flights of his own lost muse, Ellen Terry, encapsulates the instant, when Orpheus gazes back at his wife and in so doing loses her. In this first version, noted by *The Athenaeum* on 28 December 1867 as 'a triumph of imagination' and exhibited at the Academy in 1869, the poet still clutches his lyre with the single unbroken string symbolizing Hope (No. 81) – (in the full-length version, exhibited at the Grosvenor in 1879 and the Paris Salon of 1880, the instrument has fallen to his feet). He clasps Eurydice's breast, she falls away, her arms lose their grip, her flesh pales, her head becomes limp, and she slips back to oblivion. Her transparent *mouvementé* drapery contrasts with his vigorous, ruddy body, and heightens the sense of desire and impotence of love in the face of death. A similar half-length version in which the figures occupy more picture space was given to his second wife Mary as a wedding present (1870-80, Fogg Art Museum).

Rossetti combined the themes of ecstasy and death in *Beata Beatrix* (1863-70, Fig. 9), in which his late wife Lizzie is presented as Dante's Beatrice at the spiritual moment of death. The French artist Gustave Moreau, absorbed by the subject of death, had exhibited an idealized vision of Orpheus's severed head in the 1866 Paris Salon. *Jeune fille thrace portant la tête d'Orphée* shows the poet's head juxtaposed on to his lyre carried in the limp arms of a Thracian girl, whose closed eyes intensify his fate. The Orpheus theme continued to absorb Watts and would be taken up by Moreau and the European Symbolists in the 1890s.

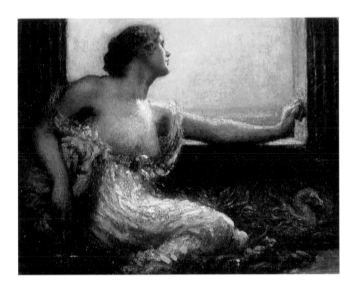

24. *Hero*, c.1869-1885
Oil on canvas
21 x 27 cm (8 ½ x 10 ½ in)
Private Collection

Madeline Wyndham appears to have been the model for *Hero*, a priestess of Aphrodite. Leander used to swim across the waters at night to meet Hero, who guided him by holding up a torch. One stormy night Leander drowned. Moonshine highlights her face and dress rather than a torch, and the sea-horse, or hippocampus by her knee, and distant sea spray indicates Leander's fate. The atmospheric effects of the broken brush strokes suggest that the picture was painted in about 1883-84, probably from earlier drawings.

25. *Endymion*, 1869
Oil on canvas
52 x 65 (20 ½ x 25 ½ in)
Private Collection, courtesy of Nevill Keating
Pictures Ltd (illus. p.15)

Watts's first picture of *Endymion*, was much admired by his contemporaries, Rossetti thought this alone worthy to launch the Academy's second century (though Watts did not exhibit it in 1869). In April, Ford Madox Brown hailed it as 'a masterpiece that would do credit to any school in existence, or that has existed, as full of power in execution as it is poetic in conception'. Endymion, the shepherd sent to eternal sleep by Jupiter in return for perpetual youth, received nocturnal visits from the moon goddess Diana. Although Watts based the pair on Parthenon figures, and emulated Titian's use of colour to enrich form, combined with Tintoretto's to create mood, his colour harmonies and diffusion of light and energy were extremely inventive. The moon goddess, swathed in phosphorescent draperies, surges over the sleeping youth in the form of a crescent moon – a supreme example of the Wattsian curve stretching the imagination.

David Stewart has observed that Watts was raising frustration to the highest: while Endymion awaits, never to receive the sexually animating power of Diana, the goddess becomes the victim of her own chaste, yet erotic, seduction of paralysed flesh. For Watts's imaginative style, this first *Endymion* had an exceptionally fine finish. Bought for six hundred pounds by the Glasgow collector William Graham in 1869, it was acquired ten years later by Sir Charles Tennant. Watts tackled the theme twice more, in a vertical format of 1893, and the more abstract visionary version of 1903 (No. 26).

***26.** *Endymion*, c.1869-1903
Oil on canvas
121.92 x 104.14 (48 x 41 in)
Watts Gallery

Having laid in the canvas in 1869-70, Watts left the larger *Endymion* untouched for some thirty years. He returned to it again at the age of 86, and in 1903 gave it a more ethereal finish. The picture was seen by Chesterton as 'the very soul of Greece. It is simple; it is full and free; it follows great laws of harmony, but it follows them swiftly and at will; it is headlong, and yet at rest, like the solid arch of a waterfall. It is a rushing and passionate meeting of two superb human figures.' Watts exhibited this mystical *Endymion* at the New Gallery within months of his death in 1904.

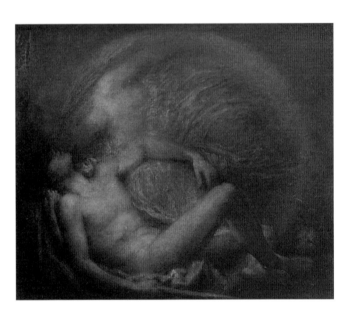

27. *The Genius of Greek Poetry*, c. 1856-78
Oil on canvas
66.04 x 53.34 cm (26 x 21 in)
Watts Gallery

Begun soon after Watts's return from the Aegean Sea, *The Genius of Greek Poetry* is a visionary anthropomorphic study symbolizing the Greek mind, expressed in the two colours most prevalent in nature – yellow forming light, and blue atmosphere. Watts imagined the Greek gods to be larger and more beautiful than human beings – 'born in the light and created out of the material formed by the delight the Greek took in external conditions'. In the islands he had observed 'all that is most exquisite in nature', the harmonies that had stirred Homer and Pheidias and, he believed, 'may well account for the birth and development of the divine faculties. The graceful mythology of the Greeks … was the outcome of constant communion with such loveliness.' (MSW, 1912, III, pp. 50-51).

Here, the contemplative figure on the rocks is inspired by the forces and phenomena of nature, passing in a vision before his eyes. Developed from the Pheidian figure of *Dionysos* (then believed to represent Theseus), he appears more engaged than Achilles in a similar pose in the mural Watts executed for the Marquess of Lansdowne at Bowood in 1857-58. The stream of nymphs from *Titans* also reappear in the small *Island of Cos*.

When Watts exhibited *The Genius of Greek Poetry* at the Grosvenor Gallery in 1881, critics were mystified. Only *The Art*

Journal offered an oblique compositional comparison with Charles Gleyre's contemplative figure in *Illusions Perdues* at the Musée du Luxembourg in Paris. Watts's assistant Emilie Barrington explained its broad significance in the catalogue to his retrospective exhibition at the Metropolitan Museum of Art in New York:

> The prominence humanity held in the Greek mind, the association of the effects in nature, and the entire conditions in the world with humanity being so strong that all effects and moods of nature weave themselves in his imagination into semi-human existences; the winds and currents, the hours of the decay, the earth, sea, and air, all natural phenomena he invests with human forms, attributes, and mood.

Watts also painted a darker *Genius of Northern Poetry*.

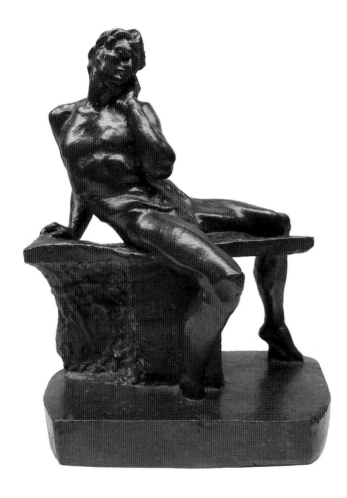

28. *Study for The Genius of Greek Poetry*, c. 1856-57
Bronze
30 x 24 cm (11 ½ x 9 ½ in)
Watts Gallery

For the figure of *The Genius of Greek Poetry*, Watts, adapting the Parthenon figure of Dionysos, made a wax model and cast it in bronze – presumably, for future reference. In the painting itself, the figure appears to be more alert, concentrating on the vision passing before his eyes.

29. *Island of Cos*, 1869
Oil on canvas
27 x 53.5 cm (10 ½ x 21 in)
Private Collection

Worked up from tiny watercolour sketches of the island of Cos (usually spelt 'Kos' today), sketched aboard H.M.S. *Desperate* as the artist began the return voyage, after witnessing the excavation of Halicarnassus in June 1857. This mirage-like seascape was just as mystifying when it was exhibited at the Dudley Gallery in 1868-69. The nymphs massing below the sea recall the contemplative giants from *Chaos* and *Titans* and may refer to the foundation of Greek mind.

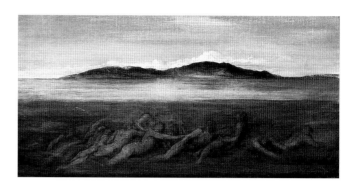

30. *The Island of Cos*, 1883
Oil on canvas
86.5 x 112 cm (34 x 44 in)
Private Collection, Courtesy of Christie's

The larger, more mystical picture of *The Island of Cos*, was completed fourteen years later, when Watts was exploring atmospheric light effects. Highly symbolic, it contrasts the inevitable demise of man's achievement – the foreground ruins – with the greater timelessness of nature and the human soul. On 27 December 1883, Watts explained the picture to its purchaser James Mirrlees, the Glasgow civil engineer that he had no wish to be didactic, that he was compelled to offer more than a beautiful painting and that without the suggestive element, art was, in his view, defective:

> In my picture *The Island of Cos* the unchanging serenity of sky & sea, – unchanging & eternally serene as far as human influence extends – is in contrast with the decay of human efforts in the visible destruction of their triumphs – The butterfly hovering over these ruins is the emblem of that undying part of humanity which the religious enthusiast (no matter of what creed) & the philosopher alike may

accept – However little we may be able to certify respecting the spiritual side of man's nature, & however little he may be satisfied with any explanations of the unknown that have been put forth, a bare materialism does not recommend itself to me – I think the artist & the poet (I ought to have put the poet first, unless they are one & the same) may be allowed to dream. (MSW Cat. S. 79c and NPG, XII, 6.)

The butterfly, as the symbol of the soul, would reappear in Watts's painting of *The Open Door* (1888, South London Art Gallery). His interest in the colour of J.M.W. Turner's later work is evident in *The Island of Cos* and in his visionary mountainscape of *Carrara, from the Leaning Tower of Pisa*, painted on silk in 1881 with tints that become a celebration of blue as the mountains rise, grand and remote, over the horizon. In place of the ruins and butterfly, a vine, symbolizing Immortality, and lizard, the attribute of logic lie on a foreground marble slab representing the Carrara quarries.

31. *Study for Olympus on Ida*, 1872
Ink wash
15.5 x 10 cm (6 ½ x 4 in)
Watts Gallery

*32. *Study for Olympus on Ida*, 1872-79
Oil on canvas
64.77 x 53.34 cm (25 ½ x 21 in)
Watts Gallery

The arrangement of the curtain folds above the bed where Watts lay recovering from a hunting injury in November 1872 gave him the idea for a triple nude ensemble, which he was to develop into two poetic compositions of the goddesses Pallas, Juno and Venus. Referring to drawings from the statuesque maid Long Mary, and with Madeline Wyndham as model for the face and shoulder studies, he began the first in December 1872. Ultimately named *The Judgment of Paris* [Watts constantly renamed both versions], this key study of the nude seen from the front, side and behind, in the landscape setting of Mount Ida, was exhibited at the Deschamps Gallery in London in 1876 and at the 1878 Exposition Universelle in Paris and was much admired by the French. The critic Ernest Chesnau, subsequently hailed Watts as the only English painter to treat the female nude simply from the point of view of style, 'with no other object than to realise its purely plastic beauty'.

In the celestial setting of *Olympus on Ida*, the goddesses present themselves, with bodies facing forward to the invisible Paris – the viewer – closer in design to the curtain folds that inspired the idea. Watts was so taken with the opalescent quality of his first sketch for this grouping that he left it unfinished. Noted by Joseph Comyns Carr in the French periodical *L'Art* for 'the abstract simplicity of style' – a controversial aspect of Watts's Symbolist works – the sketch was reviewed by *The Athenaeum* on 11 January 1879: 'They stand in an atmosphere of mist, which seems to shimmer, while golden light pulsates through it between the great dames and the spectator, thus becoming a magnificent veil, which is not the less effective and impressive, because its margins are tinged with purple and merged with the cooler outer air.' In the sketch and the larger finished version exhibited at the Grosvenor Gallery in 1887, Aphrodite is seen standing on the right where the lustre is strongest, with light interwoven through her golden hair and shimmering down her legs. Beside her is the grand figure of Pallas Athene, who appears to be wearing a crown and on the left is Hera, the proud, chief goddess of Olympus.

Watts explained to William Moss, who purchased the large picture in January 1890: 'I have tried to express without attributes the different characteristics of the Goddesses, & by the qualities of surface to suggest a certain sense of the celestial purpose accompanying them.'

33. *Europa*, early 1860s, reworked late 1890s
Oil on canvas
66.04 x 52.07 (26 x 20 ½ in)
Watts Gallery

The dual forces that increasingly interested Watts are combined in the brutal beauty of Jupiter and the contented, but fearful Europa, whom he is carrying off to Crete, where, as the glint in his eye suggests, he is about to ravish her. Mention of her flying drapery in Ovid's *Metamorphoses* gave the artist free reign to explore the luscious arrangement of folds that characterized his imaginative work. Richard Jefferies draws attention to Watts's use of earth colours here. The more finished version at The Walker (National Museums Liverpool) was the original design.

Fig. 18
The Judgement of Paris, 1872-74
The Farringdon Collection
Trust

There can be no great art that has not for its religious basis sun-worship. It is by the sun's influence that we live and breathe and have activity, in fact life!

34. *Clytie*, c. 1867-78
Marble
71.1 x 60.96 x 43.18 cm (28 x 24 x 17 in)
Guildhall Art Gallery

Watts had barely finished his first large-scale sculpture when he embarked on a ground-breaking bust of the impassioned water nymph Clytie. Spurned by Apollo, she twists back to face the sun god and begins to metamorphose into 'a flower like a violet'. Watts had painted his bride and muse Ellen Terry clutching these to her heart in *Choosing*, and in 1865, after they parted, he had painted a picture of *Clytie*.

Aspiring to enliven modern sculpture, Watts turned his back on the cold neoclassical style of contemporary sculpture, and modelled a bust of *Clytie* in clay. The nymph writhes in massive Michelangelesque *contrapposto*. She has none of the repose, even, of Greek sculpture. To achieve vigorous muscle tension, Watts hired the Italian model Angelo Colarossi, made studies from a current sitter Louise Lowther for the nymph's coiled hair; her head, breasts and posture were taken from Long Mary, and the infant Margaret Burne-Jones twisting and turning in her mother's arms supplied the straining pose that pushed the parameters of classicism. On 3 December 1867, the speaker of the House of Commons, John Denison wrote that seeing the bust in Watts's new sculpture studio – a draughty greenhouse, had moved him to reread Ovid.

For this marble version of *Clytie*, Watts rented studio space from the sculptor George Nelson at 8 Ravens Place, off the new Goldhawk Road in Hammersmith. He selected an unusually fine white block without blemish or stain, and broke up the surface into innumerable facets to produce 'a better effect of atmosphere and a more palpitating quality of surface than chiselling the form with more direct touches'.

At the same time Watts was transforming the Oxford bust into a painting of *The Wife of Pygmalion*, which he exhibited with the unfinished marble *Clytie* at the Academy in 1868. Aware that this was unlike other sculpture of the day, he asked Gladstone's opinion of her, and outlined the qualities he aimed to achieve:

Flexibility, impression of colour, & largeness of character – rather than purity – gravity, – qualities I own to be essentially necessary to sculpture but which being made as it seems to me exclusively the objects of the modern sculptor have deadened his senses & some others making part often of the glories of ancient Art, & resulted in bare & cold work.

Emilie Barrington, Watts's assistant, observed that, 'he felt his own genius stronger, more peremptory, when influenced by sensuous qualities, by enthusiasm for colour and for the form which produced on him, as on the Greeks, an aesthetic feeling of delight beyond the cold, merely intellectual approval'. As she pointed out, his enthusiasm while chiselling marble, was infectious. This clearly affected the poet Algernon Swinburne, who had been sitting for his portrait and he reviewed the bust in Notes of the Royal Academy Exhibition 1868:

Never was a divine legend translated into diviner likeness. Large, deep-bosomed, superb in arm and shoulder, as should be this woman growing from flesh into flower through a godlike agony, from fairness of body to fullness of flower, large leaved and broad of blossom, splendid and sad, yearning with all the life of her lips and breasts after the receding light and the removing love – this is the Clytie indeed whom sculptors loved for her love of the Sun their God. The bitter sweetness of the dividing lips, the mighty mould of the rising breasts, the splendour of her sorrow is divine …We seem to see the lessening sunset that she sees and fears too soon to watch that stately beauty slowly suffer change and die into flower, that solid sweetness of body sink into petal and leaf. Sculpture such as this has actual colour enough without need to borrow of an alien art.'

Edmund Gosse in his seminal reassessment in *The Art Journal* in 1894, placed Watts's *Clytie*, 'that swallow of 1868 … with the veracious texture of its flesh ... as 'the true forerunner' of the innovative, naturally expressive, New Sculpture Movement.·

The marble *Clytie* was widely exhibited, notably at the 1878 Exposition Universelle in Paris, lent by the Rt Hon W. F. Cowper-Temple MP. Various bronze casts were taken from the clay model – (Tate Britain, Watts Gallery, and George Eliot owned one) and there are two other marble busts, not carved by Watts, but by an assistant, at least one by Nelson.

35. *Study for Clytie*, c. 1865
Sanguine and Charcoal, heightened with white chalk
31 x 25.5 cm (12½ x 10 in)
Watts Gallery

36. *Study for Hyperion*, c. 1855
Sanguine and charcoal on paper
51 x 37 cm (20 x 14½ in)
Watts Gallery

A study of Arthur Prinsep as Hyperion, a Titan of light and early sun god.

Gordon and her daughters Alice and Georgina, of whom the artist was particularly fond. Watts gave the picture to Georgy and signed and dated it in 1849. The image reappeared in one of his frescoes of *The Elements* (1853-56), for Earl Somers; and the artist readdressed the theme in 1865, painting a picture closer in style to Rembrandt (The Walker), when he was advising and sat to the photographer Julia Margaret Cameron for No. 36.

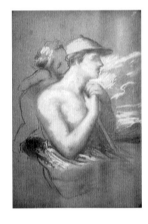
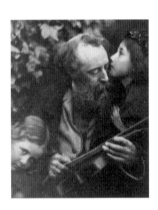

37. *Fear*, c. 1835-36
Charcoal on brown paper
50.5 x 44.5 cm (20 x 17 ½ in)
Watts Gallery

At the age of ten, George Watts made two dynamic drawings on the subject of Fright, a head study from the engraving by Jean Audran from Charles Lebrun's *Espressions des Passions de l'Âme* of 1727, and an allegorical figure study after an engraving from Sir Peter Paul Rubens' *The Peace at Angers* in the Marie de' Medici series (1621-25, Louvre, Paris). His father's sudden rages of frustration as he struggled to invent a musical instrument that would combine wind and string terrified the young George Watts, causing permanent damage to his nerves. Mr Watts had now fallen into debt, and his son helped support the family through portraiture.

In contrast to his earnest Romantic-style self-portrait painted at the age of seventeen (1834, WG), Watts roughed up his straggly hair, and, with the aid of a looking-glass, adopted the open-mouthed expression and furrowed brow of Caravaggio's *Medusa* (c.1598, Galleria degli Uffizi, Florence) to create an astonishing self-portrait symbolizing *Fear*.

38. *Study for The First Whisper of Love*, 1846
Blue and red chalk, heightened with white, on board
42 x 29 cm (16 ½ x 11 ½ in)
Private Collection

In the format of Rembrandt's *The Evangelist Matthew Inspired by the Angel* (1661, Louvre, Paris), this study for *The First Whisper of Love* (1846, Santa Barbara Museum of Art) and was drawn at the Villa Careggi, where Watts was joined by Lady Duff

39. Julia Margaret Cameron, *The Whisper of the Muse*
1890s print after the albumen print of 1865
13 x 10 cm (5 ½ x 4 in)
Watts Gallery

Watts first met Julia Cameron's sisters in the winter of 1849. From January 1851 he lived as a tenant of her sister and brother-in-law Thoby and Sara Prinsep at Little Holland House in Kensington, where he painted portraits and symbolic frescoes featuring her family. Like her sisters, she was devoted to an eccentric idea of beauty. Their rich flowing robes and shawls that combined modern Parisian art with draperies of the High Renaissance and the Orient, foreshadowed the Aesthetic Movement.

When Cameron took up photography in 1864, she turned to Watts for artistic guidance, gave him albums of her earliest photographs and sent batches of prints for his criticism, which he gave frankly. Her diffused focus and broad modelling of form and colour through light, shadow and tone was comparable to the abstract technique of his symbolic pictures.

Cameron hero-worshipped Watts. She persuaded him to sit many times to her lens and registered eleven images of him. His collaboration in her quest to emulate High Art 'combining the real & ideal & sacrificing nothing of Truth by all possible devotion to Poetry & *beauty*,' resulted in one of her best-loved images. (Letter to Sir John Herschel, 31 December 1864, quoted in Ford, 1975, pp. 140-41.)

In April 1865, at Cameron's home in Freshwater on the Isle of Wight, Watts posed with his violin and two young neighbours for *The Whisper of the Muse*. The instrument is central to the photograph and suggests the musical harmony underlying his art. So thrilled was the photographer at having created poetic images worthy of her 'divine' artist that she inscribed the prints '*The Whisper of the Muse* – A Triumph!'

40. *Study for a fresco of The Elements*, c.1853-54
Sanguine
19.5 x 13 cm (7 ½ x 5 in)
Watts Gallery

In autumn 1853, in preparation for the Lincoln's Inn and
Palace of Westminster frescoes, Watts travelled to Venice
and Padua. While the courts were sitting on his return, he
embarked on a further large-scale project, a series of large
frescoes of *The Elements* in the drawing rooms of the Earl
Somers's London residence, 7 Carlton House Terrace. Watts
originally proposed to enlarge designs by Louisa,
Marchioness of Waterford because opportunities for female
artists were rare, and he wished to promote her
'transcendent talent'. But the earl, who supported his
imaginative ideas when the public turned the other cheek,
wanted Watts to paint them himself. *The Elements* are infused
with the full range of Wattsian influences – flying
Titianesque figures, elegant Phidian form, monumental
Michelangelesque groups, and his own sculpturesque form
and ideas for the cosmic *House of Life* fresco scheme.

41. *Watchman, What of the Night?* 1863-64 (illus. p. 12)
Oil on canvas
64.77 x 52.07 cm (25 ½ x 20 ½ in)
Private Collection

The teenage actresses Kate and Ellen Terry were brought to
Little Holland House by the dramatist Tom Taylor in 1863 and
sat for a double portrait. Kate, a leading lady on the London
stage, recognized her younger sister's growing affection for
Watts, and gave up sitting. Ellen Terry had devoted her young
life to the theatre. Earlier that year the designer Edward
Godwin had created a daring Greek *chiton* for her role as Titania
and roused her interest in the beauty of design. Her excitement
at his art elicited an enthusiastic response from Watts. Ellen
became his muse and learned from his imaginative thoughts to
develop her skills for High Art, performing for his brush with
the intensity she gave to the stage.

She posed for this visionary picture, initially as Joan of Arc.
Armour, whose heroic and chivalrous qualities fascinated Watts,
featured in many of his visionary works, most recently in *Sir
Galahad* (No. 75). Ellen stood for hours in the heavy suit. So
intent were the artist and actress that both were taken by surprise
when she fainted against his arm. (The accidental dab of carmine
over her heart was left on the canvas to remind himself to be
more considerate.) Her illuminated face, blue eyes, breastplate
and the strands of her hair suggest an inner vision. Giving the
picture a new title, *Watchman, What of the Night?*, she is now seen
as Isaiah's watchman in his vision of the fall of Babylon; her
hands pressed to her breastplate, she elicits an ambiguous
response – 'The morning cometh, and also the night: if ye will
enquire, enquire ye: return, come.' (Isaiah 21: 11-12.)

The picture remains unfinished. Watts married Ellen Terry
on 20 February 1864. They parted within months, leaving a
remarkable legacy of their brief marriage in art. *Choosing* (Fig.
10), painted in jewel-like almost Pre-Raphaelite intensity, shows
Ellen in her bridal gown, attempting to smell an exotic scentless
camellia, symbol of worldly vanities – the theatre – while she
clutches to her heart a small bunch of fragrant violets that
symbolize Innocence and Love. Even today the bloom of her
skin is palpable. Her charisma spurred her husband to produce
outstanding paintings, and her face features in some of his
most important visionary work, *Eve Tempted* (prime version, c.
1872-85, Tate Britain) and *Love and Life* (No. 96). As Watts's
assistant, Emilie Barrington, recorded: 'In *Watchman, What of the
Night?* … it was not Isaiah, but the dramatic genius of his sitter
influencing the artist's imagination in a psychic manner, which
made the work what it is, a quite inspired creation.' (Barrington,
1905, p. 35).

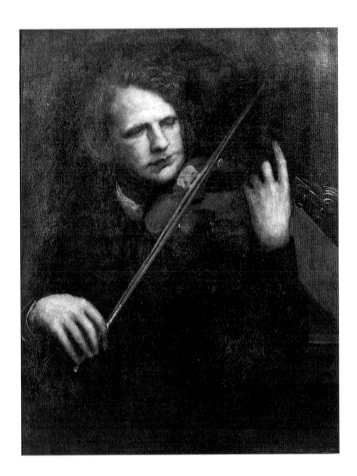

42. *Miss Violet Lindsay*, 1880
Oil on canvas
66.04 x 53.34 cm (26 x 21 in)
Watts Gallery

Marion Margaret Violet Lindsay, the future Duchess of
Rutland, and herself an artist, can also be seen as Watts's muse
in that she inspired to infuse her portraits with a sense of
mystique. She modelled for various symbolic works: in armour
as a knight *Rehearsing a Tableau* (the picture was afterwards
renamed *Joan of Arc*), draped in purple as *A Reverie* and for *The
Court of Death* (No. 102). Her father, Colonel Lindsay, moved
by the poetry of this portrait, asked Watts to leave it at this
stage. He used it as a study for a symbolic painting in armour,
later entitled *Joan of Arc*, and began again the famous study in
blue and gold of Violet Lindsay, to which he attached John
Keats's sonnet 'Blue! 'Tis the life of heaven'. In her Prussian
blue dress that fell in soft folds, her golden hair contrasting
with the distant mountains and azure sky, Violet was seen as
the Spirit of Womanhood. The Belgian Symbolist Fernand
Khnopff reviewing the opening exhibition of *La Libre
Esthéthetique* in Brussels in 1894 hailed the picture as 'a superb
jewel ... a harmonious *ensemble*, of a richness without parallel.'
(Khnopff, 1894, III, p. 32).

43. *A Lamplight Study: Herr Joachim*, 1865-66
Oil on canvas
91.44 x 68.6 cm (36 x 27 in)
Watts Gallery

Watts sought to infuse his imaginative paintings with a sense of
musical harmony. Brought up above his father's musical
instrument workshop, he played the violin himself only
moderately well, but loved listening to music. The finest
musicians of the day used to perform at the Little Holland
House salon.
 One evening as Joseph Joachim (1831-1907) was playing in
the lamplight, Watts painted a picture of the Hungarian violinist
absorbed in his music. From the position of his left hand and
two raised fingers we sense the vibrato; and the hairs of his bow
are splayed indicating pressure, the bow moving over the strings.
We can almost imagine the sound of music, as Watts intended in
his symbolic paintings. The lamplight study of Joachim, disliked

for the low colour tones at the Royal Academy in 1867, was
exhibited internationally at the Paris Exposition Universelle in
1878, the Metropolitan Museum in New York in 1884-85 and at
the Universal Exposition in St Louis in 1904.
 Cosima Wagner's response to the portrait is interesting and
reflects Joachim's criticism of the anti-semitism of her husband,
the composer Richard Wagner: 'I can read the whole biography
of this thoroughly bad person in this picture; that is not what the
painter intended, but it is the very thing which reveals his talent
– that he has depicted the truth without realizing it! Indeed, by
trying to express something splendid.' (Gregor-Dellin and Mack,
1978, I, pp. 962-67).

44. *Orpheus and Eurydice*, c.1868-72 (illus.p.30)
Oil on canvas
65 x 38 cm (25½ x 15 in)
Watts Gallery

Musical spirit pervades this more visionary version of *Orpheus
and Eurydice*, which Watts exhibited at the Dudley Gallery in
1872. As a chiaroscuro nude study, it presumably preceded the
clothed full-length painting of similar size (Aberdeen Art
Gallery and Museum) completed that year, and is very different
from no. 21. The figures are stretched out, and as in all full-
length versions, Eurydice's arm has dropped down, her upper
body has fallen further back and Orpheus's arm is around her
waist rather than her breast. Even in this monochrome version,
Watts conveys emotion and achieves a dynamic contrast
between the living and the dead, throwing moonlight down
Eurydice's silvery body and deepening the body colour of
Orpheus, who still holds his lute. Shadows heighten the sense
that he cannot save his wife, that she is slipping back to
oblivion. In the final full-length version (Salar Jung Museum,
Hyderabad), he has dropped the instrument and there is more
space between his body and hers.

To Watts, to Aesthetic and Symbolist painters, music was the supreme art and conveyed profound emotion through its form. Orpheus almost defeating death twice by his music; at the end of his story, his severed head floats on the river and he continued to sing thus becoming a metaphor for the power of art and the immortality of artistic creation. Among artists who treated the theme of Orpheus are Rossetti, Burne-Jones and Leighton, Waterhouse, Deville, Moreau and Redon, the last three chosing to portray the severed head. HU and VFG

45. *Study for Orpheus*, 1868-72
Plaster
44 x 29 x 29 cm (17 ½ x 11 ½ x 11 ½ in)
Watts Gallery

The figure originally modelled in wax or clay and then cast in plaster relates to the full-length versions of *Orpheus and Eurydice*, of which there are five of various sizes from 1872-1903. The movement and tension, remarkable in so small a figure, is characteristic of Watts capturing the extreme moment of the subject. RJ

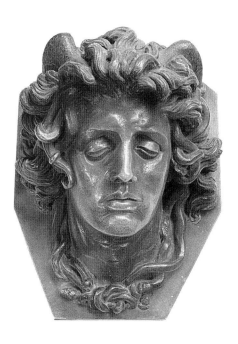

46. *Medusa*, 1871-73
Alabaster
54 x 44 x 37 cm (21 ½ x 17 ½ x 14 ½ in)
Watts Gallery

Having recently painted *The Wife of Pygmalion* (No. 20), Watts returned to the obverse theme, *Medusa*, the serpent-haired Gorgon who turned beholders to stone. He and his assistants now carved two heads, the first (1871-73), for his Manchester patron Charles Rickards, was of fine marble. 'We have been most lucky in the marble having a really beautiful bloom', he wrote to Rickards on 2 July 1871. At the time Watts was carving a memorial to Bishop Lonsdale (1869-71) in alabaster, for Lichfield Cathedral. Enchanted by the colour and texture of the alabaster, he stained the marble to emulate these qualities, and considered sculpting *Clytie* in alabaster. Instead he carved the monument to Lord Lothian (c1870-78, Blickling Church) and this head of *Medusa* in the medium. More Italianate in style, the carving of the hair is similar to that of Lord Lothian.

In the *Fortnightly Review* (November 1869), Walter Pater had discussed the Leonardo *Medusa*, to which Watts's early

heads (nos. 4 and 5) related. Swinburne had drawn attention to Rossetti's drawing *Aspecta Medusa* (1865, City Museums and Art Gallery, Birmingham) and William Morris revived the story of Perseus in poetry in *The Earthly Paradise* (1868-70).

47. *Ophelia*, c1863-78
Oil on canvas
76.2 x 63.5 cm (30 x 25 in)
Watts Gallery

Ellen Terry, chosen for her first Shakespearean speaking role at the age of eight, posed for Watts as Shakespeare's deranged maiden, *Ophelia*, peering down through the branches of the 'willow growing aslant a brook' from which she falls to her death. As originally painted, *Ophelia* bore a striking resemblance to the actress. 'It struck me as one of the loveliest surprises I have ever seen in art. It haunted me for days, the individuality was so strong, the poetry in it so tender', Emilie Barrington recalled. Watts, who habitually took up pictures years after he had begun them, reworked *Ophelia* in the 1870s. Idealizing the figure, he radically altered the painting which he exhibited at the Grosvenor Gallery in 1878. This is a very different image from the Pre-Raphaelite paintings of Ophelia, notably Millais's famous painting of Lizzie Siddal as the drowning maiden (1851-52, Tate Britain), Arthur Hughes's picture of Ophelia by an oak tree (1863-64) Manchester City Art Gallery)and Rossetti's group painting (1864, Oldham Art Gallery).

Although Watts had lived apart from the actress for many years, their divorce was not finalized until 13 March 1877. When she joined Henry Irving's company, appearing as Ophelia at the Lyceum in December 1879, which ran for a triumphant 100 performances, Watts sent Ellen a drawing he had enlivened from a Window and Grove photograph of her in the rôle. (Barrington, 1905, pp. 35-36; Cheshire, 1989, p. 47.)

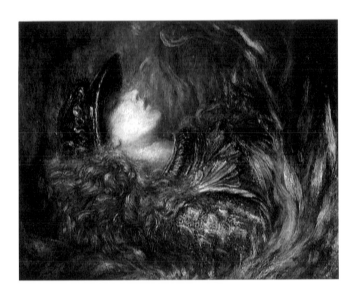

48. *Brunhild,* c.1880
Oil on canvas
66.04 x 53.34 cm (26 x 21 in)
Leighton House Museum

Watts found the music of Richard Wagner as imaginative and spiritually uplifting as the poetry of Tennyson. His opera cycle, *The Ring of the Nibelungs,* (1848-74) was taken from the medieval German epic poem Nibelunglied, in which Brunhild is the warlike queen of Iceland; her father, the god Wotan places her asleep on a mountaintop surrounded by fire, from which she is rescued by Siefried. Watts's painting of *Brunhild* foreshadows artists of the Art Nouveau, in that her hair appears to merge with the flames that almost engulf her. The French poet Stéphane Mallarmé's description of Wagner's music – 'An absolute which is at last understood emerges from the retreating waters; it is like a mountain peak which stands isolated and glittering in all its brilliance' – could be applied to Watts's visionary painting, but above all, to his statue, *Physical Energy.*

Fundraising for his honeymoon in 1886, he sold the picture to Emilie Barrington, who wrote that the subject struck Watts one dark winter afternoon when they were sitting by the fire, her green velvet hat suggested the helmet and facial shadow. *Brunhild* was exhibited at the Guildhall in 1895 and at the St Louis World's Fair in 1904 (MSW diary, 2 August 1891; Barrington, 1905, pp. 36-37 and 165)

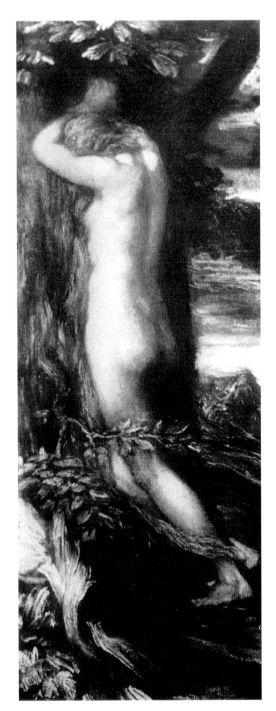

49. *Eve Repentant,* 1868-1903
Oil on canvas
251.46 x 114.3 cm (99 x 45 in)
Watts Gallery

Eve Repentant is the third in the Eve trilogy, representing stages of human life – creation (No. 15, *She Shall be Called Woman*), awareness of the senses (*Eve Tempted*) and remorse indicating conscience, 'the supreme spiritual force' (*Eve Repentant*), which Watts addressed in *Dweller in the Innermost* (Fig. 4). Watts explained to his patron Charles Rickards on 6 June 1873, that the trilogy was part of an epic from Genesis, designed to hang together in public with *The Creation of Eve* (No. 14), *After the Transgression* (renamed *Denunciation of Adam and Eve,* Private collection). Only small versions were available for sale. The later large *Eve Repentant,* laid in by W. E. F. Britten in May 1889 was given to the nation (Tate Britain).

On 2 March 1893, Léonce Bénédite, in search of foreign artworks, for the Musée Nationale du Luxembourg in Paris selected *Eve Repentant* and *Love and Life* (see No.96). In the event he chose the latter. He admired the English school of art, of which he considered Watts to be the head. Seeking to achieve the sentiment of power and meakness, Watts worked on *Eve Repentant* for much of 1893; from 6-11 February, he refreshed his knowledge of form by studying from a model, Mrs Stephenson, in particular for the arms and hands of *Eve Repentent.* He worked on this painting well into his eighties. On 4 August 1903, a visitor was surprised to find him on the top of the studio steps hard at work on *Eve Repentant.*

Watts refused to have the picture engraved because his idealized treatment of the nude – from studies of the attenuated, almost androgynous form of 'Long Mary' – was not popular in England. Knowledge of anatomy, classical sculpture and a strong visual memory, enabled him to work away from the living model. He liked to distort the figure for expressive effect. Eve's abject shame is conveyed by a head bowed below what is realistically plausible. HU and VFG

50. *Paolo and Francesca*, c.1872-84 (illus. p. 28)
Oil on canvas
152.4 x 129.54 cm (60 x 51 in)
Watts Gallery

In the fifth canto of the Dante's *Inferno*, the adulterous lovers Paolo Malatesta and Francesca da Rimini, were condemned to the second circle of hell where they are doomed to be buffeted in a whirlwind for eternity: 'Th'Infernal hurricane, that knows no sleep, / Propels the spirits with its ruinous force, / Whirls, smites, torments them in its reckless sweep.' Watts first painted *Paolo and Francesca* in fresco in Italy (c.1845, Victoria and Albert Museum), seated and embracing, in a similar pose to Dante Gabriel Rossetti's later watercolour of 1862 (Cecil Higgins Art Gallery, Bedford). Watts's subsequent easel paintings depicted the lovers in hell, the first, probably painted at the Villa Careggi, was exhibited at the British Institution in London in 1848 (Private collection).

This final version of *Paolo and Francesca,* painted largely between 1872 and 1875, was first exhibited at the Grosvenor Gallery in 1879, at the 1883 exhibition of International Art at the Georges Petit Gallery in Paris, where the painting was seen to suggest 'a passion too strong for death', and at Watts's solo exhibition at the Metropolitan Museum of Art in New York in 1884. Widely recognised as one of his masterpieces, it was hailed by the *Art Journal* described it as 'one of the master's crowning achievements'. (*The Art Journal* 1882, p. 62.)

The works of Dante, with their sublime and extreme themes, were rediscovered as sources of inspiration throughout Europe in the late eighteenth and early nineteenth centuries by artists of the Romantic Movement. The dramatic story of Paolo and Francesca's forbidden love became a favourite topic for pictorial treatment. Of the many artists who depicted the lovers in hell, the French academic painter Ary Scheffer may have inspired Watts's composition, though all owe a debt to Flaxman.

Watts was at home in the presence of married women in the households of Lord and Lady Holland in Florence, and of Thoby and Sara Prinsep in Kensington. The models for Francesca in the first and last paintings are of married women. Virginia Somers was the face for the present version of *Paolo and Francesca*. In 1850 Watts had felt a romantic attachment to Virginia Pattle, but she married Viscount Eastnor, the future Earl Summers. Here the Countess is seen as Dante's guilty lover, cradling Paolo, an idealized projection of the artist's younger self.

The model for the first painting of Francesca, appears to have been inspired by the sensual Marianne Ricci, who married Count Walewska in June 1846; it has been suggested that the model for the second was Watts's teenage bride, but the features are not those of Ellen Terry. The third version shows the model Marie Ford, from whom Rossetti also painted. In this final version where the figures have a more death-like pose and pallor, Watts may have been exploring the theme of the continuance of love after death. Whereas in the first three paintings, Francesca is nude, or virtually nude, in this final, visionary version, her *mouvementé* drapery, which Watts developed to focus attention on the face, heightens the deathly effect and the sense of floating in the Inferno. As one critic observed, 'we feel the change that death has wrought, a change that gives tranquillity alike to passion and to pain, and … the solace of reunion.' (Dante's *Inferno,* Canto V, Cercio II, pp. 31-33; Loshak, 1963, pp. 476-85; Franklin Gould, 2004, ch. 2; Minneapolis, 1978, p. 86, cat 28.) HU

51. *Thetis*, 1866-93
Oil on canvas
192 x 54 cm (75 ½ x 21 ½ in)
Watts Gallery

In Greek mythology, Thetis was a sea nymph, the wife of Peleus and the mother of Achilles. In 1858, Watts had painted a narrative fresco from the story of Achilles for the Marquess of Lansdowne at Bowood in Wiltshire, *Achilles Watching Briseis Led Away from his Tents* (WG). By the mid 1860s, when Watts painted *Thetis,* his ideas were more influenced by the ideals of aestheticism. The mood of the painting is sensuous. The classical title links to the background seascape, recalling Watts's travels in the Aegean Sea in 1855-56, when he joined Sir Charles Newton's expedition to excavate Harlicarnassus. The voyage inspired many mythological and landscape paintings in the 1860s. The length of time between the journey and the finished works suggests that they owe as much to the reappraisal of classicism which took place in aesthetic circles in the 1860s than to their original geographical inspiration.

The *Thetis* exhibited here is a larger version of the painting which Watts exhibited Academy of 1866, part of the revival of interest in painting the nude instigated by Watts and Rossetti. The standing nude figure binding her hair derives ultimately from classical sculptural prototypes and their re-interpretation in the French neo-classical and academic traditions. The pose of the figure in a narrow upright format was used by Ingres in works such as *Venus Anadyomene* (1848, Musée Condé, Chantilly, France) and *La Source* (1856, Musée d'Orsay, Paris)*,* which Watts may have seen in Ingres's studio when he visited Paris in 1856, and certainly saw it at the 1862 London International Exhibition. Watts's composition in turn inspired other British aesthetic movement painters such as Albert Moore, whose *A Venus* (York City Art Gallery) was shown at the Academy in 1869. Watts's idealized treatment of the human figure, taken from his studies from the elongated body and limbs of 'Long Mary' was emulated by the aesthetic painters of the day. A drawing for *Thetis* inscribed 'Miss Smith' indicates that her face was taken from Ellen Smith, a Chelsea laundry maid who also posed for Rossetti. Watts's paintings of the nude in the 1840s derive from traditions of painting which can be traced back through Etty to seventeenth-century painters such as Rubens. His different approach in the 1860s must owe much to the problems of reviving the nude in a different and more sensitive cultural climate. The vertical format appears to ennoble and purify the figure beyond sexual desire. Inviting association with architectural form, it exemplifies the 'sensuous intellect', the Greek perception of the human figure favoured by the eighteenth-century German art historian Winckelmann. HU

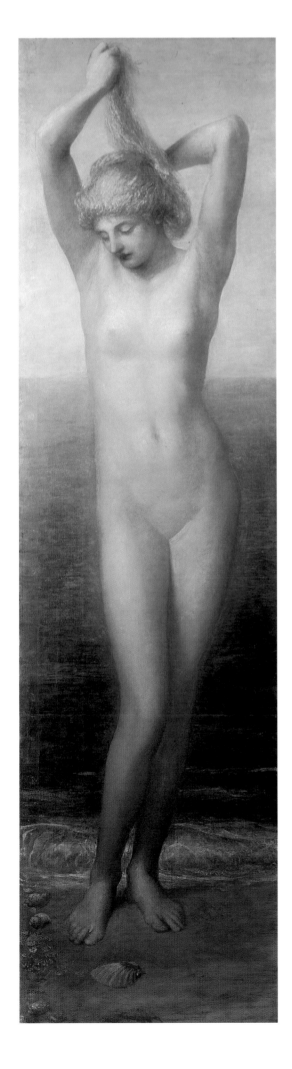

52. *Uldra*, 1883-84
Oil on canvas
99 x 86 cm (26 x 21 in)
Watts Gallery

In ancient Scandinavian mythology Uldra was a fairy who was half seen through the rainbow of mist and spray above a waterfall. Watts's opalescent vision of *Uldra* was painted in tints no deeper than those of a nautilus shell, at a time when he was experimenting with atmospheric effects, produced by broken prismatic colour. The face of *Uldra* was inspired by Dorothy Dene, the model and muse of Lord Leighton. Although the format is conventional, the technical effect was revolutionary in England.

Inspired by the sensuous half-length figures developed by Titian and the Venetian school, nineteenth-century painters of the Aesthetic Movement, led by Rossetti and Watts gave the genre a new artistic importance and vitality, returning in the 1860s. Among Watts's contributions were *A Study with the Peacock Feather* (Fig. 3), *Clytie* (c.1865, WG), *The Wife of Pygmalion* (No. 22) and *The Wife of Pluto* (No. 70) *Uldra* is a later innovation within the tradition. The symmetrical composition, the lack of emphasis on sensuality and the intricate and subtle colour etherealize and spiritualize the figure.

At the Grosvenor *Uldra* was noted by critics: for her 'exceeding fairness, delicacy and grace might well fire the eye … The beauteous vision, albeit garments of man-made fabric she has none, nay nor a skin of beast to enwrap her fair form, is yet clothed in a kind of ethereal haze'; and at Watts's retrospective exhibition at the Metropolitan Museum of Art in New York (1884-85), American critics were enchanted: 'Uldra, the genius of the painter is prismatic, many coloured, sounding the depths of human thought, rising to the heights of human aspiration, and holding the experience of the ages in the hollow of its hand.'

The head of *Uldra* appeared as Aphrodite, the most lustrous, right hand figure in Watts's key nude composition of the three goddesses in *Olympus on Ida* (Fig. 5), exhibited at the Exposition Universelle in Paris in 1889. The poetic ethereal quality of the painting is one that would be embraced by the European Symbolists, notably Fernand Khnopff in his studies of women in the late 1890s. HU

53. *Sunset on the Alps, A Reminiscence*, 1888-94
Oil on canvas
143.5 x 110.4 cm (56 ½ x 48 ½ in)
Watts Gallery

Watts's immediate inspiration for *Sunset on the Alps* was a powerful and particular visual experience. Fascinated by the effects of light, cloud and rock formation, Watts painted a series of contrasting images of the Alps following his European trip in 1887-88. He and his wife travelled up by rail from Aix-les-Bains in the south of France, towards Geneva, and as the train steamed into La Roche-sur-Foron the station at sunset, they were struck by the sight of crimson clouds towering over the giant mountain-tops. 'Suddenly, a line of snowy peaks blazed out upon a background of giant cumulous clouds. Before there was time for the least change to dim these glories, we were whirled away, still speechless with astonishment.' Watts depicted the scene on a golden ground. Mary Watts records on 8 May 1889 that the canvas was under way. He immediately captured the diamond glitter, the height and weight of the peaks, but, she lamented that the grey English winter had dimmed his impression. Without the glitter, however, Watts's composition of orange-red masses could be seen to relate to landscapes by the modernist French painter Paul Gauguin and the Nabis movement.

Sunset on the Alps was first exhibited at the Alpine Club in 1894, as *An Alpine Peak* and described as 'a reminiscence of a vision of one of the peaks of the Mont Blanc chain'. In choosing to translate this into an exhibition painting, Watts created a work which related in innovative ways to traditions and conventions of landscape painting. The compositional structures of most Victorian landscape paintings ultimately derive from conventions developed in the seventeenth century. Dividing foreground, middle ground and distance, they use horizon-breaking objects to frame or articulate the scene, draw the viewer's eye into the central distance and use human figures or indications of human presence as key features.

Watts's landscape is unusual and a symptom of this breakdown of tradition. It has an upright format, lacks a foreground, has a single, central mountain form overtopped by a cloud and lacks a human presence. Mountain scenes, particularly alpine scenes, grew in importance in the context of eighteenth-century tourism, became a staple of the Romantic sublime and continued in popularity in the Victorian period. They provide a partial context for Watts's painting, particularly in precedents for eliminating the human. However, although such diverse works as Francis Towne's *The Source of the Arveiron: Mont Blanc in the Background* (watercolour, 1781, Victoria and Albert Museum) and John Brett's geological *Glacier of Rosenlaui* (1856, Tate Britain) contain no figures, they represent foregrounds on which a notional spectator could stand, and their compositions of glacial valleys lead the eye back into space, whereas Watts represents the mountain as an almost heroic object. The two comparisons cited are topographical views. The golden towering cloud in Watts's painting suggests he intends an underlying metaphysical dimension, allying his work to the emotionally weighted landscapes of the Romantics. There may be a distant echo of the clouds overtopping the Alps in Turner's famous *Snowstorm: Hannibal Crossing the Alps* (1812, Tate Britain) which was available to Watts in the National Collection. It is tempting to relate the composition to that of Caspar David Friedrich's seminal altarpiece *The Cross in the Mountains* (1807-8, Gemalde Galerie Neuemeister Dresden) where a central crag backed by a sunburst suggests a divine presence in nature, although there is no indication that Watts was aware of this work.

Among Watts's varied Alpine views are *Sant' Agnese Mentone* (1888, Private Collection), in which Watts highlights the bony structure of the mountains in the south, *The Alps near Monnetier* in the Haute Savoie (1888-93, WG) and a cloud study 'glittering as silver with sapphire shadows' looking towards Mont Blanc.(MSW diaries, 7 and 20 May 1889, 15 and 22 October 1891; MSW, II, pp. 126-27.) VFG and HU

54. *The Two Paths*, 1903
Oil on canvas
76 x 63 cm (30 x 25 in)
Private Collection

The Two Paths was inspired by a vivid dream, in which the downward path left a terrible impression on Watts's mind, 'much darker than he cared to express in the painting'. By painting over and over again, Watts achieved what he called the 'breathing quality' in this dream landscape. (MSW, II, p. 313). Exhibited at the New Gallery in 1903, *The Two Paths* was purchased by Albert Wood, to whom Watts wrote that August, that he had not intended to part with the picture, 'It need not have any title … It is not so much an allegory as a piece of imagery which it requires a peculiar disposition of mind to perceive or accept'.

However, the origins of the subject lie in the image of the route to salvation from Jesus's Sermon on the Mount. 'Enter ye in at the strait gate: for wide is the gate, and broad is the way that leadeth to destruction, and many there be which go in thereat: Because strait is the gate and narrow is the way, which leadeth unto life, and few there be that find it.' (Matthew 7: 13 – 14. See also Luke 13: 24.) The theme was further entrenched in English-speaking protestant Christian traditions by its development in Bunyan's *Pilgrim's Progress*. The moral choice between the difficult but right path and the easy but wrong one is a staple of the Victorian literature of self improvement, both fictional and non-fictional.

Interestingly, in visual art the theme of choice between contrasting ways of life is traditionally expressed in figurative rather than landscape terms, through the subject of the choice of Hercules. This is frequently represented in Renaissance and Baroque art (and is parodied by Joshua Reynolds in a well-known portrait composition, *Garrick between Comedy and Tragedy* 1760 – 61, private collection.) Despite Watts's enthusiasm for academic art, he never undertook a figure painting on this subject or theme. His late treatment of it in this landscape painting has therefore a multiple significance. It is a clear indication of how late in his life he was increasingly willing to let landscape carry complex meanings he had previously expressed through the human figure.

Although he considered that his mind was broadening, it may also indicate how in old age he was increasingly revisited by the judgemental structures of the harsh evangelical Christianity of his childhood. He had consciously rejected these in youth, but his continuing treatment of themes of time, death and judgement show their continuing emotional presence. Watts's preferred stance was to present the positive and negative forces of life in balance with one another, as this exhibition explores. For him to make a direct representation of an implied moment of moral choice between good and bad is unusual. That the inspiration for Watts's image lay in a nightmare, may reveal its early roots and unconscious psychological significance. VFG and HU

*55. *Satan*, 1847
Oil on canvas
199.39 x 133.35 (78 ½ x 52 ½ in)
Watts Gallery

A terrific sense of power, movement and mystery charges
across the canvas, as the nude embodiment of the Evil Spirit
his great right shoulder and arm pulled back and down,
marches through the abstract torrent of nature; his head turns
in profile away from the viewer, his raised left hand shielding
his face from the radiance of God. *Satan* was produced in
preparation for fresco shortly after Watts's return from Italy,
when he was planning to emulate Michelangelo and fill an
English hall with inspirational cosmic frescoes. Its biblical
source is from the book of Job: 'And the Lord said unto
Satan: Whence comest thou? Then Satan answered the Lord
and said, From going to and fro in the Earth and from
walking up and down in it.' (Job 1: 7). Through association
with Job, an innocent man who suffered material loss at
Satan's hands, the picture can be seen as a symbolic dimension
of social criticism.

The half length figure is reminiscent in format of
Francisco Goya's *The Colossus,* although there is no indication
that Watts could have known this work. Its powerful
muscularity may also derive from classical sculptural
prototypes or from the paintings of Michelangelo. The figure
is shown with his head turned in profile away from the viewer,
his raised left hand shielding his face from the radiance of
God. Ruskin was an admirer of this work, despite his
preference for landscape over figure painting and for
particularity over generalisation. In a letter inviting Watts to
dine at his parents' home in Denmark Hill, Ruskin remarked, 'I
don't understand the new picture, but it is glorious and Satan
has his cheekbone all right.' (Quoted in Barrington, 1905, p.
24; Macmillan 1903 150*.)

Satan was undertaken at the outset of an unhappy period
of Watts's life when the artist found his grand style paintings
were increasingly out of fashion with the public, and the
public commissions he must have hoped for when he returned
from Italy. His increasing preoccupied with moral and social
protest against greed and the tyranny of the rich over the poor
is most clearly revealed in his four 'social realist' paintings such
as the *Found Drowned* (No. 7). HU and VFG

56. *The Meeting of Jacob and Esau*, 1862-68
Oil on canvas
243.84 x 154.94 cm (96 x 61 in)
Watts Gallery

The wood-engravers George and Edward Dalziel
commissioned leading nineteenth-century artists to submit
drawings for an illustrated Bible. In December 1863 Watts
submitted three: *The Meeting of Jacob and Esau, The Sacrifice of
Noah* and *Noah Building the Ark.* As he wrote on 18 February
that year, he would have preferred subjects of a more abstract
character, for example, from the Book of Job, or the Prophets
especially Ezekiel. I do not fancy subjects that mere costume

pictures – Moses receiving the Tables or the Brazen Serpent
would be much more to my taste'. (British Library: Add Ms.
39,168, fol. 52). Nevertheless Watts developed them into easel
paintings.

The Meeting of Jacob and Esau is taken from (Genesis 25: 24-
34). Jacob, having cheated his brother Esau of his birthright,
returned in fear of his brother's vengeance: 'And Esau ran to
meet him and embraced him, and fell on his neck and kissed
him and they wept.' (33: 4). *The Meeting of Jacob and Esau* –a
smaller version of the work shown at the Academy in 1868
(Salford City Art Gallery) – could be seen as transitional
between 'history' and 'aesthetic' approaches to painting.
Although the biblical narrative with its moral dimension is
closely allied to history painting, the interest in conveying
emotion by formal analyses and bodily expression is closer to
aesthetic priorities, especially in view of Esau's hidden face. In
that context it is interesting that Rowland Alston, Curator of
the Watts Gallery in Mary Watts's time, lays such stress on the
picture's formal arrangement: (Alston, 1929, pl. XXVIII) Watts
produced a separate painting of Esau (RA 1865, WG).

Dalziels Bible Gallery was not published until 1881. However,
the interest in the grand Old Testament subject it reinforced or
kindled among its collaborators – among them Leighton,
Burne-Jones, William Holman Hunt, Simeon Solomon and
Ford Madox Brown – helped to keep interest in high artistic
style alive in the 'realist' artistic climate of the early 1860s. This
is arguably a factor in shaping English aestheticism. Certainly
Watts's growing interest in the Genesis story, led to the epic
series about Eve (Fig. 8 and nos.14, 15 and 49) and Cain, which
Watts treated as the story of mankind, consistent with *The
House of Life* fresco scheme, but by 1873 the subjects were to
be painted on canvas. (Dalziel, 1901, p. 246.) HU and VFG

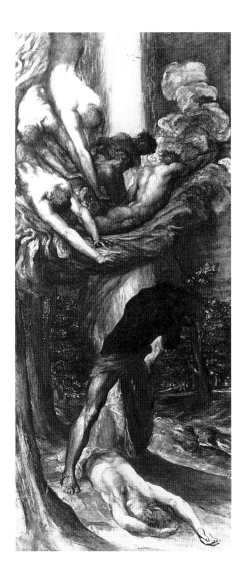

If I were a poet and musician like Wagner, I could make a fine cantata or oratorio of the subject. The first act would be to describe the innocence of the two brothers in their boyhood, the first shadow of the stain in the character of Cain just indicated; then, as the story grew, to mark the widening difference between them – the angelic guilelessness of Abel and the darkening of Cain's heart through the sin of jealousy, the ever-increasing desire to make himself grater than Abel ending in the madness of his wrath and the murder of Abel. The denouncing spirits, as I have painted them, represent the voices of conscience reproaching him with the many sins that culminated in the murder. The brand is set upon him; he is shut out from contact with all creation; he has closed the avenue of sympathy with his fellow-men; as he decides that they shall be unknown to him he becomes unknown to them. The brand, forbidding human vengeance ('No man may slay him'), constitutes the most terrible part of the punishment; he is driven out from all contact with created things –unseen, unacknowledged, unknown. Not only are his fellow-men unconscious of his presence, but all animate nature has cast him out: no bird or living creature acknowledges his being. For him no bird sings, no flower blooms, evil passions haunt and follow him, making discords in his ear; but all the while, one voice, as of an angel, is heard, and more and more prevails, until worn and weary nature can bear no more, and, surrendering to the Voice, he returns to Abel's altar, there to give himself up a sacrifice; and there the angel removes the curse and he dies forgiven. (MSW, I, 257-59)

After exhibiting the present version of *The Denunciation of Cain I* at the Galerie Georges Petit in 1883, Watts painted a sequel. (See no.58.)

57. *The Denunciation of Cain*, 1871-72
Oil on canvas
180 x 99 cm (58 x 26 in)
Watts Gallery

The Royal Academy changed their rules in order to elect the reluctant artist an associate in January 1867. Exceptionally, Watts was promoted to a full Academician that same year. The larger thirteen-foot version *The Denunciation of Cain*, exhibited at the Burlington House in 1872 as '*My Punishment Is Greater Than I Can Bear*' was the customary diploma picture subsequently presented to the Academy. This more vigorous, smaller version was completed at the same time, was exhibited at the Galerie Georges Petit in 1883.

In the fourth chapter of Genesis, Cain, the son of Adam and Eve, jealous of his brother Abel, murdered him in a field. God imposed a curse upon Cain, that he would be a fugitive, to which Cain replied, 'My punishment is greater than I can bear'. (Genesis 4: 11-13). Conceived as part of a series on the story of mankind, as discussed in no.56, *The Denunciation of Cain* was intended by Watts to symbolize 'reckless, selfish humanity'. Here, Cain is seen standing defiantly over his murdered brother and attempting to defend himself from the spirits bringing down the curse of God, while a pillar of flame rises heavenwards from Abel's body.

Watts came to see the story of Cain as a subject for a cantata. As the son of a musical instrument maker, he had a great love of music and often wished he could compose music or poetry. Instead he infused his paintings with a sense of rhythm and harmony. He said of Cain:

58. *The Angel Removing the Curse of Cain*, 1885-86
Oil on canvas
63.5 x 35.56 cm (25 x 14 in)
Watts Gallery

Increasingly Watts wished to present the story of Cain as a psychological study, not only of the biblical tale, but of the human beings who passed by Cain during his isolation. The large version of *The Angel Removing the Curse of Cain*, which he exhibited as *The Death of Cain* in 1886, he also presented to the Academy.

Cain, an outcast, doomed by the curse to be invisible, to travel the world with no feeling for other men, has returned to Abel's altar and offers himself a sacrifice. Cain is seen at the point of death; his muscles, powerless, have shrunk down to his skeleton; his head and arms fall and he repents as the angel – radiant in the large version – endeavours to break down Cain's selfish isolation and soften his heart. As the angel removes the curse and his soul is received at the gates of heaven. This is one of the most extraordinary examples of Watts's sense of counterbalance, or good and evil interwoven. The artist explained, 'I intend simply that the sacrifice is accepted. The flaming angel sweeps away the cloud'. (MSW. Cat. S. 21c; *The Athenaeum*, 8 Aug 1885, p. 184.)

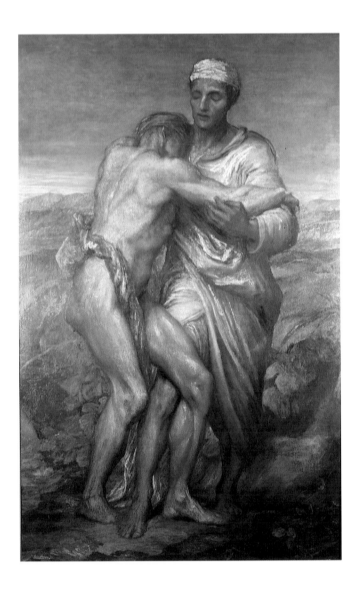

60. *The Good Samaritan*, 1849-1904
Oil on canvas
105.41 x 97.79 cm (41 ½ x 38 ½ in)
Watts Gallery

The subject is taken from the parable in the New Testament: Luke 10: 39-37, in which a traveller on the road from Jerusalem to Jericho was attacked and left half dead by robbers Ignored by a priest and a Levite, he is attended to by a Samaritan.

There are three known versions of *The Good Samaritan* by Watts, who was first drawn to the subject after reading about the activities of the prison philanthropist Thomas Wright. Executed at the time that he had resolved to paint symbolic pictures to inspire the British public, his eight-feet canvas of the two figures was exhibited at the Royal Academy in 1850 and was accepted as a gift by Manchester Town Hall. As such, it represented the earliest fulfilment of Watts's artistic ideal.

The present image, worked on by the artist until the end of his life. Whereas in the other version the traveller is resting his cheek against the Samaritan, here, he turns away from the viewer and rests his face against the Samaritan's shoulder. In 1899, Watts painted a third horizontal version, showing the traveller lying unclothed and helpless in the road. Distrustful of religious formality, Watts valued religion as 'the constant desire to do right … like some powerful spring in machinery, keeping up the motion of the wheels into pressure'.

61. *Prometheus*, 1857-1904
Oil on canvas
66.04 x 53.34 cm (26 x 21 in)
Watts Gallery

Prometheus, in Greek mythology, was a Titan, one of the giants who inhabited the primeval world. He created the first humans from clay and stole fire from the gods for the benefit of humankind. Zeus, father of the gods, punished him for this by chaining him to a rock where an eagle daily devoured his liver. He was finally rescued by Hercules. From the age of Aeschylus, fire represented a spark of divine wisdom that distinguished humanity from the rest of creation.

Following Goethe's ode *Prometheus* (1773), set to music by Schubert, nineteenth-century Romantics became fascinated by the myth. To Byron, Prometheus (1816) typified both freedom and the heroic champion of humans against tyranny, which conception Shelley devoped in *Prometheus Unbound* (1820), leading to cosmic regeneration. In a Romantic artistic context, he is the archetypal artist, bringing down divine inspiration, conveying it to others and suffering for his vision.

Gustave Moreau's various treatments of the subject (prime version 1868, Musée Gustave Moreau, Paris), show Prometheus in bondage, but with the divine flame (see Pierre Louis Mathieu, *Gustave Moreau*, 1977, p. 106), whereas Watts's interpretation is cosmic, relating visually and thematically to *Chaos* (No. 13), *The Genius of Greek Poetry* (No. 27) and *The Titans* (No. 11). Originally his Prometheus faced a fiery sun. Watts conceived the design after his return from the Greek islands in 1857. The reclining nude male figure – free of chains – derives from the marble pediment figures of the Parthenon and the twisting pose of *The Dream* (National Gallery) believed in the Victorian period to be by Michelangelo. Watts ultimately painted over the sun, and added the last touch to the canvas in 1904, when he exhibited the picture unfinished and unresolved at the New Gallery. His *Prometheus*, seen from behind, appears to be gazing into the distance, perhaps towards the dawn of a new world, yet, as we know, the artist died in despair at the state of the nation and of art.

CAROLINE CORBEAU, HU and VFG

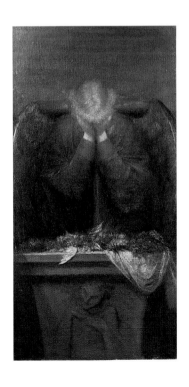

62. *A Dedication*, 1898-99
Oil on canvas
137.16 x 71.12 cm (54 x 28 in)
Watts Gallery

Since a fatal childhood accident when he trapped his pet bird in its cage door, birds, or their feathers symbolized innocence in Watts's paintings. Known variously as *The Shuddering Angel* and *The Sorrowing Angel*, and exhibited at the New Gallery in 1899 as *A Dedication*, this picture of an angel weeping over an altar piled with iridescent birds' feathers, was painted as a protest against the cruelty of killing birds for their feathers, a subject he first addressed in a letter published in *The Nineteenth Century* in 1881..

Watts, appointed an Associate of the Society for the Protection of Birds, permitted the society to use the picture for their leaflet in their campaign against the trade in feathers in 1899, and Wilfrid Scawen Blunt, who that year saw the picture when he was sitting for his portrait, reproduced it as the frontispiece to *Satan Absolved*, his diatribe against greed. At the New Gallery, *The Art Journal* found *A Dedication* so majestic that if the lesson were lost, its colouring alone proved the artist's genius. In any other hands the angel weeping over an altar of feathers 'would smack of hyperbole'.

at the dockside by women masquerading as nuns. So shocked was Watts that from five to eight o'clock one morning in July 1885, he drew this drawing of *The Minotaur* crushing an innocent bird in his brutal hand. His assistant Emilie Barrington reported that Watts worked best when his Celtic passion was roused. (Barrington, 1905, p. 38).

The Athenaeum announced the finished painting to the public on 25 July 1885. Leaning on the angle of a parapet, his brawny human back to the viewer, the brute stares over land and sea; his bull's ears twitch at the approach of his victim, as he mindlessly crushes the bird beneath his fingers. Apart from the grim force of the design,' the journal reported, 'the work is remarkable for the harmony and appropriateness of its colour and tone, its virile draughtsmanship, and the energetic modelling of the flesh.'

Watts noted in the catalogue when he exhibited *The Minotaur* at the Walker Art Gallery that autumn, 'the real mission of Art – not merely to amuse, but to illustrate and embody the mental form of the beautiful and noble, interpreting them as poetry does, and to hold up to detestation the bestial and brutal.'

Mary's diary extracts in October 1888 – 'Signor calls the Toynbee Hall workers "Crusaders who know what modern war should be"' – coincide with inquests on the gruesome mutilation of prostitutes in Whitechapel, 'when the human monster actually rises for a moment to the surface and disappears again, leaving a victim dead and disembowelled,' as a journalist then reported the 'Jack the Ripper' murders.

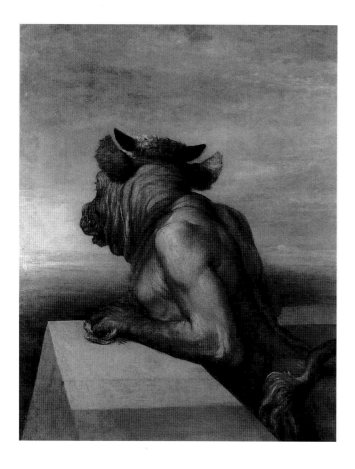

63. *The Minotaur*, 1885
Charcoal
96.52 x 79 cm (38 x 31 in)
Watts Gallery

W. T. Stead's sensational exposé of child prostitution 'The Maiden Tribute of Modern Babylon', printed in the *Pall Mall Gazette*, 6-10 July 1885 appalled Watts. The social reformer Josephone Butler had revealed that thousands of children as young as thirteen – the legal British age of consent (compared to twenty-one in France) – were being procured to feed the wretched appetite of the London Minotaur. Many poverty-stricken mothers believed their children were going into domestic service or even thought prostitution less unappealing than the dreadful conditions in factories. Deception was rife. Girls arriving from Ireland *en route* for convents were ensnared

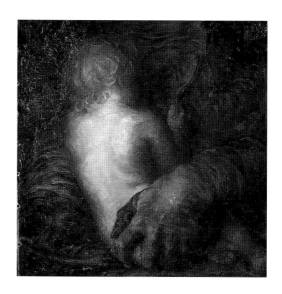

64. *Monster and Child*, c.1885
Oil on canvas
45.72 x 45.72 cm (18 x 18 in)
Private Collection

Uncatalogued by Mary Watts, but clearly also motivated by Stead's report on child prostitution, Watts painted this disturbing study of a child in the clutches of a monster.

64. *Outcast Goodwill*, 1894-95
Oil on canvas
100.33 x 67.31 (39 ½ x 26 ½ in)
Watts Gallery

'I am making studies for a picture I shall call *Good will*, an outcast child but strong; of the race of the Giants!' Watts wrote in May 1894. Behind the outcast infant Goodwill who had a flower in one hand and holds out the other for alms, are smoking factory chimneys. Symbolizing Trust, Innocence and Love cast out by the fierce competitive commerce, *Outcast Goodwill* was exhibited at the Academy in 1895. The colouring was admired but, as so often with Watts, the message mystified critics. However, in 1901 the picture was presented through Mrs Stephen Coleridge to the Society for the Prevention of Cruelty to Children.

65. *Peace and Goodwill*, 1888-1899
Oil on canvas
71.12 x 45.72 cm (28 x 18 in)
Watts Gallery

An ironic subject suggesting the reverse, *Peace and Goodwill* was designed at Aix-les-Bains in 1888. Peace was to be a queen, a starving outcast from her kingdom. 'She will turn wearily towards a streak of light which may mean the dawn of better things. The son, her heir, is still only a young child upon her knee.' Even the artist did not know whether that light represented dawn or conflagration (MSW, pp. 124-25). The picture epitomises Watts's use of art to stimulate serious moral reflection. The painting is one of a group of images which recreate the iconography of the Madonna and child in secular terms. They began with the fresco painted in the 1850s for Little Holland House, *Humanity in the Lap of Earth* (Leighton House Museum) and include *The Slumber of the Ages* (No. 104; MSW Cat. S. 133.c.).

Mary Watts recorded her husband's method as he developed the composition from a small wax figure draped in wet handkerchiefs:

The wax lady is poised on the edge of the table, and he, a few feet off, is leaning back in his chair, one knee thrown across the other. All the lines are long and come

so well, his figure reminds me of nothing so much as one of his own silverpoint drawings. His drawing-book, held at arm's length with one hand, is just supported by his raised knee, the other hand is working away busily.

He made gouache sketches, adding colour and regal robes. That the rough figure could suggest such beauty surprised her. 'Before Signor begins a new picture, he does not see the design very distinctly. He has first a very strong mental impression of the ideas he wishes to convey, then he is conscious of a certain nobility of outline in keeping with the idea, but nothing more than that. The rest comes as he works it out on paper or on canvas.' (MSW 1912, II, pp. 124-25; diary extracts 16-18 May 1888.)

Exhibited at the New Gallery in 1899, five months before the outbreak of the Boer War, the painting highlights Watts's aversion to 'art for art's sake', for example, to works such as Moore's *Jasmine* (1880, WG), in which, despite the beauty of form and colour there is a deliberate and total rejection of the important human dimensions of meaning, relationship and morality.

Watts destined a larger version of *Peace and Goodwill* for display in a public forum, and Mary Watts gave the unfinished canvas to St. Paul's Cathedral after her husband's death as a companion to *Time Death and Judgment* which he had presented in 1893. This small painting was given by Watts to his friend Mrs. Andrew Hichens, the former May Prinsep, who later presented it to the Watts Gallery. On exhibition at a small retrospective of Watts's paintings at Leighton house in 1903, where Roger Fry hoped that that one day it would be properly placed as a mural decoration. (*The Athenaeum*, 4 April 1903, pp. 440-1). Although Fry was soon to be associated with Modernism, such praise shows his strong admiration for Watts earlier in his critical career.

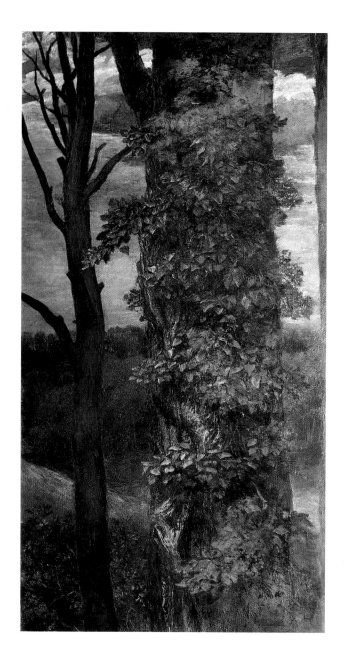

against Impressionism, he had shown every leaf cleanly painted, with sense of the smear in art he so despised. The two tree trunks crossing the frame from top to bottom break all conventional compositional rules – drawing and photographic manuals still occasionally warn the amateur against this. Mary Watts's manuscript catalogue of her husband's work notes this unconventionality specifically: 'Perhaps nowhere else in the whole range of his work is the absence of a quality he disliked and named "picture making" so conspicuous in its absence.' (MSW Cat. S. 116a). In addition some passages of the painting, particularly the palette knife work on the ivy leaves and the prismatic texturing of the bark reveal to a very high degree the extraordinary freedom and innovation of Watts's late painting technique. HU and VFG

*67. *Green Summer,* c1895-1903
Oil on canvas
(66 x 35 ½ in)
Watts Gallery

Green Summer depicts the wooded grounds of Limnerslease, Watts's home in Compton, seen from his studio window. A large and ambitious composition, this is one of many late landscape paintings, of which there are no alternative versions, perhaps due to its origins in the direct study from nature. At the end of his life, Watts declared, 'I want to paint landscape more and more.' He developed the painting in the first instance to seek out 'the variety to be found in the full green of summer.' and worked on the composition for some eight years. He believed that its distinct qualities derived from this period of extended study: 'If it could be done all at once with a dextrous swish of colour, you would not have anything that was not apparent at once.' This statement indicates Watts's opposition to Impressionist values, which is discussed elsewhere in the catalogue. (MSW, II, pp. 312-13; Cat.S. 66c.)

Watts finally exhibited *Green Summer* in 1903 at the New Gallery, his favoured exhibiting venue in the last years of his life. After he had taken the status of Honorary Retired Academician, allowing him to pull out of teaching and administrative responsibilities, he showed only one painting each year at the Academy. When the work was exhibited, it was praised by Roger Fry, revealing strong admiration for Watts in the period before he became identified with modern art. To Fry, *Green Summer* was 'as true and brilliant as an *impressioniste* could desire, and yet withal so gloriously harmonious in colour, comparable to the background of Titian's *St John*. By painting it over and again, rather than applying a 'dexterous swish of colour', Watts had given the picture his atmospheric breathing quality. (*The Athenaeum*, 2 May 1903, p. 569.) HU and VFG

66. *The Parasite,* c 1895-1903
Oil on canvas
30.71 x 106.68 cm (78 x 42 in)
Watts Gallery

Watts's composition, an informal and unconventional nature study, clearly had a deeper symbolic meaning in view of the ivy that is strangling and will destroy the tree. In reality, the two trunks are part of the same Scots pine tree in the artist's garden, as can be seen in *Green Summer* (No. 69). The upper section has already been killed by the ivy.

In the late nineteenth century, the *nouveaux riches* played a changing role in British society. Dominated by financiers and rentiers, they amassed and displayed their wealth ostentatiously and conspicuously, unlike the majority of mid-century capitalists and entrepreneurs. Watts perceived this group as unproductive and damaging to national vitality. They are probably symbolized by the ivy. Watts's alternative symbol for rampant materialism is the golden robe, which appears in other late works such as *Mammon* (No. 69), *Progress* (No. 107) and of course *Can these Bones Live?* where it is shown as destroying the English oak.

But in *The Parasite*, exhibited at the Academy in 1903, Watts was also directly concerned with pictorial qualities. In a protest

Art is progression, revolution, evolution & gravitation towards renewal

Watts's great symbolic subjects addressing the universal issues of human existence, conceived in the 1860s, evolved with changes through the 1870s, and were refined in the 1890s. He invented a new iconography for images of Time and Death. *Love and Death* was recognized as a masterpiece at the landmark opening of the Grosvenor Gallery in 1877. Interest in Watts's imaginative works spread to Europe, America and Australia. *Love and Life* was his key message to the era – the prime version was given to the American people, others to France and to Britain. *Love Triumphant* at the moment of death completed the trilogy. *Hope* springing from despair became his best-loved picture. In the name of progress, Watts addressed conflict between nations. Returning to the question of Man's origins and his destiny, Watts ultimately sought to 'lift the veil' and paint the unpaintable, the Creator.

The hitherto sceptical French critic Robert de la Sizeranne, passing them on the staircase up to the art library, discovered by the time he had reached the last step that mythological painting was not dead after all. Two pictures had converted him: *Love and Death* and *Love and Life*.

Greed must be annihilated

68. *The Wife of Pluto*, (c.1865-89, illus p. 22)
Oil on canvas
66.7 x 54 cm (26 x 21 in)
National Museums Liverpool: The Walker

After the break-up of his marriage to the teenage actress Ellen Terry, Watts painted a series of sensual half-length nude paintings, largely on classical themes of unfulfilled longing, for example, *The Wife of Pygmalion* (No. 22), *Chytie* (c.1865-66, WG) and *The Wife of Pluto*. In each, the body is idealized from studies he made of the Little Holland House maid Long Mary. However, he believed that sensory experience should inform art. As he later stressed to his assistant Emilie Barrington, 'We must the more we are developed as human beings be guided and inspired partially by the senses.' (Barrington, 1905, pp. 36 and 41.) All three pictures were clearly inspired by Ellen, especially *The Wife of Pluto* which features her face and hair.

In Greek mythology, Persephone the innocent young daughter of the corn goddess Ceres, was gathering violets and lilies when 'Pluto saw her, and loved her, and bore her off – so swift is love'. The god of the underworld and giver of riches, swept her away and raped her. Watts wished to remove Ellen from the 'the temptations and abominations of the stage,

giving her an education & if she continues to have the affection she now feels for me, marry her' (typescript, WG). As artist and muse their brief marriage left an enduring legacy. However, the young actress was restless and the elder artist needed peace.

The Wife of Pluto, in impure contrast to the jewel-like Pre-Raphaelite style painting of Ellen in her wedding dress – choosing between the fragrant violets she holds to her breast and the exotic scentless camellia she attempts to smell – shows an idealized Persephone, ravished yet unsatisfied, with her nose thrust towards luxuriant silk drapery shaped like a giant unscented carnation. Watts felt deeply guilty that he had ruined Ellen's life. They resumed a secret correspondence in later life, which may have caused him to universalize the picture into a protest against 'the disease of wealth', as he described the picture to the Liverpool collector James Smith, who bought the picture for 500 guineas in April 1890. (Letters to James Smith, 3 and 11 April 1890; NPG aXIV, 16 and 18.)

69. *The Return of Godiva*, 1879-90 (illus.p.37)
Oil on canvas
185.4 x 81.3 cm (73 x 48 in)
Watts Gallery

As a protest against images of Lady Godiva as a mere sex symbol, Watts presented her noble ordeal after she has ridden naked through the streets to persuade her husband the Earl of Mercia to reduce taxes. 'All the feelings of womanhood surge up in her mind', and she collapses into the arms of the grateful people of Coventry. Watts intended not only to stimulate, but to provoke his apathetic contemporaries to a higher level of thought. (Cat.S. 64b; *The Athenaeum*, 11 January 1879, p. 58.)

His attitude to art embodies complex mixtures of innovative originality, extreme traditionalism, (which can seem unexpectedly radical in its rejection of Victorian norms), and an unquestioning acceptance of the dominant ideologies of his society. Although at this stage he painted few historical subjects, for Lady Godiva, he looked again to Anglo Saxon England, which he drew on for *Alfred* (No. 6) and *A Fair Saxon* (c.1868, WG) to promote moral reflection, his iconography is unusual – most Victorian artists depict the ride itself or Godiva setting forth (See: Coventry 1982).

The emotional intensity of her expression reminds the viewer of Victorian attitudes to female sexuality (while unintentionally suggesting images of sexual release to the modern eye.) Elevation of female purity was central to normative definitions of gender. Transgression from these norms is usually portrayed by the woman's eventual expression of shame and often by her subsequent death. The very concept of a 'fallen' woman implies deviation from a norm, and in Victorian paintings of fallen woman, shame is given a key role in order to emphasise the normality of purity, as in Holman Hunt's *Awakening Conscience* (1853-54, Tate Britain), Rossetti's *Found* (1853-82, Delaware Art Museum) and Egg's *Past and Present* (1858, Tate Britain). It is implicit in Watts's *Found Drowned* (c.1848-50, WG) where the red heart-shaped medallion suggests that the woman has drowned herself for loving not wisely, but too well. Lady Godiva, however, is seen experiencing extreme shame precisely because she is 'pure'. This is the paradox of Watts's treatment, more effectively shown than in any other Victorian image. She voluntarily endures the shame in pursuit of a higher moral end, even though the sexual dimension of her action is at variant with Victorian perceptions of female propriety. Thus *The Return of Godiva* is comparable to the *Two Paths*, in the dramatisation of the trials of undertaking difficult but right courses of action.

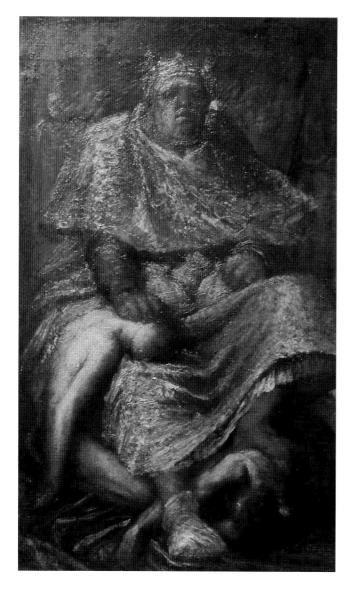

70. *Mammon (Dedicated to His Worshippers)*, 1884
Oil on canvas
53.34 x 31.75 cm (21 x 12½ in)
Watts Gallery

Appalled by the stifling effects of the machine age, Watts became increasingly obsessed with the need to quash Mammonism, the evil influence and devotion to wealth, deriving from the Aramaic word for 'riches' and revived by Milton in *Paradise Lost* (1650-63) and notably here, by Thomas Carlyle in *Past and Present* (1843). Brought up in a household where money was short, Watts was fearful of falling into debt. Through portrait commissions after his first public achievement, a top award in the 1843 Palace of Westminster competition, the 26-year-old art, came into contact with people of unlimited wealth. On his return from privileged residence in Italy the palazzos of Lord and Lady Holland, the poverty and misery he saw in London filled him with guilt, which he partially addressed in an imaginative painting, *Life's Illusions* of 1849 (Fig. 1).

Watts's earliest extant reference to Mammonism is in a letter to John Ruskin of May 1871, offering to subscribe to his proposed Guild of St George, even if the venture proved impractical, 'I don't care, it is a protest against Mammon-worship'. Incurring the disapproval of his closest friend Sir Frederic Leighton, Watts vigorously pursued the protest in polemics written for the *Nineteenth Century* in the 1880s and in increasingly didactic paintings. (MSW, I, 263).

Mammon (Dedicated to his Worshippers) as the prime version (1884-85, Tate Britain) was named when Watts first exhibited it in Birmingham in 1885-86, takes the form of a papal portrait, painted in similar pose, yet it is the antithesis of his recent portrait of Cardinal Manning (1882, National Portrait Gallery). The gross frowning figure in a crown of gold coins and ill-fitting golden robes, sits on a throne bearing finials of skulls. His donkey ears recall Carlyle's Ovidian reference to 'serious, most earnest Mammonism grown Midas-eared'. However, unlike the artist's earlier Ovidian subjects, painted at the point of metamorphosis, *Mammon* does not move, except to press his cruel message. Moneybags sprawl in his lap as he deadens mankind, his blood-red left foot bears down on the prostrate body of a man, his fat right fingers, over the head of a kneeling nude maiden, crush her lifeless on to his richly draped knee. Watts explained to Marion Spielmann of the *Pall Mall Gazette*, the victims were naked, 'Because they are types of humanity, and had they been clothed the force of my meaning and teaching would be altogether gone.' (Spielmann, 1886, p. 15.)

His expression in this small painting of *Mammon*, more grotesque than in the Tate version, illustrates Watts's point even more strongly. In a paper for the National Association for the Advancement of Art, Watts wrote in 1889, 'While Mammon, the deity of the age, more cruel than Moloch, cold and unlovely, without dignity or magnificence, the meanest of the powers to whom incense has ever been offered, sits supreme, great art, as a child of the nation, cannot find a place; the seat is not wide enough for both.' (MSW, III, 268; Carlyle, 1912, 163.) Watts painted two further companion subjects, *Vindictive Anger* and *The House of Wrath* (1885, Private Collections).

70a. *For He Had Great Possessions*, 1893-94
Oil on canvas
95.25 x 47 cm (37½ x 18½ in)
Watts Gallery

To Watts, possessions were harmful as inward distraction. 'Our health even depends upon our mental capacities being drawn outwards', he said. Emphasizing the misery of riches, *For He Had Great Possessions* asserts Watts's belief of the importance of spiritual as opposed to material values. The subject is taken from the New Testament, St Matthew 19: 22, in which Jesus advises a rich young man that to be perfect he must sell all he has, give the proceeds to the poor and follow him. Hearing these words, the young man 'went away sorrowful: for he had great possessions'. It was after this encounter that Jesus told his disciples that it was easier for a camel to go through the eye of a needle than for a rich man to enter the Kingdom of God.

From his early days as a history painter, Watts had a deep interest in the expressive potential of the human body which was reinforced by his study of the Renaissance masters in Italy and further through contacts with the painters of the aesthetic movement. He frequently turns the heads of figures or hides their faces so that bodily rather than facial expression carries the emotional weight of the painting. This tendency may be reinforced by his admiration for the expressive qualities of the Parthenon pediment figures in which many of the heads are damaged or missing. These interests are exemplified in the design of this painting. The man's face is hidden but we can read his feelings by the bowed head. As with *Eve Repentant* this is posed at the limit of realistic anatomical possibility for greater emotional effect. We can also read his reluctant materialism from the pose of his prominent hand, which fingers the opulent ring he is reluctant to part with. HU

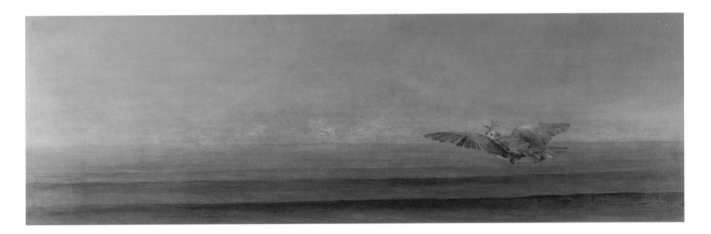

71. *The Return of the Dove*, oil, 1868-69
Oil on panel
185.42 x 61 cm (23 ½ x 73 in)
The Faringdon Collection Trust, Buscot Park,
Oxfordshire

Watts painted four known pictures on the theme of Noah
and the flood. The first, painted when he was commissioned
to produce drawings on the theme for the Dalziel brothers'
Bible, shows Noah building ark in which he will live while
God floods the earth to drown all sinners (1862-63, WG). In
the last, *After the Deluge* (No. 111), he would explore the
power of the Creator. *The Return of the Dove* and *The Dove
Which Returned Not Again* (No. 72), both taken from Genesis
chapter eight and brought together for the first time for
almost a century, show the artist's fascination with the idea
of triumphing over evil. In *The Return of the Dove*, the
exhausted bird is seen, with an olive branch in its beak, flying
over the still subsiding waters, whose far-reaching ridges
indicate the rhythm of the sea; distant hilltops, tinted pale
gold and rose, emerge through vapour into the sky, which
gradually becomes clear blue and fills the upper two-thirds of
the picture. The antithesis of Millais's compressed Pre-
Raphaelite version, in which a girl stands inside the ark
clutching the dove, which is being kissed by her companion,
The Return of the Dove was Watts's first picture to inspire a
poem; and as it seemed suited to engraving, the artist set a
high value to reflect copyright.

The Return of the Dove aroused a sensation at the
revolutionary 1869 Royal Academy exhibition, over which
Watts and Leighton presided. The two Olympian painters
transformed the summer exhibition, celebrating the
emergence of classicism, idealism and a broader range of
modern art, and showing the influence of Continental styles.

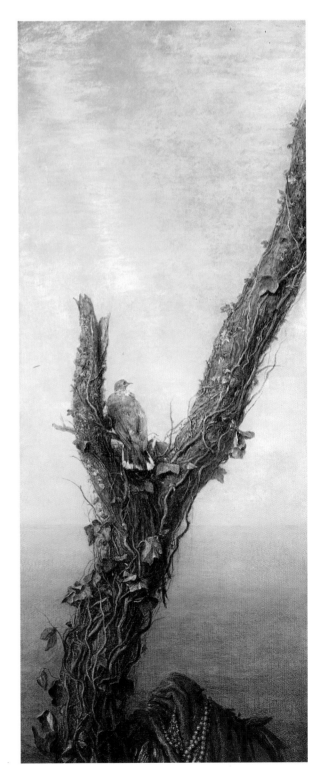

72. *The Dove Which Returned Not Again*, 1877
Oil on canvas
175.3 x 71.1 cm (69 x 28 in)
Private Collection, Courtesy of Christie's

'Though the picture is but a stump & a bird, it represents
perhaps more than any thing I have done the accumulated
experience of my life. In it I have carried farther than in any
other picture certain qualities that I have been striving after
for a great many years,' Watts wrote to his Manchester
patron Charles Rickards on 27 March 1877 (NPG: 3,153-56).
Painted from nature at the Isle of Wight and exhibited at the
Academy in 1877, *The Dove Which Returned Not Again* was an

audacious vertical development of its calm horizontal predecessor (No. 71), after the flood waters had dried up (Genesis 8: 12). The cloudless background, low horizon and subsiding floods suggest nature readjusting to a brighter future, yet the storm-damaged upper branch of a tree, rising diagonally in sharp focus across the foreground is disturbing. Its ivy stems have been loosened and stripped of all but a few sodden ivy leaves; an animated dove perches in its fork and on a broken stump below are remains of jewels and luscious drapery, symbols of the greed the floods were sent to destroy, and to the artist, a growing modern problem. Unique in his day, Watts's highly imaginative treatment here is a protest against the evils of the day *The Dove Which Returned Not Again*. Towards the end of his life, he used an ivy-covered tree trunk to attack destructive social forces in *The Parasite* (No. 66).

Aspiration …
The most divine impulse that we know

73. *The Utmost for the Highest,* 1888
Bookplate
9 x 5 cm (3 ½ x 2 in)
Watts Gallery

Watts's wife asked him to compose a motto to embellish a seal, his Christmas present in 1888. 'The Utmost for the Highest' reflects his attitude to life and art, his commitment to paint elevating pictures to raise art to the status of poetry and music, and thereby to stimulate the minds of the British people. To accompany the motto Mary Watts designed a decoration of a pool reflecting a shining star, the idea inspired by Benvenuto Cellini, whose autobiography the couple were then reading. A daisy used to remind the artist that even a tiny action should be in keeping with a great aspiration. Whereas his art simply symbolizes his idea, Mary infused her decorative art with multi-national symbols. Here in Watts's bookplate the Tree of Life is entwined with ears of corn, symbolizing a fruitful life, a heart, suggesting love, and, in the form of a Celtic triskele, a star 'the highest of small things'. (MSW, II, pp. 137-38.)

74. *Study for Sir Galahad,* 1855
Pencil
56 x 47 cm (22 x 18 ½ in)
Private collection

Watts lived as the tenant of Thoby and Sara Prinsep at Little Holland House in Kensington, where he was treated as one of the family. Invited to Paris by his patron, Lord Holland in 1855, Watts took with him the Prinseps' fifteen-year-old son Arthur. There he made a series of drawings of Arthur's head and long

hair, which he later featured in spiritual paintings of heroic knights in armour on themes of Aspiration, notably for *Sir Galahad* (No. 75) and *Aspiration* (1866-87). Arthur subsequently became a general of the eleventh (Prince of Wale's own) Bengal lancers idealized as a knight in armour and now Lieutenant-General of the 11th (Prince of Wales's own) Bengal Lancers.

75. *Sir Galahad,* 1860-62, illus p.11
Oil on panel
53.6 x 26 cm (21 ½ x 10 ½ in)
Private Collection

Highly spiritual and poetic, this is a small early version of *Sir Galahad* standing by his horse is one of Watts's best-loved idealized subjects. He exhibited the prime life-size version (Fogg Art Museum) at the Royal Academy in 1862. Sir Galahad was the perfect knight of the Round Table in Sir Thomas Malory's prose romance *Morte d'Arthur* (c. 1470). His successful quest for the Holy Grail made him a symbol of the utmost purity, which combined with his strength of faith held great appeal for Watts and his contemporaries. Like William Morris, who encouraged Rossetti and Burne-Jones, he was doubtless inspired to paint the subject after Alfred Tennyson epitomized Sir Galahad in a poem published in 1842. But unlike the Pre-Raphaelite painters, Watts's *Sir Galahad*, though poetic, is a universal contemplation of chivalry, rather than an illustration of Tennyson's narrative. The poet, a close friend of Watts, was expanding the Arthurian subject for his *Idylls of the King*, when he came to sit for several portraits at Little Holland House.

Watts was a keen horseman and often used a horse in his art to express emotion. Fascinated by the chivalrous, heroic qualities of armour, he had painted a self-portrait in armour in Italy in 1843, and was soon to begin another as a knight on *The Eve of Peace* (1863-76, Dunedin Public Art Gallery, New Zealand). The bravery of his young model undoubtedly inspired the artist as he painted from drawings of Arthur Prinsep (No. 74). Arthur had since been wounded in the Indian Mutiny and was serving in India when Watts immortalized his features as *Sir Galahad*.

Watts reworked his original large watercolour to present to Eton College in 1897, to inspire the youth of England as a symbol of purity, chivalry and dignity, 'the characteristics of a gentleman'.

HU and VFG

76. *Studies for National Rifle Association Logo and Medal,* 1860
Pencil
12.1 x 10.8 cm (4 ½ x 4 ½ in)
Watts Gallery

The War Office, fearing invasion by Napoleon III of France, authorized the formation of a Volunteer Force and National Rifle Association headed by Lord Elcho. Watts was one of the first to enlist in the 38th Middlesex (Artists) Volunteer Artists Corps on 10 May 1860. Lord Elcho, a long-standing friend asked him to design the Elcho Shield to be awarded to the winner of an annual competition to encourage international small-bore shooting, and requested a sketch on 14 January 1860. Watts supplied chalk drawings of Reginald Cholmondeley in Volunteer uniform and of battle scenes for the shield, and at his suggestion, a figure of a running man was used for target practice at Wimbledon Common. In his designs for the National Rifle Association medal and logo, Watts drew images

of Britannia, idealized heroic figures shaking hands in a gesture of peace, and the two standing figures of a Plantagenate archer standing beside a rifleman of 1860, which remain the logo of the association today.

77. *The Queen's Medal of the National Rifle Association,*
Silver
5 cm (2 in) diameter
Watts Gallery

The Queen's prize of £250 and a gold medal was awarded to the best shot at the annual National Rifle Association competition, and the runner-up received a silver medal, both inscribed with the association motto 'Sit perpetuum' ('Let it last for ever'). This medal, hallmarked with the anchor and lion of Birmingham and minted in 1898, by Elkington & Co of Regent Street, was cut by George Gammon Adams, maker of the Great Exhibition medal of 1851 and the Queen's Jubilee medal of 1887.

Watts, himself a good shot, had a small rifle range in the grounds of Limnerslease, his home at Compton in Surrey, and he continued to shoot almost to the end of his life. RJ

78. *The Happy Warrior,* 1884 (illus. frontispiece)
Oil on canvas
77 x 64.3 cm (30 x 25 in)
Bayerische Staatsgemäldesammlungen, Munich:
Neue Pinakotech

Arguably Watts's most visionary painting, *The Happy Warrior* represents a young knight at the moment of death. As his head falls back, his spirit emerges, a beautiful female embodiment of the ideal for which he has fought and died. (The spirit was originally intended as 'a vision of his love bending over him and kissing his brow, Emilie Barrington wrote at the time in the catalogue entry to his Metropolitan Museum of Art retrospective.) Watts named the picture after Wordsworth's poem *Character of the Happy Warrior*, and his patriotic endeavours in life, and extended the idea with the imagery of the spirit of death. He was extremely moved by the expression of the visionary in art, not religious as such, but reaching out to what he called 'the truest religious sensibilities, suggestively touching philosophical imagination.' He and Mary read and discussed the spiritual philosophy of early civilizations and followed modern developments. Watts exhibited the picture at the Grosvenor Gallery in 1884, at which time he was elected an honorary associate member of the new Society for Psychical Research. (Metropolitan Museum of Art 1884-85, cat. 87; *Journal for the Soc for Psychical Research*, I, April 1884, 33-34).

This dreamy quality, the imagery of death and search for self was embraced by the European Symbolists, notably the Belgian artist Fernand Khnopff (1858-1921). In a format similar to *The Happy Warrior*, Khnopff's narcissistic drawing *My Heart Weeps for Days of Yore* depicts a woman seeking, almost kissing, her mirror image (1899, various versions designed as a frontispiece to *La Pléiade*, the poems of Grégoire Le Roy). Like Watts, Khnopff regarded the circle as a symbol of perfection and in *My Heart Weeps for Days of Yore* shows just part of the curved mirror and image, as Watts did so often elsewhere – for example in *Hope* (No. 81) to stimulate the imagination. (Brussels 2004, cats. 155-59).

The Happy Warrior was one of a large group of pictures Watts lent to the Munich Artists Association exhibition in July 1893. Elected an honorary member of the Munich Academy

of Fine Arts, he, unusually, agreed to sell *The Happy Warrior*, the only version of this supreme symbolic subject, to the association, for half price. (MSW Cat. S. 69b; Munich, 1893, cat. 1654a.) In January 1894, Watts was surprised to read a Zoroastrian poem in which the warrior questions the vision 'who art thou?' and the lovely vision answers 'I am thyself, thine own deeds have made me'. Fascinated by Laing's *A Modern Zoroastrian*, a study of the dual spiritual forces of good and evil, he felt his work harmonized with 'this effort of the human mind, always trying to raise itself to its *own* origin. (MSW diaries, 17 September 1893 and 2 January 1894.)

The stained-glass designer Christopher Whall incorporated *The Happy Warrior* into the top tracery light of St Andrew's Chapel, Grahamstown, South Africa. (cf. drawing, V&A. E.2134-1924.)

79. H. D. Rawnsley, *Ballads of Brave Deeds* (J. M. Dent, 1896)
Frontispiece: *The Happy Warrior*, photogravure
Private Collection

Watts played a significant role in the revival of the craft movement. Canon Hardwicke Rawnsley was founder of the Keswick School of Industrial Art, of which Watts was a generous supporter. Impressed by Watts's prime participation in art exhibitions for the poor, notably in Whitechapel, he wrote poems about the artist's paintings, and was co-founder of the National Trust, of which Watts was a council member. Rawnsley's dedication in his *Ballads of Brave Deeds* 'to my dear friends G. F. and Mrs Watts, whose sympathy encouraged me to put on record in verse these deeds of heroism' refers to Watts's long-held plan to erect a memorial to unsung heroes. In 1899, he commissioned Ernest George to design a covered way in the churchyard of St Botolph's Aldersgate, for plaques commemorating brave deeds. (Rawnsley, 1923, pp. 126-27.)

80. *Study of a woman, possibly for Hope*, c.1865-70
Plaster cast from
16.5 x 25.5 x 19 cm (6 ½ x 10 x 7 ½ in)
Watts Gallery

The image appears among his outline sketches jotted down in the 1840s as ideas for *The House of Life* fresco scheme. His conception of the form appears as an amalgam of prophets from the ceiling of the Sistine Chapel. (WG, sketchbook 15/5.) In the late 1860s Watts developed the image from studies of Long Mary and executed a nude sketch of the figure with her foot tucked under her thing (formerly in the collection of Mrs Coombe Tennant).

81. *Hope,* 1885-86, illus. p. 7
Oil on canvas
150 x 109 cm (59 x 43 in)
Private Collection, Courtesy of Christie's

This is the first completed version of Watts's best-known and most admired subject from the moment it was exhibited at the Grosvenor Gallery in 1886, as *The Athenaeum* forecast: 'A piece of tone harmony not less impressive than it is delicate and as a harmony of colour not less subtle than it is novel, this picture is sure of a welcome.' (*The Athenaeum*, 24 April 1886, p. 561).

Watts conceived the image in the 1840s and in the late

1860s worked it up from Long Mary studies into a nude sketch, which appears in the late 1860s, which appears in the left panel of Harry Bates's panel of *The Story of Psyche* (No. 100). He was prompted to paint the clothed painting in 1885, when he feared that his adopted daughter Blanche Somers Cocks might lose her baby. Emilie Barrington's often quoted period of 1877-86 refers to pictures she witnessed when she was Watts's assistant, and her unnamed friend modelled for *Hope*. (Barrington, 1905, pp. 37 and 93.)

In this central Wattsian image, Hope sits on top of the world, her eyes blindfolded as she plays her lyre, of which every string is broken, except one, and from this she tries to make the most beautiful music, listening with all her might to the tiny sound. 'It is only when one supreme desire is left that one reaches the topmost pitch of hope', Watts explained. Inspired by the Elgin marbles, he painted idealized figures in lumininous classical draperies, with increasingly *mouventé* folds, to leave the face and, in *Hope*, the feet, bare – to heighten the expression. The circular section of the globe beneath her, is designed on the Wattsian principle to stir the imagination. But the pathos of her pose, her head bent close to her lyre, caused many to view the image as one of despair. More disturbing, however, is a little undated drawing of a Madonna figure and children entitled *Hope: Death's Door* (WG), which may be an early study for *Evolution* (No. 105). Disturbing ambiguity was very much a feature of the European Symbolists. *The Scream* (1893, Oslo National Gallery) by the Norwegian painter Edvard Munch is perhaps the antithesis of Watts's *Hope*, which Munch would have seen at the 1889 Exposition Universelle in Paris. While Watts was painting the picture the French Jean Moréas defined the term 'Symbolist' – the idea being more significant than perceptible form – which artists adopted to described Wattsian concepts that had mystified the British public for decades.

Hope was one of the three 'theological virtues' represented in art since the Middle Ages. Watts painted all three together and as separate subjects, not regarded as a trilogy. Until Watts painted *Hope*, the most famous nineteenth-century representation was the French painter Pierre Puvis de Chavannes's pictures of adolescent girl (clothed in Fig. 20, and nude the version at the Musée d'Orsay, Paris) seated on a wall in the devastated battlefields of the Franco-Prussian War, holding out a symbolic branch of oak.

Watts painted several versions of *Hope* and a copy by Cecil Schott was among those given to Toynbee Hall in Whitechapel, but, as Emilie Barrington reported in 1886, he painted a second, more important version for the nation (MSW, 1912, II, p. 106). For the contrast between the present version, bought by Joseph Ruston and the picture given to the Tate in 1897, see Barbara Bryant's catalogue entry to *The Age of Rossetti, Burne-Jones & Watts: Symbolism in Britain*, in which she also notes an interesting connection with Rossetti's *A Sea Spell* (1877, Fogg Art Museum), of a woman in a similar pose, making, albeit wild, music – 'to what sound her listening ear stoops she?' wrote Rossetti in his poem for the picture. (Tate Gallery 1997, pp. 67-68 and 201-2, cat. 76.)

In 1903, Pablo Picasso reflected the imagery of Watts's *Hope* in two of his Blue Period paintings, *Life* (Cleveland Museum of Art) and *The Old Guitarist* (The Art Institute of Chicago), of which David Hockney made an aquatint in 1977.

83. Sir Edward Coley Burne Jones (1833-98)
The Wheel of Fortune, c.1871
Bodycolour
48.3 x 24.1 cm
(19 x 9 ½in)
Tullie House Museum and Art Gallery, Carlisle

In classical antiquity the Wheel of Fortune was said to raise the fallen and abase the proud, and it was one of the designs Burne-Jones planned for the Troy triptych, which Burne-Jones planned to paint in Watts's new studio at Little Holland House in Kensington. In the event he did not paint it there, nor did he complete the project. This early design for *The Wheel of Fortune* belonged to Watts, who exhibited it at the New Gallery in 1898. The final composition was one of Burne-Jones's favourites and he later treated it in multiple versions in *The Triumph of Love*. (1871, WG.)

Fortune is seen in a more dynamic pose, and shows not three but five figures bound to her wheel. In style, it relates to Burne-Jones's work of the late 1860s, when he, Rossetti, Whistler, and other artists in their circle, experimented with monochromatic colour schemes, for example, *Green Summer* (1864, Private Collection). The dynamism of this study reflects Burne-Jones's admiration for Michelangelo, whose work he had studied in Italy in 1871, no doubt encouraged by Watts (Tate Gallery 1997, p. 132). They were artistically close, and Watts's qualities of dynamic form and painterliness had begun to appear in Burne-Jones's work. A particularly relevant comparison to this study is the gouache *Night* (1870, Private Collection) which is more finished but has a similar blue colour scheme, dynamic figure and swirling draperies. HU and VFG

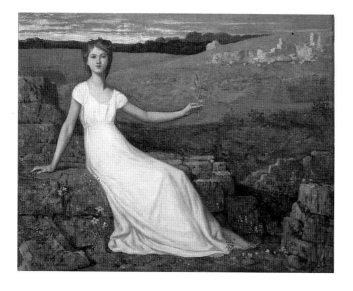

Fig. 20
Pierre Puvis de Chavannes (1824-98)
Hope, 1872
Walters Art Museum, Baltimore, USA

84. *The Rider on the Pale Horse*, 1867-82
Oil on canvas
66 x 53.54 cm (26 x 21 in)
National Museums Liverpool:
The Walker

The Rider on the Pale Horse, representing the power to kill, was the first painted by Watts in 1868, and the last of the four Apocalyptic horsemen encountered by John in Revelation, 6: 1-8: 'And behold a pale horse: and his name that sat on him was Death, and Hell followed with him. And power was given unto them over the fourth part of the earth, to kill with sword and with hunger, and with death, and with the beasts'. In 1883, Watts exhibited the series, first in the slum schoolrooms of St Jude's Whitechapel, where the Reverend Samuel Barnett explained the significance, and then in the avant-garde cultural setting of the Grosvenor Gallery in Bond Street, where they were found unintelligible, to all but 'those who are not offended by the extreme application of Mr Watts favourite theories about tone and finish' (*Pall Mall Gazette*, 2 May 1883, p. 4). More than usual, the controversial abstract finish Watts applied to these awesome visionary studies of power and light, seemed to distract rather than stimulate the spectator.

This apocalyptic series, keenly sought by the Liverpool collector James Smith in 1890, was probably inspired by the eighteenth-century poet and painter William Blake, the subject of a recent biography by Alexander Gilchrist (1863) and an essay by Algernon Swinburne (1864). Watts's shrouded personification of Death astride its frenzied mount was more searing than Blake's swashbuckling *Death on a Pale Horse* (c.1800, Fitzwilliam Museum, Cambridge).

***85.** *Time, Death and Judgment*, 1868-84 (illus. p. 14)
Oil on canvas
243.84 x 168.91 cm (96 x 66 ½ in)
St Paul's Cathedral, on loan to the Watts Gallery

Time, Death and Judgment, one of Watts's most powerful metaphysical subjects, had come to him, complete, in a vision. He quickly drew the composition in chalk. Usually he built up designs from an initial impression in his mind's eye, combined with an idea in his brain to spark a unique conception, which he refined – barely altering the composition – over the years. Though he referred to the subject at first just as *Time and Death*, Emilie Barrington's report indicates that figure of Nemesis with the scales of Justice was there from the start. All three represent superhuman beings of 'a Titanic race'. (Barrington, 1905, pp. 93, 112 and 128.)

Watts reinvented allegory, with a new anthropomorphic vocabulary, transforming the conventional imagery of Time and Death. He even grew to dislike the name of the genre, preferring to refer to these subjects as 'symbolical' or 'imaginative'. Whereas hitherto Time was seen as an old man and conveyed longevity and destructive effects, Watts paints a vigorous marching youth, conveying that the positive notion that Time must pass. His darker body colour is intended to show that he is travelling through the elements and, revealing

Watts's modern reforming spirit, to appeal to people the world over. His stony eyes were 'unchangeable ... not cruel, only heedless of what may happen as he inevitably presses forward, pausing neither to inflict, to spare nor to mend', Mrs Barrington explained in the catalogue to the Watts retrospective at the Metropolitan Museum in New York in 1884. Neither the body colour nor the eyes of Time are much liked, but with Watts, the idea is paramount.

Increasingly absorbed with the subject of Death, not least due to his own precarious health, which he kept in check, partly through diet, he dispensed with the old 'grinning skeleton', as he put it, and conceived Death as passive (for death is inevitable)and tender, rather than terrible. He therefore paints her as female, seen here looking down at flowers in her lap. Suggestively Proserpine was gathering flowers when she was snatched by Pluto, the classical god of the underworld, and taken to be queen of his kingdom of the dead.

The figures are moving away from the earth's curve and, though the iconography of Judgment, with scales in one hand and the avenging sword in another is conventional, the treatment, the extended arm and fiery sword and flamboyant flame coloured drapery suggests the Wattsian height of activity: that a death has occurred and Nemesis is beginning to pass judgment.

Watts's earliest extant reference to the subject is in a letter of 24 October 1868 addressed to his patron, Charles Rickards, who has expressed unusual interest in the poetry of the unfinished painting at a time when allegory was out of favour'. Yet the artist saw these important universal subjects as the work for which he wished to be known, and had planned to bequeath them to the nation. Exhibited at the Grosvenor Gallery, the picture was still considered too esoteric in 1878, and no doubt explains why his conception that year for a public monument of *Nemesis*, quite natural in view of the monumental sculptural form of the figures – was not carried out. In 1884, the year this picture was completed, a mosaic of the subject was set into the façade of St Jude's Church, Whitechapel, and in 1886 another version was presented to Canada.

86. *Study for Time, Death and Judgment*, 1886 or after
Ink and pencil
15.5 x 14.3 cm (6 ½ x 5 ½ in)
Watts Gallery

This drawing on the verso of a Society for Psychical Research paper of 1886 reveals that Watts continued to refine the head of death. Feathers in place of drapery around the forehead indicate that he conceived the figure as the Angel of Death, which was the title he originally gave to *The Court of Death* (No. 102), to *The Messenger* (No. 90), and to *Death Crowning Innocence* (No. 92).

87. *Study for the Head of Death in Time, Death and Judgment*, 1877-78
Gesso
36 x 28 x 18 cm (17 x 11 x 7 in)
Watts Gallery

In June 1870 Lord Westminster commissioned Watts to sculpt an equestrian statue of his Norman ancestor *Hugh Lupus*, for Eaton Hall in Cheshire. Watts modelled the life-size sculpture in gesso grosso, learning the art from a Florentine sculptor named Fabrucci. The quick-drying medieval technique was less harmful to his health than damp clay, which needed constant attention in order to not to lose precision, whereas gesso – tow soaked in a mixture of size and plaster of Paris, applied in

layers with the fingertips – hardened and could be cut or chiselled into form. Watts abhorred impasto in his painting, but he delighted in markedly textured surface. This is also evident in the gesso, and reaches its climax in his statues of Tennyson and the famous *Physical Energy*. Watts used the material to model this head of Death for *Time, Death and Judgment*. In the painting Death looks down sadly at the withering flowers in her shroud, and the well known 'sadness of a deep-set eye' is heavily accentuated in the gesso. (Barrington, 1905, 51.)

88. *Love and Death,* 1869-75 (illus. p. 33).
Oil on canvas
152.4 x 73.5 cm (59 ½ x 29 ½ in)
Bristol City Museum and Art Gallery

Since William Schomberg Kerr, the eighth Marquess of Lothian sat for a portrait in 1862, Watts had seen creeping paralysis gradually erode the health of the young marquess. The prognosis, that he would die a premature death that neither medical expertise, love nor wealth could prevent, haunted Watts for years. It led to his preoccupation with death in art, and the theme of the impotence of Love facing the inexorable approach of Death, which he encapsulated in *Love and Death,* a metaphysical masterpiece, one of the most remarkable and disturbing images in nineteenth century England.

After Lord Lothian's death in July 1870, Watts exhibited this first version of the subject at the Dudley Gallery. A monumental figure draped in grey-white, with head bowed, seen from behind presses open the door of a house which Love, a naked anguished youth with broken wings, attempts to shield, but he cannot avert the inevitable. His nakedness in Watts's iconography represents humanity. The title and idea of Death's shadow falling over the figure of Love relate to Tennyson's poem of the same name, and the imagery and conception is uncannily similar to Gustave Moreau's *The Young Man and Death* (Fig. 11) painted after the premature death of the artist Théodore Chasseriau and exhibited at the 1865 Paris Salon: a young man stands in front of a doorway protected by a nude female embodiment of Death, with a winged cherub and scattered roses at their feet. Presumably, Watts would have heard about the picture from Leighton, Rossetti or Whistler. Dante Gabriel Rossetti also confronted the conflict between Love and Death in his central Symbolist image *Beata Beatrix* (Fig. 9), in which his wife Lizzie Siddal is presented as Dante's Beatrice at the spiritual moment of death, while in the background the Dante looks towards the figure of Love.

Yet the imagery of *Love and Death* is unrelenting, very much his own. Watts had brooded over the conception for years. His intention, as Emilie Barrington explained in the Metropolitan Museum of Art catalogue of 1884-85, was 'to transmit by form and colour a vision of an idea'.

At the 1874 Royal Manchester Institution exhibition, the chief – if controversial – highlights were this first version of *Love and Death* and Jean-Baptiste Camille Corot's *Saint Sebastien*. Critics declared that no modern master approached Watts in the field of allegory. When Watts's drawing of Love was questioned, the artist replied that 'I have not reproduced the first little boy you might meet in the street, but a symbol, representing strength, vigor [sic] & activity'. (NPG aII, ff. 341-44 and 356-58.)

A larger version of *Love and Death* (with the symbolic addition of a dove on the path) at the opening exhibition of the avant-garde Grosvenor Gallery in 1877 attracted the attention of Oscar Wilde. Struck by the 'inevitable and mysterious power' he wrote in a review for Reporting for *Dublin University Magazine*: 'Watts's power … lies in his great originative and imaginative genius, and he reminds us of Aeschylus and Michael Angelo in the startling vividness of his conceptions'. (Wilde, 1877, p. 119. At the Grosvenor, Burne-Jones and Watts were recognized as artists of imaginative and poetic power; and in a review for the French periodical *L'Art*, Joseph Comyns Carr introduced them to the Continent as leaders of contemporary art (Carr, 1878, pp. 14-15.)

Of the dozen versions Watts painted of this most compelling Symbolist subjects, the three largest were gifts to the Whitworth Institute in Manchester, the Tate and the Art Gallery of South Australia in Adelaide.

89. *Study for the Head of Love in Love and Death*, c. 1895-96
Terracotta, after wax model
37.5 x 24 x 19 cm (14 ½ x 9 ½ x 7 ½ in)
Watts Gallery

Mary Watts records that when clay was found on the Limnerslease estate – for her village pottery class to model decorative tiles for a mortuary chapel in Compton – Watts made use of it. Modelled from his archive of studies from Arthur Prinsep for the head of Love in *Love and Death*, the clay of the same density and colour as the Compton clay, and shows evidence of being moulded rather than slip cast. The left side only of Love's face is complete in detail, giving the same appearance as the face of Love in the various versions of the picture. A photograph of the studio at Limnerslease shows the head on a stand in the centre of the room. (Bateman 1901, p. 3.) The patina of a modern bronze cast of the terracotta reveals the exquisite delicacy of the modelling of the contours of the face, less apparent in the matt surface of the clay. RJ

90. *The Messenger*, 1884-85
Oil on canvas
111.76 x 66.04 cm (44 x 26 in)
Watts Gallery

The Messenger is the Angel in charge of the beginning and end of life, the Angel of Death who in *Time, Death and Judgment* (No. 85) and in *Death Crowning Innocence* (No. 92). In Watts's iconography, figures of Death are 'messengers of the Great Power', rather than the power itself. His conception of Death as a friend had struck him during a severe illness calm, when his vision of the calm, standing figure seemed to be waiting by his side ready to release him from suffering. As *The Messenger*, she stands against the light, cradling an infant in her left arm. Her strong right arm is slightly stretched towards a reclining dying figure, who appears to be drawn towards her. In other versions, the largest of which he gave to the nation in 1897 (1883-85, Tate Britain), he discarded attributes of a life's work lie on the floor at his feet. As in the earlier work, Watts wished to show the power of death over all ages and conditions of humanity.

Victorians derived a sense of nobility in death and bereavement, and found *The Messenger* a source of comfort. The relationship of the two figures recalls those in images of miraculous healing, notably that between St John and the lame man in Raphael's famous cartoon *St Peter and St John healing the Lame Man at the Beautiful Gate of the Temple* (Royal Collection, on loan to the Victoria and Albert Museum). There is a poignancy in the transformation of an image of healing into one of death, which symbolized Watt's desire to depict Death as a beneficent figure. HU and VFG

90a. Julia Margaret Cameron, *The Dream*, 1869
Albumen print
34 x 26.5 cm (13 ½ x 10 ½ in)
Watts Gallery

The Dream, based on Milton's *On His Deceased Wife* and clearly influenced by Rossetti's *Beata Beatrix* (Fig. 9), was composed in the Venetian format of both Rossetti and Watts. Cameron's

image reflects the Victorian devotion to grief and mourning in art, the belief that images of suffering moved the soul – very much the impression of Watts's work at exhibition. Both he and Cameron used painterly shadows and highlights to suggest profound thoughts. The model, Cameron's parlourmaid Mary Hillier, posed for many photographs as the Madonna, and sat in the same pose to Watts for *Charity* (1864-95, Private Collection).

After Watts praised this print, which Cameron registered in March 1869, the photograph had it lithographed 'The Dream – Quite Divine G. F. Watts'.

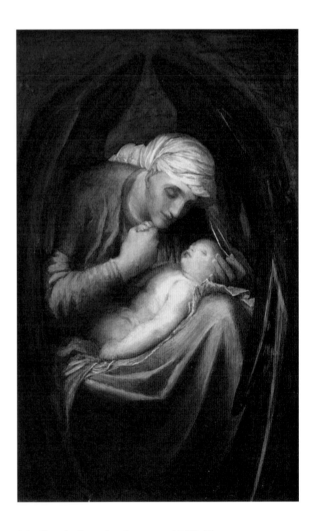

92. *Death Crowning Innocence*, 1887-93
Oil on canvas
91.5 x 66 cm (26 x 36 in)
Private Collection

On 7 October 1886, when his fiancée Mary Fraser Tytler was staying at her family home Aldourie Castle in Inverness-shire, her three-year-old nephew died after a riding accident. Watts sent a drawing of 'the Angel of Death with a child in her lap on whose head she is placing a circlet, of Death the Angel crowning Innocence' to comfort the boy's parents. His idea was that she should model a memorial from the design which indeed she did in 1891, after her husband had painted of the subject (Chapman, 1945, p. 122).

Keen to devote as much time as possible to painting great moral truths, Watts wished to make *Death Crowning Innocence* as beautiful as *Hope*, to appeal to friends, to comfort the bereaved. He wanted the colour to be full of emotion and the angel to be 'solemn, but tender & protecting'. He sent as *The Angel of Death* it to the opening exhibition of the New Gallery in May 1888,

where, to his gratification, the picture was understood. The message is clear and comforting. Watts felt that universal subjects inspired by personal experience – like this the angel of *Death Crowning Innocence* and *Love and Death* (No. 88), the effect should be greater.

93. The Century Guild, *Hobby Horse*, 1884, No I
Watts Gallery

Death Crowning Innocence appeared as frontispiece to the Century Guild's literary journal *Hobby Horse* in 1887. Watts, a fervent social reformer, called for the revival of craftsmanship in papers published in *The Nineteenth Century* in the 1880s, and was invited to endorse the new crafts guilds. A collective of designers headed by Arthur Heygate Mackmurdo, founded the Century Guild in 1882 with the idea that all branches of art – building, decoration, glass-painting, pottery, wood-carving and metalwork – should not be regarded as trade, but as honoured expressions of the artistic spirit. The guild's aim, the ambition for which Watts had long fought, was to raise the stature of the arts and crafts to that of music and literature. To this end, the Century Guild concentrated on design reform. Their new aesthetic was reflected in *Hobby Horse*. Mackmurdo inscribed the first number to Watts, 'offered with all respect to England's greatest painter, one who gains the Guild's unbounded esteem' (The Century Guild, *Hobby Horse*, No. I, April 1884).

94. *Arts & Crafts Exhibition Society Testimonial*, 1897
Watercolour and ink on paper
39.5 x 28 cm (15 ½ x 11 ½ in)
Watts Gallery

The exhibiting arm of the Art Workers' Guild (founded in 1884), the Arts and Crafts Exhibition society designed this testimonial to Watts in commemoration of 'his enthusiasm for their highest forms and the expression of the noblest ideals', on the occasion of his eightieth birthday.

95. *Study for Life in Love and Life*, 1863-64
Sanguine
32 x 29 cm (12 ½ x 11 ½ in)
Watts Gallery

Watts used this study from Ellen Terry, for the head of his major Symbolist work *Love and Life*. After the teenage actress was brought to his Kensington studio in 1863, she modelled for a double portrait with her sister Kate, and before and during their short-lived marriage in 1864, was Watts's muse, modelling for portraits and imaginative works.

96. *Love and Life,* 1882-93 (illus. p. 18)
Oil on canvas
222.5 x 123.5 cm (87 ½ x 48 ½ in)
Private Collection

To Watts, his great 'painted parable' *Love and Life* embodied his most significant universal message to the era. 'Naked, bare life sustained and helped up the steeps of human conditions, the path from the baser existence to the nobler region of thought and character.' Of the three large important pictures on the theme, presented to the British nation in 1897 (National Gallery of British Art, now Tate Britain), to France for the reopening in 1894 of the Musée du Palais du Luxembourg, this is the prime version, presented to the American people in 1893, following his exhibition at the Metropolitan Museum of Art in New York in 1884-85, the first retrospective of a living artist.

In 1865 Watts exhibited an early sketch, entitled *A Design for a Larger Picture*, at the Royal Academy in which, *The Athenaeum* reported on 6 May that 'Love with wings of fire, drags a strong man along a thorny path', thus the first design for *Love and Life* was shown in public before the converse *Love and Death* (No. 88). The first sketch stirred critics. 'There is such a flush of colour and so wealthy an idea of *chiaroscuro* … that all must wish to see it fully developed.' By the time Watts returned to the theme in 1882, having given considerable thought to the 'great moral conception of life, its difficulties, duties, pains and penalties', he reversed the sexes, preferring to contrast the frailty of human life with universal love. His modern message was that love forgotten in the heat of the moment leads to injustice and misery in the world. 'Justice should be the mainspring of all our actions', he wrote, and Love should lead the way.

Wings, suggesting the universal, rather than personal or carnal spirit of Love, are outstretched to shade Life – a nude female figure representing humanity – from the heat of the sun, and tenderly guides over the rocks of human existence to the ethereal blue of the higher atmosphere. (MSW, 1912, III, p. 227.)

In contrast to the fiery sketch of 1865, Watts was now experimenting with lighter tones – notably, the flesh colour of the maiden – and atmospheric effects, in the sky and distant mountain ranges. The figure is worked up from Long Mary studies with the head and hair of Ellen Terry.

The Metropolitan Museum exhibition attracted unprecedented interest. Watts, much respected on the Continent, was elected an Honorary Fellow of the Museum in May 1885 and in October he offered *Love and Life* to the American people, to inaugurate an art collection for a National Gallery – 'in token of the great interest I feel in the national progress. The American Secretary of State, T. F. Bayard confirmed President Cleveland's appreciation. In the meantime the picture travelled with the Watts Collection on tour to Birmingham, Nottingham, Saltire and Rugby school, and it was not until 1893 that *Love and Life* returned to America for the World's Columbian Exhibition in Chicago, celebrating the 400th anniversary of the discovery of America.

After a tussle with the Metropolitan Museum (see Franklin Gould, 2004), the picture was accepted by a Resolution in Congress in 1894, but the President's decision to hang it in the

White House aroused stormy protests from the Women's Christian Temperance Union, objecting to the presence of 'two naked figures in atrocious postures' in the presidential residence. At the Grosvenor Gallery in 1885, the British version was among many nude paintings attacked en masse by the prudish treasurer of the Royal Academy, John Calcott Horsley, but this was quite different from the individual disgust at his own work. Such was Watts's distress, having led the revival of the classical genre of nude study in England, that he wished to destroy the picture, which had an eventful life, juggling between the Corcoran Gallery and the White House, where it hung in President Roosevelt's dining room and Woodrow Wilson's study, and the Smithsonian Institution, until it was sold in 1987.

The influence of *Love and Life* appeared in much art of the day, in Harry Bates's bronze, ivory and mother-of-pearl statuette, *Mors Janua Vitae* (Fig. 12) – despite the reference t0 death rather than Love – in Alfred Gilbert's statue of *Icarus* (No. 97), in Annie Swynnerton's *Cupid and Psyche* (1891, Oldham Art Gallery and Museum), and in Picasso's two figure groups in *Life* of 1903, in which he attempts to sum up the meaning of existence.

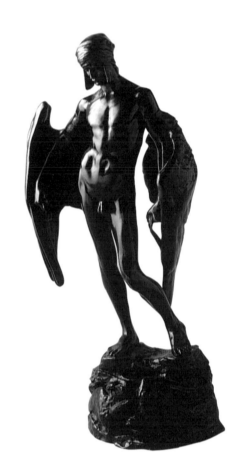

96a. *Sketch for Love and Life*, 1882
Plaster
57 x 38 x 32 cm (23½ x 15 x 12½ in)
Watts Gallery

Larger and more highly finished than the usual preparatory models Watts made in preparation for pictures, this plaster sketch, modelled in clay for *Love and Life*, indicates the importance of the composition in the artist's mind. Although the composition is close to that of the final paintings, there are certain differences: the figure of Life is more hunched, as though tripping over obstacles, whereas in the painting she looks up to Love for support, and her face bears a resemblance to Long Mary, the source of so many of Watts's idealized female figures. In the sketch, Love, whose features are similar to the head of Love, taken from Arthur Prinsep in *Love and Death*, and the figure leans down towards Life, rather than leading her upwards, as in the paintings.

97. Sir Alfred Gilbert (1854 -1934), *Icarus*, c. 1889
Bronze
49.9 cm (19½ in) high
Private Collection

Alfred Gilbert, the most important figure in the New Sculpture movement, had a deep admiration for Watts, which was strengthened when he was commissioned to model his portrait bust in 1888. Inspired by Watts's metaphysical paintings at the Grosvenor Gallery retrospective, he was modelling a roundel *Post Equitem Sedet Altra Cura* (c.1883-87, Birmingham Museum and Art Gallery) in imagery informed by two paintings by Watts *Life's Illusions* (Fig. 1) and *Fata Morgana* (1946-89, Leicester City Museums). *Icarus* owes much to *Love and Life*, which Gilbert must have seen at the Little Holland House Gallery, opened to the public by Watts in 1881 – (before his retrospective exhibitions) – so that his imaginative works could be seen hanging together. At mixed exhibitions they clashed with most other work of the day.

Commissioned by Frederic Leighton, president of the Royal Academy, the full-size version of *Icarus* (1884, National Museum of Wales, Cardiff, 106.7 cm high), aroused a sensation at the Academy exhibition of 1884.

Gilbert was given free choice of subject. In Ovid's *Metamorphoses*, Icarus was the son of the craftsman Daedalus, who designed wings of wax and feathers to enable them both to escape from the labyrinth. Icarus flew too high, the sun melted the wax, he plummeted into the sea and drowned. Gilbert has represented the moment when the young Icarus tries his wings. More than an illustration of the myth, Gilbert's work, emulating the Wattsian artistic expression of an idea, carries deeper and more personal meanings characteristic of the emerging Symbolist movement. Leighton himself had painted the earlier moment, Daedalus strapping on his wings, in *Daedalus and Icarus* (1869, The Faringdon Collection, Buscot Park, Oxfordshire).

Gilbert identified himself with Icarus, and his statue symbolizes Ambition.. 'It flashed across me that I was very ambitious: why not Icarus with his desire for flight?' The subject suggests the ambition but also the rashness which Gilbert found in his own character, which would lead to his disgrace and bankruptcy in 1901 and long exile in Bruges. (McAllister, 1929, p. 62; Tate Gallery, 1997, p. 254.)

HU and VFG

98. *Love Triumphant*, 1893-98
Oil on canvas
133.35 x 63.5 cm (52½ x 20½ in)
Watts Gallery

Love Triumphant was the sequel and supreme culmination of the metaphysical love trilogy, following *Love and Life* and *Love and Death*. Watts made the first drawings for the subject in 1893-94, began this smaller painting 1895-96, included it unfinished in his New Gallery retrospective in 1896-97. When he exhibited the finished work at the Academy in 1898 (cat. 310), *The Art Journal* observed that 'In its solemnity and dignity the work stands alone

... an isolation akin to that which Sanzio saw in Michelangelo.' (*The Art Journal*, 1898, p. 163).

The winged spirit of Love is seen rising above Death on the right and Time, the 'constructor and destroyer [who] sinks and falls', Watts explained. 'Love alone Triumphant spreads his wings rising to seek his native home, his abiding place'. He wished to emphasize that Love's feet are on the ground, because 'All that is spiritual must get its impetus from the ground beneath our feet'. (MSW diary, 13 March 1898; Alston, 1929, pl. VIII).

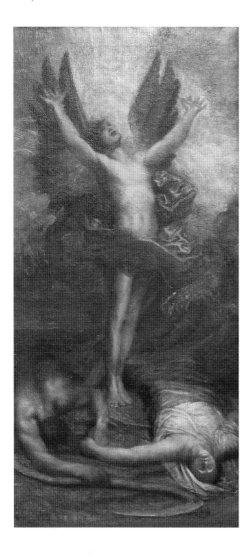

99. *Shakespeare's Sonnets* (J. M. Dent, 1896, 1927 edition) Frontispiece: photogravure of *Love Triumphant*

For the last volume in his Shakespeare series, with title-pages designed by Walter Crane, J. M. Dent, seeking as a frontispiece an 'emblematic idea of Shakespeare's genius, something in the

nature of Michael Angelo's Moses or David that would symbolize his greatness' approached Watts. No longer painting to commission in 1896, Watts invited the publisher to his studio. Dent was very taken by his oil sketch for *Love Triumphant*, which Watts explained was the final subject in the trilogy after *Love and Life* and *Love and Death*: 'Life struggling up cruel rocks with bleeding feet, forgetting its pain and learning to love because of the joy inbeing first loved, loving on even to cruel sacrifice and then death, and at last love becomes triumphant over both the agonies of life and death and ascends into the complete fullness of love.' Dent recognized 'if that does not characterise the genius of Shakespeare, it does the spirit of the *Sonnets*.' Watts lent No. 98 from which Dent produced a frontispiece for *Shakespeare's Sonnets*. (*The Memoirs of J. M. Dent*, 1849-1926, 1928, pp. 62-64.)

100. Harry Bates (1850-1899) *The Story of Psyche*, 1887
Silvered bronze
Side panels: 33.02 x 24.3 cm (13 x 9 ½ in)
Centre panel: 33.02 x 74.93 cm (13 x 29 ½ in)
National Museums Liverpool: The Walker

Harry Bates, who had studied under the French sculptors Aimée-Jules Dalou and Auguste Rodin, was the most devout classicist of the New Sculpture movement of which Watts, Alfred Stevens, Frederic Leighton and Rodin were leading figures. Bates's sculpture pays tribute to the style and iconography, of Watts's paintings.

Cupid swept the beautiful Psyche – meaning 'soul' – back to his palace, where he forbade her to set eyes on him, Lucius Apuleius related in *The Golden Ass* (second century AD). One night she disobeyed and glanced at his sleeping figure, hot oil dripped from her lamp and woke him. He left her and. Psyche wandered the earth in search of him. Eventually Mercury carried her up to heaven, where she was reunited with Cupid. The story of Psyche was seen as symbolic of spiritual growth through her suffering and experiences. Watts's painted *Psyche* standing alone and forlorn, after Cupid had fled – in the vertical format of *Thetis* (No. 51) – the prime version purchased for the nation by the Chantrey Bequest (1881-82, Tate Britain). Similarly, Leighton's *Bath of Psyche* (1890, Tate Britain) follows the vertical format of Ingres's *La Source* (1856, Musée d'Orsay, Paris). Annie Swynnerton's *Cupid and Psyche* (1891, Oldham Art Gallery and Museum) was inspired by Watts's *Love and Death* (No. l88); and Burne-Jones explored the legend extensively.

The triptych form of Bates's *The Story of Psyche*, exhibited at the Royal Academy in 1887, suggests painterly origins. In the left panel, the pose of Psyche recalls Watts's first sketch of *Hope* of the 1860s; and the shrouded figure of Mercury in the central panel is informed by *Love and Death*. (Beattie, 1983 p.155.) HU

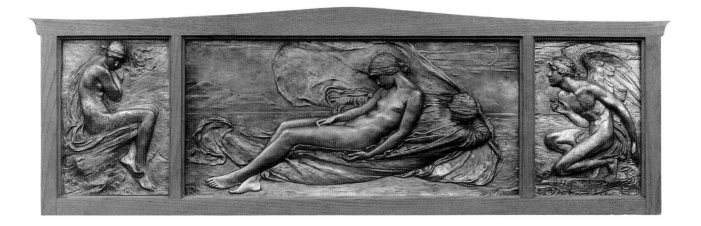

102. *The Court of Death*, c.1871-1902
Oil on canvas
93.98 x 63.5 cm (37 x 25 in)
Watts Gallery

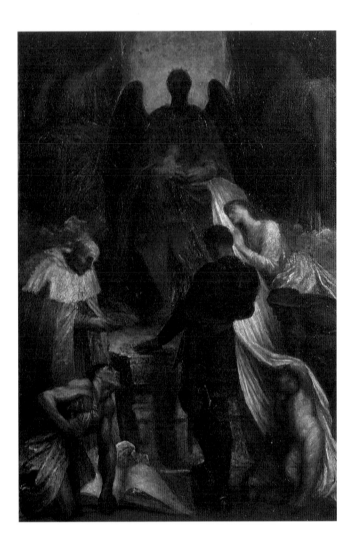

Watts gave the highest importance to the majestic *Court of Death*, designed as *The Angel of Death* in 1853 to dignify a mortuary chapel in which there were to be mass burials. Its origins therefore lie in Watts's concern with the value of all human lives, no matter what their social position Although the chapel was never built, the artist painted various versions, notably a 14-feet high canvas which he completed on his eighty-fifth birthday. This painting was carried on simultaneously as a study and it is significant that its two exhibitions in Watts's lifetime were in philanthropic art exhibitions, aimed at a working-class audience, at the South London Art Gallery in 1889 and at the Whitechapel Art Gallery in 1891. The original first version intended for the chapel is now in Manchester City Art Gallery.

Secularising imagery of the Virgin and child enthroned with saints, angels and donor figures, in the format of an altarpiece, Watts depicts the angel presiding over her court of death. Seated in shadow, in front of a glow of light suggesting Hope, she is flanked by attendants representing Silence and Mystery; she nurses an infant in her lap – the beginning of life and keynote to the picture – and receives homage from humanity; protected by neither status nor age, the nobleman lays down his coronet and a soldier presents his sword. Death is presented as a release for some. The sick woman and the poor, crippled man seem to yearn towards it. And in the foreground the baby, still unconscious that birth leads inevitably to death, plays with death's shroud. At their feet lies the book of Life. When a patron suggested adding a symbolic cross, Watts refused. There is never a reference to dogma or creed in his art, as this would curb the universality of the message.

Ruskin noted the work in a letter of 14 May 1864 as 'the Trionfo della Morte – Madonna'. To test public opinion of his supremely important subject, Watts exhibited it at the Dudley Gallery in 1871, as a design for a larger picture. *The Times* drew links with William Blake's Robert Blair's *The Grave* (1808). Both Watts and Blake conceived the grave as 'Heaven's Golden Gate': 'Neither frigid nor fantastic, his allegory of death touched the heart and kindled imagination.' (*The Times*, 14 November 1871.)

In a moving photograph in 1894, Watts himself, small, elderly and stooped, posed in front of his monumental unfinished composition, which he handed over to the nation on 19 March 1902.

103. *Love Steering the Boat of Humanity*, 1899-1901
Oil on canvas
198.12 x 137.16 cm (78 x 54 in)
Watts Gallery

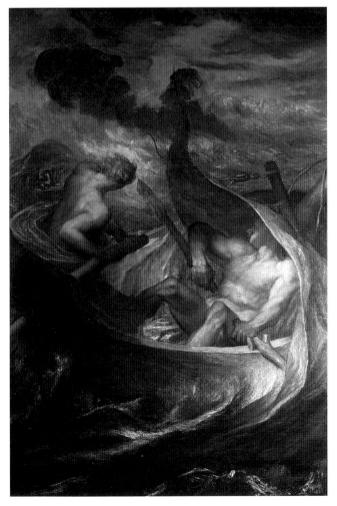

In the early 1890s Watts planned to paint a lifeboat, of Man, in conflict in the midst of forces he cannot control, sustained by Love at the helm, but did not pursue the picture until the outbreak of the Boer War, about which he held strong views. Pessimistic about England's future, Watts believed that the nation had a vital role to play in South Africa. In his polemic 'Our Race as Pioneers' Watts pressed the need to defeat the Boers for the benefit of world progress and civilization. Modern civilization was not exemplary, but as humanity was impelled to move forward it opened the way for better things, letting in light and air. But he warned, 'The undeniable loss of prestige, and the rancour exhibited by surrounding nations,

make our position one of great peril … we may lose all, for we shall lose all if we cease to be one of the dominant Powers.' He came to see in the horrors of war a redeeming patriotic grandeur, an opportunity for social reform and national service, and for progress.' (*The Nineteenth Century and After*, May 1901, reprinted in MSW, 1912, III, p.293.)

For the imagery of *Love Steering the Boat of Humanity*, whereas Théodore Géricault's *Raft of Medusa* (1817, Louvre, Paris) and William Etty's *Youth on the Prow, and Pleasure at the Helm* (1830-32, Tate Britain) showed overcrowded boats, Watts made his case with just two figures, one representing humanity, the other universal Love. *Love Steering the Boat of Humanity* was exhibited at the New Gallery in 1902, with the caption, 'Poor humanity has caught a terrible crab,' for which the 85-year-old artist, undimmed by age, was ridiculed by critics.

104. *Slumber of the Ages*, 1898-1901, illus. p. 38
Oil on canvas
134.5 x 122 cm (42 x 37 in)
Watts Gallery

An inauspicious variant of the fresco *Humanity in the Lap of the Earth* (early 1850s, Leighton House Museum), painted on the walls of the original Little Holland House half a century before, *The Slumber of the Ages* shows the same child on the lap of a now less attentive, dozing woman. As in *Peace and Goodwill*, the artist has disturbingly adapted the format of a seated Madonna and child On canvas laid in earlier by his assistant Charlotte Wylie, who in 1875 painstakingly removed and preserved his frescoes when he moved house, the picture symbolizes the brevity of life and small human aims. (MSW. Cat. S. 133 c; Barrington, 1905, 98 illus; Alston, 1929, pl. 10.)

JULIA DUDKIEWITZ and VFG

105. Frederic, Lord Leighton (1830-96) P.R.A. (1830-96)
Study for Cymon and Iphigenia, c. 1882-83
Plaster
12.5 x 53 x 29.5 cm (4 ½ x 20 ½ x 11 ½ in)
Watts Gallery

Watts prized this model of Iphigenia's sleeping companions for *Cymon and Iphigenia* (RA 1884, The Art Gallery of New South Wales, Sydney), given to him by Leighton, the president of the Royal Academy. Whereas he found Leighton's pictures too perfect, leaving little to the viewer's imagination, Watts admired the president's preparatory models and sketches. The subject, taken from Boccaccio's *Decameron* (Fifth Day, novel I) – the shepherd Cymon, spellbound by the beauty of the sleeping, is transformed by the power of Love – Iphigenia symbolizes qualities both men loved in art, the elevating influence of beauty. Yet, it heightens their differences, for Watts's increasingly didactic paintings provoked Leighton to insist in his presidential Discourse on 10 December 1881 that escapism should be the mission of art and negated the Wattsian use of art to convey moral truths. (Royal Academy of Arts, 1996, p. 199; Leighton, 1896, pp. 54-55.)

*106. *Can These Bones Live?* , 1898
Oil on canvas
152.4 x 190.5 cm (75 x 60 in)
Watts Gallery

Exhibited at the New Gallery in 1898, the title of this sinister picture is from the vision of Ezekiel who breathes life into dry bones (Ezekiel 37: 3). As such *Can These Bones Live?* expresses an hint of hope, giving a psychological edge over the more appealing ivy-covered *The Parasite* (No. 66), to which this picture relates. Here Watts attacked the state of the nation, showing the English oak, inscribed in Anglo-Saxon 'Alfred me planted', crushed by a golden pall – the corrupting effects of affluence – which covers symbols of destruction, death and corruption. Dry bones of mankind and the quill of literature and learning lie among birds' feathers – see No. 62. In the nettles of untilled soil are a pole trap, assassin's knife, drunkard's cup, gambling dice and an empty purse. Productive work symbolized by the workman's tools is destroyed in the general fall and the whole stands in a desolate and ruined landscape. Yet, with indomitable spirit the old oak sprouts a single wispy shoot.

The imagery reflects Watts's picture of a shrouded epitaph *Sic Transit* (1890-91, Tate Britain), but in *Can These bones Live?* the underlying message is that only spiritual renewal has the power to counter the destructive human, national and environmental consequences of untrammelled materialism. Fernand Khnopff, reviewing the New Gallery exhibition for *The Magazine of Art*, discussing the coercive effect of these 'sick gems, as one might fancy – all this forces itself on the attention of the most sceptical, and compels the mind to deep and gloomy meditation', but concluded: 'Now these pictures of Mr Watts' are very 'well done.' Is it not wise, then, to admire in silence? (MSW Cat. S. 22c; *Magazine of Art* 1898, p. 431.)

RJ, HU and VFG

There is no law more distinctly divine than that which says, 'Onwards!'

107. *Evolution*, 1898-1904 (illus. p. 35)
Oil on canvas
167.64 x 134.62 cm (66 x 53 in)
Watts Gallery

Evolution, as Watts expressed in his cosmic fresco scheme, notably, in *Chaos* (No. 13), was a central preoccupation in the nineteenth century, and especially after Darwin's *The Origin of Species* (1859) which dislodge religious certainties among the Victorian intellectual community. Watts addressed the issue in 'Our Race as Pioneers', describing the English people as 'agents of the great law – Movement, Progress, Evolution' (MSW, 1912, III, p. 278).

The picture expresses this uncertainty, with the anxious female figure searching the horizon above her hoard of quarrelling children. Watts spoke of the picture as 'Earth and her troublesome children', and suggested 'evolution' as a title within weeks of his death. The image recalls Anthony Van Dyck's *Charity* (1827-28, National Gallery). Crucially, however, Watts has transformed the traditional image, and reinterpreted a theme where human love can be seen as a metaphor for divine providence, for the uncertainties of the modern age. Watts's monumental figure-painting here may well have influenced the twentieth-century sculpture of Henry Moore. (MSW diary, 22 October 1898; Cat. S. 51c; see also Franklin Gould, 2004.)

HU and VFG

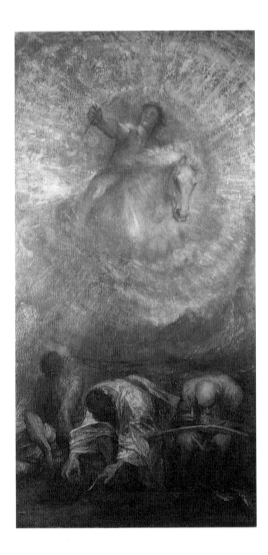

110. *Physical Energy*, 1882-1904
Gesso
348 x 389 x 152.5 cm (137 ½ x 154 x 60 in)
Watts Gallery

This is the model for Watts's metaphysical masterpiece, *Physical Energy*. A universal embodiment of the dynamic force of ambition, the restless urge to achieve more, it was described by the sculptor as, 'a symbol of that restless physical impulse to seek the still unachieved in the domain of material things'. Watts regarded the statue as his most important work for the nation. The rider, an idealized characterization of the great men of the era, guides the horse with one hand on the reins, and with the other he shading his eyes, to scan distant lands yet to be conquered. Setting the group on an incline to suggest a rising wave, Watts combined in the horse's pose, a sense of arrested action and impatience.

In June 1870, the Marquess of Westminster commissioned Watts to sculpt a life-size equestrian statue of his ancestor *Hugh Lupus*. While preparing a small sketch model, the artist conceived the idea of a symbolic group embodying 'human will bridling in brute force', but the marquess wanted an historic portrait, which Watts indeed infused with a sense of brute force. He preserved the alternative symbolic model for future use.

Both statues were modelled in *gesso grosso*. – tow soaked in a mixture of size and plaster of Paris. Watts learned the medieval technique from his Florentine assistant, Aristide Fabrucci. (Barrington, 1905, p. 51). Watts nailed large sheets of brown paper on to a framework of a section of a horse – *Hugh Lupus* was constructed on a wooden framework, *Physical Energy* on metal). He cut the sheets to the shape of the horse, drew lines in charcoal indicating the action he wished to express. The

*108. *Progress*, 1888-1904
Oil on canvas
281.94 x 143.51 cm (111 x 56 ½ in)
Watts Gallery

In old age, Watts was increasingly concerned to promote progress and the advance of science. Attacking the general apathy of the nation in this explosive golden image, he determined to rouse people and to stimulate in them a desire for progress. Having conceived image in 1888, Watts largely painted *Progress* from 1902, after *The Court of Death* was removed from Limnerslease studio and given to the Tate Gallery.

In an expression of the spiritual and intellectual ideals, the spirit of Progress, Watts's apocalyptic conqueror, *The Rider on the White Horse*, leaps through a golden blaze* (which appears to symbolize the power of the Creator). Below, an old man is hunched over his book, a rich man grubs for more gold, a sluggard snoozes, and one figure looks up at the spirit of Progress in the air and begins to rise.

*The reverberations or refracted rays may also relate to those in *Dweller in the Innermost* (Fig. 4) intended to embody consciousness which Watts prized as 'the ethical manifestation of reason'. (Cats. S. 40a and 121a; Alston, 1929, pl. VII.)

109. *Progress*, 1888
Pen and ink
13.5 x 19 cm (5 ½ x 7 ½ in)
Watts Gallery

quick-drying gesso mixture was applied over the wooden in layers, modelling the wet squashy mixture into the rough shape of the muscles, and when it was dry, cut or chiselled it into form. Watts created the statues on a sculpture trolley in the garden of Little Holland House. Always experimenting, he developed an innovative method, breaking up the plaster surface, like an Impressionist painting, to catch the light and heighten the sense of force.

After *Hugh Lupus* vacated the trolley in the autumn of 1882, Watts began the larger statue known at first as *Active Force, Vital Energy* and ultimately, *Physical Energy*. His initial idea was to represent the *Theseus* figure from the Elgin marbles as the rider, but realized that the form was more suited to reflection than action. By December 1883, *The Athenaeum* reported 'great progress with a colossal equestrian group', which the reviewer described as 'the world-subduing energy which conquers savagery and compels civilization'. Watts envisaged *Physical Energy* representing 'five thousand years of activity, and the grace of as many achievements', and considered recording on the pedestal the names of Genghis Khan, Timon the Tartar, Attila, and Mahomet.' In 1888, Burne-Jones's son Philip, prior to painted Watts at work on the statue, arranged for Henry Cameron to take photographs of the sculptor standing on the scaffold with the giant gesso horse and rider in the background.

Increasingly Watts sought to make the rider resemble Man as 'a part of the great creation! – cosmos in fact – his great limbs like rocks & roots, head like sun' – as indeed he achieved in *The Titans* (No. 11) in *Chaos* (No. 13). He wished to convey the idea of mastery over the animal 'a mastery so complete that the man begins to look beyond'. The horse's impatient trample shows that he has been restrained, yet the reins are not tight. Watts was an experienced horseman and used to control his mount with his legs, keeping a light hand on the reins. So that he could alter the position of the limbs – which he did endlessly – Watts built them up over metal bars with a hook or eye at the end. To change the direction, he sawed through the tow and plaster, adjusted the position and covered the gap with tow and plaster. By autumn 1886, Millais judged that the statue to be complete, but Watts, constantly striving for improvement, worked on the great Symbolist statue, with his chief sculpture assistant George Thompson, for the rest of his life.

In 1897, Watts had *Physical Energy* photographed by his factotum George Andrews, and formally offered it to the nation, and by January 1898, the Government had selected the site in Hyde Park. That year, the imperialist Cecil Rhodes, came to sit for a portrait and was immediately struck by the statue, as a monument to commemorate his Cape-to-Cairo railway. After his death in 1902, Watts was agreed to have it cast for Rhodes's memorial in South Africa, provided he could preserve the gesso model to complete for Britain. The Rhodes Memorial statue was cast in bronze at Parlanti's foundry in 1902 and exhibited in the quadrangle of the Royal Academy in 1904. It was while developing this model further for Britain – throwing the rider's head further back and raising the rider's outlook to a higher viewpoint – that Watts caught a fatal chill in May 1904.

The sculptor Alexander Fisher, who had supervised the casting of the Rhodes cast, again supervised the repositioning of the head and arms as Watts had planned. The London statue was cast in bronze at Burton's Foundry in Thames Ditton and erected in Kensington Gardens in 1907. A third cast (1959-60) stands as Rhodes's Memorial at the National Archive in Harare. (MSW diaries, 12, 18 June and 31 July 1892, 18 September 1893, 13 October 1897, 14 April 1902, 25 May 1904; 1912, II, pp. 101, 172, 235-56, 270-71, III, p. 270a; Barrington, 1905, pp. 12, 51-53; *The Athenaeum*, 29 December 1883, p. 874. For details, see Franklin Gould, 2004).

111. Thomas Wren (1885-1964), after G. F. Watts, *Physical Energy*, 1913,
recast for the Watts Gallery in the 1980s
Bronze
77 x 78 x 20.5 cm (17½ x 19 x 8 in)
Watts Gallery

Listed in the 1901 census as a clay-modelling worker and son of the farm manager at Monkshatch, near the Watts's home, Limnerslease, in Compton, Tom Wren was the chief modeller and mould-maker of Mary Watts's Compton Potters' Arts Guild. Wren modelled a reduction from Watts's *Physical Energy* for the Fine Art Society in 1913.

112. *Destiny*, 1904
Oil on canvas
247.5 x 138.5 cm (84 x 41 ½ in)
Watts Gallery

Three months before the artist's death, the Watts Picture Gallery opened on 1 April 1904. That month he began this seven-feet picture of the Angel of Destiny waiting behind a child with an open book, ready for life's record, as a sequel to. *Whence? Whither?*, (1903-4, private collection) which showed the infant humanity running out of the sea with open arms towards the shore of life. Thomas Wren modelled a grey terracotta relief from *Destiny* and *The Messenger* for Watts's memorial in the cloister at Compton (MSW, 1912, II, p. 319).
HU and VFG

What do I know about the Infinite excepting that it is too great to be anywhere little?

113. *After the Deluge: The 41st Day*, 1885-86
(illus. back cover)
Oil on canvas
104.14 x 177.8 cm (41 x 70 in)
Watts Gallery

On the forty-first day, according to Genesis 8: 6-9, the flood waters, having drowned wicked humanity, were subsiding, and in *After the Deluge* the sun is seen radiating over the waters as vapour trails disperse into the mist – (the vapours are seen a fraction later in the biblical story in No.71 *The Return of the Dove*). Here, Watts sought to show 'the hand of the Creator moving by light and by heat to recreate'. The artist explained, 'I have not tried to paint a portrait of the sun – such a thing is unpaintable – but I wanted to impress you with the idea of its enormous power.' At the New Gallery in 1891, this conception was seen as sublime by reviewers, 'an invention such as only the modern Blake could have given birth to'. (Cat.S. 1b.) The Norwegian artist Edvard Munch, who for years had been painting pictures for a *Frieze of Life* with the dedication Watts had pursued *House of Life* subjects, achieved a dynamic sense of energy in his painting of *The Sun* (1912, Oslo, Munch Museum).

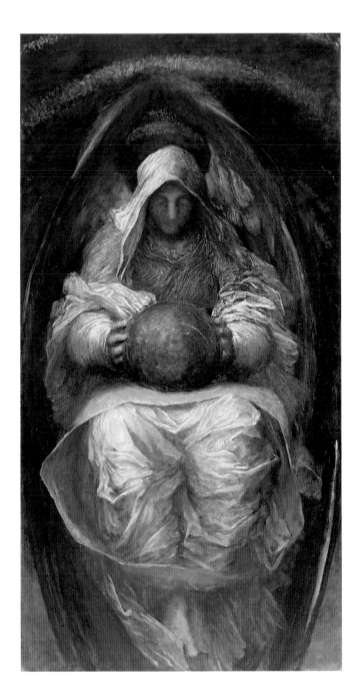

Fig. 21. *The All-Pervading*, 1887-90
Tate Britain

114. *All-Pervading*, 1887
Oil on paper
26.5 x 16 cm (10⅜ x 6¼ in)
Watts Gallery

'The figure with the Globe of the Systems may be called the spirit that pervades the immeasurable expanse', wrote Watts in the preface to his New Gallery exhibition in 1896. In old age, he increasingly turned his attention to the mystery of Creation. In December 1887, the play of light from a glass chandelier at the Villa Micallef in Malta – was the source of Watts's design for 'The all-pervading spirit of the universe'. Mary Watts noted in her diary, as her husband had began to paint the new subject, 'It promises to be most suggestive'.

This is the preliminary sketch for the major metaphysical subject Watts presented to the nation with his Symbolist series in 1897. The cosmic figure, seated within wings and cradling on its lap a blue sphere, flecked with light, suggests a spiritual

presence supporting and permeating the universe. In his unique modern iconography, Watts would no more present God as an old man than he would Time or Death. However, he has built on and transformed traditional iconography in the almond-shaped wings, reminiscent of a mandorla, which in religious art is associated with the holiest figures, usually Christ.

On 15 April 1904, a smaller version of the painting was installed over the golden altar of the mortuary chapel in Compton. The highly symbolic chapel, designed by his wife, who trained villagers to model its terracotta tiles, and funded by his portrait commissions, was the Wattses' joint gift to the parish. (MSW diary, 6 December 1887; New Gallery, 1896-97, cat. 129; Franklin Gould, 1993, pp. 37-38.) HU and VFG

115. *Sower of the Systems*, 1898- 1903
Oil on canvas
66.04 x 53.34 cm (26 x 21 in)
Watts Gallery

Here the abstract qualities of Watts's late works are given their fullest expression in a revolutionary attempt to visualize the divinity for a sceptical modern age. Having begun *The All-Pervading* in 1897, the idea of the Creator was very much in his mind. In November 1898, Watts mused about the God having talked, but not shown his face to Moses (Exodus 20: 20-22), and spoke of

> the true religious conception of the Creator & his creation – a Breath issuing forth becomes matter – controlling this matter are two laws: force which propels & gravitation which controls - & there in its enormity you have the whole thing – the conflict produced by these laws explains every phenomenon – The nebulous form of matter in its primitive conditions acted on by these two laws becoming the ordered universe.

It seemed unpaintable. If he were to symbolize the Deity, said Watts he would paint 'a great vesture into which everything that exists is woven'. He began by making circular scribbles and pierced the paper with his pencil to create a void. Refracted rays thrown by a night light on to his bedroom ceiling suggested the form of *The Sower of the Systems*. Here, a veiled robed figure of no definable sex strideĺs rapidly across the picture space, scattering suns, stars and planets from its outstretched hands. The paint handling is extraordinarily free, with streaks and dabs of gold and brilliant green clouds. The picture sparkles, surges with energy; even the sense of music with which Watts infused his pictures, seems modern. At the New Gallery in 1903, *The Sower of the Systems* – presumably, the larger version (Art Gallery of Ontario, Toronto) – mystified critics. An astonishing advance after 66 years exhibiting in public, from the Romantic style of his Academy pictures of 1837, *The Sower of the Systems* heralds twentieth-century abstraction. (MSW, 5 July 1896 and 10 and 16 November 1898; 1912, II, p. 105.) HU and VFG

116. *Death Mask*, 1904
Plaster
35.5 x 21 x 16 cm (17 x 8½ x 6½ in)
Watts Gallery

Cast from the head of the late G. F. Watts, taken by Cantoni, under the supervision of the sculptors Henry Poole and Alexander Fisher, on 2 July 1904.

1817 Born on 23 February at 52 Queen Street, London

1827 Apprenticed in studio of Hanoverian sculptor William Behnes.

1835 Enters Royal Academy Schools. Studies from Elgin Marbles.

1837 Ionides commissions the first of five generations of his family. Exhibits *The Wounded Heron* at RA.

1843-47 Awarded a top prize for *Caractacus* cartoon at 1843 Palace of Westminster competition. Travels via Paris to Florence, where he lives as the protégé of Lord Holland. Paints frescoes: *Flora, The Drowning of the Doctor* at Villa Careggi. First nude paintings *Paolo and Francesca , Story from Boccaccio* and *Echo*. Begins *Fata Morgana*, Visits Sistine Chapel. Plans to fill a British hall of frescoes. Sculpts *Medusa*.

1847 April returns to England. Rooms at 48 Cambridge Street. Top prize for *Alfred* at Westminster. Cosmic scheme for *House of Life* frescoed hall. Ruskin admires *Satan*.

1848 Plans to decorate buildings with elevating frescoes.

1849 Oxford campaign for Watts fresco. Discovers *The Oxford Bust*. Championed by Ruskin, who hangs *Time and Oblivion* in his studio. *Life's Illusions* derided. Moves to new studio, 30 Charles Street, Berkeley Square.

1850 Designs *Education and the Muses*, fresco for Taylorian ceiling in Oxford. *The Good Samaritan* at RA. Completes social realist pictures. Visits Ireland..

1851 Moves to Little Holland House (LHH) in Kensington as tenant of Thoby and Sara Prinsep. Symbolic frescoes.

1852 Dual mission for the nation: to paint symbolic public frescoes and portraits of notables. His pioneering allegories decried by RA. Refuses to exhibit after 1852. June, Lincoln's Inn accepts his offer to paint fresco. Oxford fresco rejected for nudity.

1853 Paints fresco *The Red Cross Knight Overcoming the Dragon* at the Palace of Westminster. *The Court of Death* begins. To Venice.and Padua.

1854-56 Frescoes: *Justice: Hemicycle of Lawgivers* at Lincoln's Inn and *The Elements* at Carlton House Terrace. Meets Leighton 1855. To Paris with Lord and Lady Holland.

1856-57 Pre-Raphaelites and Tennyson at LHH. Joins excavation of Halicarnassus. Reflected light over the Aegean Sea later recalled in *Genius of Greek Poetry*, and mythological landscapes. Returns to London June 1857.

1858-59 Fresco of *Achilles and Briseis* at Bowood. Exhibits at RA from 1858. Finishes *Hemicyle* October 1859.

1860 Designs *Elcho Shield*. Enrols in Artists' Rifle Corps. *Coriolanus* at Bowood. Marie Ford models for *Bianca*, studies used in *Ariadne*

1861 *Christ and the Evangelists* fresco, St James the Less, Westminster.

1862 Exhibits *Bianca* and *Sir Galahad* at RA. At Blickling paints the Marquess of Lothian, his wife and family.

1863-64 Dalziel *Bible*. Royal Academy Inquiry. *St Matthew* cartoon for St Paul's Cathedral mosaic. Exhibits *Ariadne* (model Marie Ford) at RA. Kate and Ellen Terry pose as *The Sisters*. Ellen Terry as *Watchman? What*

of the Night? GFW paints dray horses as *The Midday Rest*. 'Long Mary' nude studies. Marries ET on 20 February. *Choosing*. Julia Margaret Cameron photographs GFW and ET in Freshwater, Isle of Wight. Advises Cameron. New *Court of Death*. Half-length nude paintings. ET and GFW separate, formalized January 1865.

1865 Sits to Cameron for *The Whisper of the Muse*. Love and Life sketch and *Esau* (model Angelo Colarossi) at RA. *Titans St John* cartoon for St Paul's Cathedral. *Magdalen the Penitent*. Manchester patron, Charles Rickards sits. Lamplight study of *Joachim*. *A Study with the Peacock's Feathers* at French Gallery.

1866 Small *Thetis* at RA. Rickards' interest in poetic subjects. Mosaic of *Titian* for South Kensington Valhalla.. Proposes symbolic national monument to everyday heroes. *Major Sir Thomas Cholmondeley Owen* for Condover Church (1866-67).

1867 Elected ARA in January and RA in December. *Prayer, A lamplight study: Herr Joachim*. at RA. *Eve* series begins. *Orpheus and Eurydice*. *Oxford Bust* publicized. Gertrude Jekyll copies his *Head of a Bull* at LHH. Nude *Daphne* at the Dudley Gallery. Begins clay bust of *Clytie*. Rents sculpture studio from George Nelson at 8 Ravens Place, Hammersmith. *The Rider on the Pale Horse* begins.

1868 Evening landscape, *The Meeting of Jacob* at RA, praise for *The Wife of Pygmalion* unfinished marble *Clytie*. Scott commissions effigy of Bishop Lonsdale for Lichfield Cathedral.*Time, Death and Judgment* study for Rickards. His support spurs GFW to develop symbolic subjects.

1869 *Endymion* hailed by Rossetti , purchased by William Graham.. With Edgar Boehm, models statue of Lord Holland for Kensington. GFW and Leighton hang revolutionary Olympian exhibition at RA *Return of the Dove*, a sensation, *Orpheus and Eurydice*.. Exhibits nude *Ariadne* and *The Island of Cos* at the Dudley Gallery. Studies for *Hope*.

1870 *Daphne* and *Fata Morgana* at RA. Marquess of Westminster commissions equestrian statue *Hugh Lupus*. GFW conceives symbolic version, the future *Physical Energy*. *Love and Death* at the Dudley.

1871 Marble head of *Medusa* begins. *After the Transgression* 'most daring presentment' *Daphne, Endymion* –at International Exhibition at South Kensington *Memorial to Lord Lothian* commissioned. *Rider on the Black Horse*. *The Court of Death* at the Dudley.

1872 Philip Webb designs The Briary for GFW and Prinseps at Freshwater. RA diploma picture *Denunciation of Cain* Adopts Blanche Clogstoun. *Watching for the Return of Theseus* and chiaroscuro full-length, *Orpheus and Eurydice* at Dudley. Design for *The Three Goddesses*.

1873 *The Spirit of Christianity* begins. Richard Johnson buys *The Titans. Paolo and Francesca*. Refuses to sell *Eve in the Glory of her Innocence* to Johnson, to preserve cosmic series for the nation, or public body.

1874 The Briary completed. *Love and Death* and *Court of Death* at Royal Manchester Institution. *Dawn and Day* at the Dudley. Little Holland House is to be demolished, F. P. Cockerell designs new LHH.

1875 *The Spirit of Christianity* at RA. Emilie Barrington's first visit. Has repainted *Love and Death*. *Carrara Mountains*. 'Most complete' *Ariadne*. Charlotte Wylie preserves old LHH frescoes

1876 Moves into new LHH, 6 Melbury Road. Emilie Barrington becomes GFW's assistant. Finishes *Eve of Peace*. *Judgment of Paris* at Deschamps Galleries. Declines murals for Manchester Town Hall.

1877 At the opening of the Grosvenor Gallery GFW and Burne-Jones hailed as artist of poetic power, *Love and Death* praised by Oscar Wilde. *The Dove Which Returned Not Again* at RA. Begins life-size gesso model of *Hugh Lupus*.

1878 *Ophelia* and *Time Death and Judgment* at Grosvenor. Gold medal at Paris Exposition Universelle for *Love and Death, Judgment of Paris, Esau* and marble *Clytie*. Bust of *Daphne* begins. *When Poverty knocks at the door Love Flies Out of the Window* at the Dudley.

1879 *Return of Godiva*. Full-length *Orpheus and Eurydice* at Grosvenor, etching in *L'Art*. Statue of *Aurora* advanced.

1880 'The Present Conditions of Art' published in *Nineteenth Century*. Rickards exhibits 54 paintings by Watts at the Royal Manchester Institution. *Psyche* and *Daphne* at Grosvenor. *Orpheus and Eurydice* at Paris Salon.

1881 Builds Little Holland House Gallery. *Found Drowned* and *Time Death and Judgment* at St Judes's Whitechapel. *Genius of Greek Poetry, Endymion, Arcadia* and visionary *Carrara, from the Leaning Tower of Pisa* at Grosvenor. Violet Lindsay sits as *A Reverie* and for poetic study in blue and gold. *Britomart and her Nurse* awarded gold medal at international exhibition in Melbourne. Watts retrospective of 205 works exhibition opens at the Grosvenor. Growing reputation.

1882 *Psyche* purchased by Chantrey bequest. *Love and Life*. *Hugh Lupus* completed, begins *Physical Energy*.

1883 'On Taste in Dress' (*Nineteenth Century*). Apocalyptic rider series at Whitechapel, then Grosvenor. Experiments in atmospheric effects. Six Symbolist paintings, including opalescent triple nude *Olympus on Ida* at Galerie Georges Petit in Paris. *Love and Life* at Manchester. Mystical *Island of Cos*.

1884 *Wife of Pluto, Brunhild*. Elected to Society for Psychical Research. Mackmurdo inscribes *Hobby Horse* to GFW 'England's greatest painter' *Uldra* and *The Happy Warrior* at Grosvenor. Home Arts and Industries Ass founded. Watts retrospective at the Metropolitan Museum of Art, NY.

1885 *Mammon. Love and Life* at the Grosvenor. Declines baronetcy. *The Minotaur.*, protest against child prostitution. *Daughter of Herodias* at Royal Cambrian Academy in Cardiff. Offers *Love and Life* to USA The Watts Collection transfers to Birmingham. *Time, Death and Judgement* as gift to Canada.

1886 *Hope, Dweller in the Innermost* and *Angel Removing the Curse of Cain.* at Grosvenor. *Death Crowning Innocence, After the Deluge* begin. Important Symbolist pictures at South Kensington Museum as future gift to the nation. Marries Mary Seton Fraser Tytler

1887 Honeymoon in Egypt and Greece. *The Sphinx. Olympus on Ida* at the Grosvenor. 34 pictures at Manchester Royal Jubilee Exhibition. *Aspiration. Love and Life* and *Love and Death* for Melbourne Centennial Exhibition. *The Messenger.* To Malta.

1888 *The All-Pervading* begins. Gives a *Love and Death* to Manchester. To Naples, Mentone and Aix-les-Bains. *The Open Door.* Alpine paintings. *Death Crowning Innocence* at opening of New Gallery. *Peace and Goodwill.* Conceives *Progress.* In Brighton adds visionary effects to *Ariadne.* Conceives motto *The Utmost for the Highest.*

1889 'Thoughts on our Art of Today' published in *Magazine of Art.* Heightens visionary effect of *She Shall be Called Woman. The Sea Ghost. Off Corsica. Sant' Agnese Mentone, Wife of Pluto* at New Gallery. Paris Exposition Universelle, gold medal. Advances large *Eve Tempted, Eve Repentant* and *Progress.* 'National Position of Art'. Winter at Monkshatch, Compton, Surrey.

1890 Ernest George designs Limnerslease, Watts's home in Compton. Visionary *Ariadne* at New Gallery. *A Patient Life of Unrequited Toil* at RA. *Faith. Rider on the Black Horse* and *The Wife of Pluto*, first purchases of Liverpool patron James Smith.

1891 Agnew exhibits visionary series of chalk drawings. *After the Deluge* and *Nixie's Foster Daughter* at New Gallery. *Court of Death* at Limnerslease. *The Recording Angel.* Lady Waterford's gravestone. *Eve Tempted* (WG) begins. Declines to exhibit at Salon of Rose + Croix, Paris.

1892 *Iris* begins. *She Shall Be Called Woman* (unfinished) failure at RA. *Sic Transit* at New Gallery.

1893 *Eve Repentant. Naked and Ashamed., Naked and Not Ashamed. Endymion* (vertical) and *Promises* at RA. *Neptune's Horses* and *The Open Door* at New Gallery.. *The Happy Warrior,* among 24 works in Munich Artists Association exhibition, is purchased. Hollyer albums: photographs of works to date. Exhibited at Chicago World's Fair, *Love of Life* stays in America, arouses feminist protest.

1894 Edmund Gosse defines *Clytie* as 'forerunner of the New Sculpture'. *Europa* at St Jude's. *For he had great possessions* acclaimed at RA. *A Greek Idyll* at New Gallery. Poetic portrait of Violet Lindsay, highlight of *La Libre Esthétique* exhibition in Brussels. Photo in front of *The Court of Death*.

1895 *Jonah, The Outcast: Goodwill* at RA.. *Charity* at New Gallery. *Love Triumphant* begins. *Green Summer.* Models wax figure for *Good Samaritan.*

1896 *Earth, Naked and Not Ashamed* and *They Knew That They Were Naked* at New Gallery. *The Childhood of Zeus* at RA. Again declines baronetcy. Following death of Leighton, retires from RA. New Gallery retrospective exhibition of 155 works by Watts.

1897 *Time, Death and Judgment* and *She Shall be Called Woman* highlight of Stockholm Exhibition of Arts and Industry. *Paris on Mount Ida* at New Gallery. Reworks original *Sir Galahad* for Eton College. Watts gives Symbolist series – including *House of Life* pictures – to opening of the National Gallery for British Art (Tate Gallery). George Andrews photographs *Physical Energy. A Dedication (The Shuddering Angel)* begins.

1898 *Can These Bones Live?* at New Gallery. *Love Triumphant* at RA. *Slumber of the Ages* begins. Conceives *The Sower of the Systems.*

1899 Large *Love Triumphant* begins. *A Dedication* and *Peace and Goodwill* at New Gallery. Travels to Inverness-shire. Paints visionary landscapes. Memorial to Everyday Heroes opens in St. Botolph's churchyard, Aldersgate.

1900 *Idle Child of Fancy* and *A View of Naples* at Paris International Exhibition. *An Afterglow* at New Gallery. Third large *Love and Death* to South Australia.

1901 Queen Victoria dies. 'Our Race as Pioneers' published in *Nineteenth Century and After. In the Highlands* at RA. Roger Fry praises *Greed and Labour, Trifles Light as Air, Slumber of the Ages*, but mystified by symbolism. *Love Steering the Boat of Humanity* at Dresden International Exhibition.

1902 *The Court of Death* given to Tate Gallery. *Physical Energy* cast for Rhodes Memorial. *Love Steering the Boat of Humanity* at New Gallery. Awarded the Order of Merit. Large *Progress* at Limnerslease.

1903 Lays cornerstone of hostel and Watts Picture Gallery at Compton. *The Sower of the Systems, Green Summer, End of the Day* and *The Two Paths* at New Gallery. *A Parasite* at RA. Reworks large *Endymion.* Completes statue of Tennyson. Little Holland House Gallery closes.

1904 *Brunhild* at St Louis World's Fair. *Destiny* begins. Watts Picture Gallery opens 1 April. *The All-Pervading* installed above altar of mortuary chapel designed by his wife at Compton. Rhodes Memorial cast of *Physical Energy* in quadrangle of RA. Small *Progress, A Fugue, Whence? Whither?, Endymion* and, notably, *Prometheus* at New Gallery. Catches chill making final changes to *Physical Energy.* Dies 1 July. Funeral services at Compton mortuary chapel in Surrey and at St Paul's Cathedral in London.

1905 Watts memorial exhibition at Royal Academy. Transfers to Edinburgh, Manchester, Newcastle and Dublin in 1906.

1907 *Physical Energy* erected in Kensington Gardens, London.

Bibliography

Abbreviations:

Fiche	Courtauld Institute microiche catalogue of GFW's letters (at WG, and London art reference libraries)
LHH	Little Holland House
MSW	Mary Seton Watts and her diaries and. manuscripts (WG)
MSW.Cat.P.	MSW's manuscript catalogue of Watts's portraits (WG)
MSW.Cat.S.	Catalogue of Watts's subject pictures (WG)
NPG	National Portrait Gallery archives
V&A	National Art Archive, Victoria and Albert Museum.
WG	The Watts Gallery

Exhibitions: (Those in London are listed by Gallery):

Brussels 2004: *Fernand Khnopff*, Royal Museums of Fine Arts of Belgium

.Compton 1998: *Mary Seton Watts (1849-1938) Unsung Heroine of the Art Nouveau*, The Watts Gallery.

Coventry 1982: *Lady Godiva: Images of a Legend in Art and Society*, Herbert Art Gallery and Museum.

Grosvenor Gallery 1881-82: *Winter Exhibition: Collection of the Works of G. F. Watts, R.A.*

Liverpool 1885: *The Fifteenth Autumn Exhibition of Modern Pictures*, Walker Art Gallery.

Liverpool 2003: *Dante Gabriel Rossetti*, The Walker.

Minneapolis 1978: *Victorian High Renaissance*. Minneapolis Institute of Arts.

Munich 1893: *Münchener Jahresausstellung von Kunstwerken aller Nationen im Glaspalaste.*

New Gallery 1896-97: *Winter Exhibition: The Works of G F Watts R A.*

New York 1884-85, *The Loan Collection of Paintings by George Frederick [sic] Watts*, Metropolitan Museum of Art.

New York 2003: *A Private Passion: 19th-Century Paintings and Drawings from the Grenville L. Winthrop Collection, Harvard University*. Metropolitan Museum of Art.

Paris 1879, *Fernand Khnopff 1858 – 1921* Musée des Arts Decoratifs.

Paris 1880: *Illustrated Catalogue of the Paris Salon.*

Paris 1883: *Exposition Internationale de Peinture*, Galerie Georges Petit.

Paris 1998: *Gustave Moreau 1826-1898*, Grand Palais.

Royal Academy of Arts 1996: *Frederic Leighton.*

Tate 2000: *William Blake.*

Tate 2001: *Exposed: The Victorian Nude.*

Tate Gallery 1954: *George Frederic Watts OM RA 1817-1904*, The Arts Council.

Tate Gallery 1997: *The Age of Rossetti, Burne-Jones & Watts: Symbolism in Britain 1860-1910.*

Whitechapel Art Gallery 1974: *G. F. Watts: A Nineteenth Century Phenomenon.*

Literature:

Richard Aldington, ed, *Walter Pater: Selected Works*, 1948.

Rowland Alston, *The Mind and Work of G. F. Watts, OM, RA.*, 1929.

J Beavington Atkinson, *English Painters of the Present Day*, 1871.

Tim Barringer and Elizabeth Prettejohn, eds, *Frederic Leighton: Antiquity Renaissance Modernity*, 1999.

Mrs Russell Barrington, *G. F. Watts: Reminiscences*, 1905.

Charles T. Bateman 'Mr G. F. Watts and His Art' *The Windsor Magazine*, June 1901.

Susan Beattie, *The New Sculpture*, 1983.

Kenneth Bendiner, An *Introduction to Victorian Painting*, 1985.

Wilfrid Blunt, *England's Michelangelo: A Biography of George Frederic Watts*, 1975.

Thomas Carlyle, 'The Hero as Divinity', lecture delivered 5 May 1840, reprinted in *On Heroes, Hero-Worship and the Heroic in* History, 1907.

– *Past and Present*, 1843, III, vi, 1912 edition.

Joseph Comyns Carr, *Examples of Contemporary Art: Etchings from Representative Works by Living England and Foreign* Artists, 1878.

– Carr , *Some Eminent Victorians: Personnal Recollections in the World of Art and Letters*, 1908.

Julia Cartwright, 'G. F. Watts R.A.' *Atlanta*, V, no.49, Oct 1891.

Anon. [Robert Chambers], *Vestiges of the Natural History of Creation*, 1844.

David F. Cheshire, *Portrait of Ellen Terry*, 1989.

Ernest Chesnau, *La Peinture Anglaise*, Paris, 1882, trans L. N. Etherington, *The English School of Painting*, 1885.

G.K. Chesterton, *G. F. Watts*, 1904.

E.T. Cook, *A Popular Handbook to the Tate Gallery 'National Gallery of British Art'*, 1898.

E. T. Cook and Alexander Wedderburn, eds, *The Works of John Ruskin*, 39 vols, 1903-12.

George Dalziel, *The Brothers Dalziel: A Record of Fifty Years' Work*, 1901.

Colin Ford, *The Cameron Collection: An Album of Photographs* by Julia Margaret Cameron Presented to Sir John Herschel, 1975.

P.T. Forsyth, *Religion in Recent Art*, 1889.

Veronica Franklin Gould, *G. F. Watts: The Last Great Victorian*, 2004.

- *The Watts Chapel: An Arts and Crafts Memorial*, 1993.

Roger Fry, 'Watts and Whistler,' *Quarterly Review* 202, 1905.

Martin Gregor-Dellin & Dietrick Mack, eds, *Cosima Wagner's Diaries*, 2 vols. 1978.

Journal for the Society for Psychical Research, I, April 1884.

R. E. Gutch, 'G. F. Watts's Sculpture' *Burlington Magazine*, vol.110, 1968.

Fernand Knopff, 'Some English Art Works at the Libre Esthétique at Brussels', *The Studio,* May 1894, vol. III.

Mary Lago, ed, *Burne-Jones Talking*, 1982.

Lord Leighton, *Addresses Delivered to the Students of The Royal Academy*, 1896.

David Loshak, 'Watts and Ellen Terry.' *Burlington Magazine*, 1963, vol. 105, pp. 476–85.

Hugh Macmillan, *The Life-Work of George Frederick Watts*, 1903.

Jan Marsh, *Dante Gabriel Rossetti, Painter and* Poet, 1999, vol I.

Mc Allister, *Alfred Gilbert* , 1929.

L .T .Meade, 'The Painter of the Eternal Truths: First Paper' *Sunday Magazine*, January and June 1894.

J. G. Millais, *The Life and Letters of Sir John Everett Millais*, 1899, II vols.

The Rev L. H. Mills, 'Zoroaster & the Bible, *The Nineteenth Century*, January 1894.

George Moore, *Modern Painting*, 1893.

Richard Muther, *The History of Modern Painting*, 1896.

The National Trust, *Blickling Hall*, 1987.

Claude Phillips, 'The Progress of English Art as Shown at the Manchester Exhibition' *The Magazine of Art*, 1888.

Harry Quilter 'The Painting of George Frederick Watts, RA: A Comparative Criticism', *Contemporary Review*, Feb 1882, reprinted in *Preferences in Art, Life and Literature*, 1892.

Eleanor F. Rawnsley, *Canon Rawnsley: An Account of his Life*, 1923.

Report of the Director of National Gallery 1897 (Tate archives).

John Ruskin, *The Stones of Venice*, 1851-53, III vols.

R.E.D. Sketchley, *Watts*, 1904.

Alison Smith *The Victorian Nude: Sexuality, Morality and Art*, 1996.

Society for the Protection of Birds, Seventh Annual Report, 1897.

M H Spielmann, – *The Works of Mr G. F. Watts R.A.*, 1886.

W.T. Stead, 'Mr G.F. Watts, RA', *Review of Reviews*, June 1902.

David Stewart, 'George Frederic Watts: A Feminist Artist in the Royal Academy,' *Abstracts*, 1998.

– 'Is a Myth a Lie? A Victorian Answer in the Paintings of G. F. Watts,' *Nineteenth Century Studies,* 1991.

– 'Of Angst and Escapism, George Frederic Watts and Frederic Lord, Leighton,' *Victorians Institute Journal* vol. XXII, 1994.

Tom Taylor, ed *Life of Benjamin Robert Haydon, Historical Painter from his Journals*, 1853, III vols.

Colin Trodd and Stephanie Brown, eds, *Representations of G. F. Watts*, 2004.

Philip Ward-Jackson, *Public Sculpture of the City of London*, 2003.

Robert R Wark, ed, *Sir Joshua Reynolds: Discourses on Art*, 1997.

George Frederic Watts, The Present Conditions of Art', *Nineteenth Century*, February 1880, (reprinted in MSW, 1912, III, 147-90).

– 'The National Position of Art' 1889, (reprinted in *The Hobby Horse* No 17, Jan 1890, 2-10, and in MSW, 1912, III, 258-271.

– 'Our Race as Pioneers', *Nineteenth Century and After*, May 1901, 849-57, reprinted in MSW, 1912, III, 277-294.

MSW, *George Frederic Watts, The Annals of an Artist's Life*, 1912, III vols.

Oscar Wilde, 'The Grosvenor Gallery', *The Dublin University Magazine*, xv, July 1877.

Sylvia Wolf, *Julia Margaret Cameron's Women*, 1998.

Photo Credits

Index of Works